FAST FORWARD

Fast Forward

Contemporary Collections
for the Dallas Museum of Art

Edited by MARÍA DE CORRAL and JOHN R. LANE

With contributions by Frances Colpitt,
María de Corral, John R. Lane, Mark Rosenthal,
Allan Schwartzman, and Charles Wylie

DALLAS MUSEUM OF ART

YALE UNIVERSITY PRESS
New Haven and London

This catalogue has been published in conjunction with the exhibition
Fast Forward: Contemporary Collections for the Dallas Museum of Art.

Fast Forward: Contemporary Collections for the Dallas Museum of Art is organized by the Dallas Museum of Art.

The exhibition is presented by JPMorgan Chase and made possible by the Contemporary Art Fund through the gifts of an anonymous donor, Arlene and John Dayton, Mr. and Mrs. Vernon Faulconer, Nancy and Tim Hanley, Marguerite and Robert Hoffman and the Hoffman Family Foundation, Cindy and Howard Rachofsky, Deedie and Rusty Rose, and Gayle and Paul Stoffel.

The Museum acknowledges generous funding from David Yurman Jewelry, with additional support by the Fanchon and Howard Hallam Endowment Fund and by Tenet Healthcare.

JPMorgan Chase is proud to sponsor *Fast Forward: Contemporary Collections for the Dallas Museum of Art.* We are pleased to celebrate the generosity of the Dallas collectors and the collaboration of these families, who came together to benefit the city of Dallas, the Dallas Museum of Art, and all who visit the city's cultural institutions. JPMorgan Chase's commitment to the arts is an investment in the communities we serve.

JPMorganChase ⬡

Unless otherwise noted, all works illustrated in this catalogue
are either partial or promised gifts to the Dallas Museum of Art
or are currently in the permanent collection.

CONTENTS

Director's Foreword and Acknowledgments

THE DALLAS MUSEUM OF ART'S Centennial in 2003 was intended as a celebration of a century of growth and accomplishment. We also hoped that it might be the occasion for a substantial augmentation of the Museum's financial resources to provide for greater stability, extend planning horizons, and permit sufficient programmatic enrichment that the institution might move up a level in the American museum hierarchy. These were all worthy aspirations and, happily, were in large part achieved. What we had not expected was the outpouring of art gifts that would vault the DMA into the empyrean of those encyclopedic museums embracing contemporary art as an essential part of their curatorial program. At a memorable event held on the evening of February 10, 2005, Dallas's Hoffman, Rachofsky, and Rose families committed by promised bequest the entirety of their exceptional contemporary art collections to the Museum, a gift that now represents nearly nine hundred works and triples the DMA's current holdings of some four hundred and fifty paintings, sculptures, and media pieces (a number that does not include its sizable graphics collection). This largess garnered overnight not only the attention of the city but also the regard of the international art world.

The Hoffmans, Rachofskys, and Roses were in part inspired by the munificent example of Raymond Nasher, whose incomparable private collection of modern sculpture had, with the opening of the Nasher Sculpture Center, very recently become a public cultural treasure in the Dallas Arts District. In the broader view, however, their commitments represented a climactic moment in a much longer narrative. One of the defining moments in the DMA's history was the founding in 1956 of the Dallas Museum for Contemporary Arts, a short-lived but ambitious organization that, when it merged with the Dallas Museum of Fine Arts in 1963, partnered in creating the combined institution we know today as the Dallas Museum of Art. The spirit of those Dallasites who, begin-

ning in the 1950s, cared deeply enough about modern and contemporary art to launch and nurture a venue devoted to it has since been emulated by dedicated museum professionals and generous collectors, donors, and volunteer leaders. Among the Museum's chief objectives in recent years has been, quite explicitly, to develop one of the major modern and contemporary art collections and programs in the world. This we have regarded as a reality-based goal, one grounded in the DMA's own record of actively acquiring and presenting the work of living artists, the Dallas community's astonishing richness of private collections of impressionist, modernist, and contemporary art, and the synergies of the closely proximate Museum and Nasher Sculpture Center. This publication and the exhibition it accompanies commemorate our remarkable progress—conspicuously driven by the recent commitments of Dallas collectors to enrich on a transforming scale the contemporary art holdings of the Dallas Museum of Art—toward this objective, and they present a record of the Museum's half century of serious engagement with the art of its time.

We offer our particular thanks to the lender-donors who have made this exhibition possible: Marguerite Hoffman and her late husband Robert, Cindy and Howard Rachofsky, and Deedie and Rusty Rose for their extraordinary beneficence in making irrevocable bequests of their entire collections to the Museum; Gayle and Paul Stoffel for having so generously bestowed on the Museum multiple individual works from their esteemed collection; Nancy and Tim Hanley for affording us access to their impressive collection of contemporary Texas art; and Amy and Vernon Faulconer, Catherine and Will Rose, Cindy and Armond Schwartz, Sharon and Michael Young, and an anonymous couple for the highly valued contributions they have made from their ambitiously developing collections. The particular perspective that has informed the Dallas collectors' unprecedented benefactions has been eloquently

summarized by Marguerite Hoffman: "For me, the joy of actually living with these works of art has also been tempered by a couple of things. One, the responsibility of stewardship for these objects. All collectors are only temporary stewards of the objects they collect, whether they want to acknowledge the fact or not. I have felt a sharp sense of responsibility about the need to pass these objects on to a larger audience. Secondly, I must confess that I felt a bit guilty about owning these artworks and about the resources we had given over to our mutual addiction. The question that haunted me was, could we make a moral argument for collecting art when there is such an overwhelming amount of suffering in the world? Shouldn't we readjust our priorities if we wanted to be good people? … The tension between owning the art and enjoying it privately and the moral obligation to make a difference … was finally resolved [when], along with our dear friends, the Rachofskys and the Roses, we went public with our decision to leave all our art to the Dallas Museum of Art. For me, [this is] an elegant solution to my personal conundrum of how to be a hedonistic do-gooder: enjoy the luxury of living with the art for a time, then give it all away, no strings attached. I think I speak for all the participants involved in this bequest when I say it was the best decision we could have made and it was painless. In fact, since we have made this decision, we have been infused with more energy to continue our work on behalf of the Museum, and we have reaped the side benefit of deepening already steadfast friendships."

Fast Forward: Contemporary Collections for the Dallas Museum of Art is premised on the idea of bringing the holdings the Museum amassed over time together with the breathtaking bounty of promised gifts that have been recently lavished on it. The DMA and the donor-collectors agreed that an internationally regarded expert aligned neither with a participating party nor with the institution should be asked to take on the crucial (and sensitive) role of selecting the works for the exhibition and shaping its installation and this catalogue. We were extremely fortunate that María de Corral, the distinguished former director of the Museo Nacional Centro de Arte Reina Sofía in Madrid, architect of the highly respected contemporary art collection held by the Caixa Foundation in Barcelona and Madrid, and co-director of the 2005 Venice *Biennale*, accepted our invitation to serve as guest curator of the exhibition. Known as one of the most informed, judicious, and decisive members of the contemporary art world,

de Corral is also a colleague of great integrity, candor, and personal warmth. She has shared those qualities in abundance and it has been, for all of us involved with the realization of this project, a joy to work with her. For her efforts and achievements on our behalf, I know I am joined by the collectors and the Museum's staff in expressing to her our deepest appreciation.

Tamara Wootton-Bonner, Director of Exhibitions and Publications, has played a crucial part in the development of this endeavor, one well beyond the exemplary organizational management of projects under her aegis that she regularly affords the Museum, for which we thank her sincerely. Charles Wylie, the Lupe Murchison Curator of Contemporary Art, has been a supportive and wise counselor in the development of the exhibition and the publication as well as a contributing author to the latter, for which we are most grateful. We are very indebted to Deputy Director Bonnie Pitman for her appreciation of the significance of this project and for giving it the full support of the redoubtable resources of the institution's artistic program that she has been so instrumental in developing. We acknowledge Suzanne Weaver, the Nancy and Tim Hanley Associate Curator of Contemporary Art, Victoria Estrada-Berg, Curatorial Administrative Assistant, Victoria Scott, McDermott Graduate Intern, and Caitlin Topham, McDermott Curatorial Intern, each of whom has been deeply committed to this project and has made important contributions to its realization. We extend special appreciation to the many members of the DMA staff whose support helped bring this project to fruition, making particular mention of Jacqui Allen, Tracy Bays-Boothe, Jennifer Bueter, Giselle Castro-Brightenburg, Judy Conner, Gail Davitt, John Dennis, Diana Duncan, Brad Flowers, Diane Flowers, Carol Griffin, Vince Jones, Lance Lander, Anne Lenhart, Michael Mazurek, Kevin Parmer, Debra Phares, Elayne Rush, Chip Sims, Liza Skaggs, Susan Squires, Debbie Stack, Gabriela Truly, Eric Zeidler, and Jeff Zilm.

We warmly thank each of the following colleagues from outside the Museum's walls for their important contributions: for their catalogue essays, Allan Schwartzman, Director of the Rachofsky Collection (whose constructive influence as a partner in the development of the contemporary art holdings of Dallas is further extended through his advisory role with several other private collections also represented

in this exhibition), Mark Rosenthal, Adjunct Curator of Contemporary Art, Norton Art Museum, Palm Beach, Florida (who has also been a friendly counselor to Marguerite and Robert Hoffman), and Frances Colpitt, the Deedie Potter Rose Chair of Art History, Texas Christian University, Fort Worth; for publication design and production, the Green Dragon Office in Los Angeles, Lorraine Wild and Stuart Smith, designers; for editing, Frances Bowles; for proofreading, Sharon Rose Vonasch; for representing our distribution partner at Yale University Press, Patricia Fidler and Carmel Lyons; for exhibition design, Roberto Luna and Bill Cochrane; for specialized art conservation, Inge-Lise Eckmann Lane, whose considered touch greatly benefited the state of a number of the Museum's masterwork contributions to this exhibition, including paintings by Pollock, Kline, Gorky, and Johns; David Resnicow of Resnicow Schroeder Associates, New York; Lorena M. de Corral and Antonio Álvarez Barrios at Expoactual in Madrid; Margaret Rosenbaum, Jeanne Chvosta, Thomas Feulmer, and Angela Walsh in Dallas; and Janet Kutner, a former member of the staff of the Dallas Museum for Contemporary Arts and, from 1970 to 2006, art critic for *The Dallas Morning News,* for her vigorous advocacy of contemporary art in our city for five decades.

Since 1999 the activities of the contemporary art program at the Dallas Museum of Art have been greatly augmented through the incremental resources provided by all the generous contributors who, over the years, have responded to the special initiative that created the Contemporary Art Fund: Ivor Braka, Arlene and John Dayton, Amy and Vernon Faulconer, Nancy and Tim Hanley, Marguerite and Robert Hoffman and the Hoffman Family Foundation, Cindy and Howard Rachofsky, Deedie and Rusty Rose, Gay and Bill Solomon, Gayle and Paul Stoffel, and two anonymous donors. The development of the Museum's permanent collection of contemporary art has been significantly enriched by means of the proceeds from the DMA/amfAR *2 x 2* benefit art auction hosted annually, beginning in 1999, by Cindy and Howard Rachofsky at the Rachofsky House and, over the event's eight years, chaired by Salle Stemmons, Angie Barrett, Marguerite and Robert Hoffman, Cindy and Howard Rachofsky, Mary Noel Lamont, Sharon Young, Rex Cumming, Naomi Aberly, Brian Bolke, Deedie Rose, Emily Summers, Lizzie Routman, and Susan Kaminski.

For their generosity and commitment to the DMA's contemporary art collection and program over fifty years, we warmly acknowledge the many donors of works of art and funds, the artists who have worked with the Museum, the architects and designers who have made its facility such a welcoming place for showing art, the trustees and other volunteer leaders who have stewarded the institution, and our predecessors as DMA staff members; all have shared in helping advance the Dallas Museum of Art to its current fortunate place.

Fast Forward: Contemporary Collections for the Dallas Museum of Art is supported by the generous funding of JPMorgan Chase. We thank the bank, Elaine Agather, Chairman, JPMorgan Chase, Dallas Region, DMA trustee Martin Cox, Group Executive, JPMorgan Chase Equipment Leasing, and Michelle R. Thomas, Vice President, Chase Philanthropy, for their friendly advocacy. We acknowledge the support of David Yurman Jewelry, and specifically Sybil and David Yurman for their personal commitment to the arts in Dallas, Tenet Healthcare, Trevor Fetter, President and Chief Executive Officer, and DMA Trustee Melissa Fetter, and Fanchon and Howard Hallam for support through their newly established endowment for contemporary art exhibitions. We are very grateful to the current contributors to the Contemporary Art Fund, Arlene and John Dayton, Amy and Vernon Faulconer, Nancy and Tim Hanley, Marguerite and Robert Hoffman and the Hoffman Family Foundation, Cindy and Howard Rachofsky, Deedie and Rusty Rose, Gayle and Paul Stoffel, and an anonymous donor, for their kind liberality. And we express our appreciation to Marguerite Hoffman, Cindy and Howard Rachofsky, and Deedie and Rusty Rose for their special gifts in reinforcement of this undertaking.

Fast Forward is dedicated, *in memoriam,* to Robert K. Hoffman (1947–2006), a deeply informed and highly discerning collector, brilliant institutional strategist, assiduous cultivator of resources, and uncommonly generous patron. This book and the exhibition it accompanies reflect his vision for the Dallas Museum of Art.

John R. Lane
THE EUGENE MCDERMOTT DIRECTOR

Contemporary Art at the Dallas Museum of Art

John R. Lane

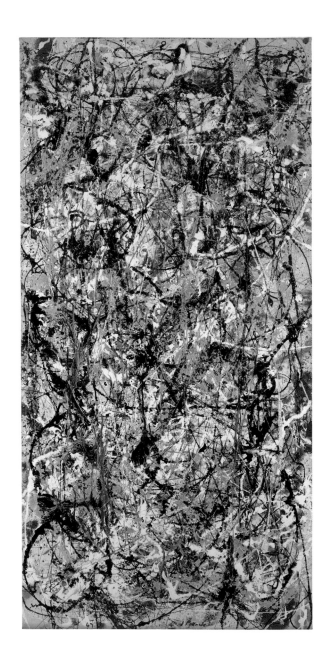

JACKSON POLLOCK'S 1947 PAINTING *Cathedral* is, literally, the founding object in the Dallas Museum of Art's contemporary collection. One contemplates this phenomenon in a state of wonder. It is not just that, in 1950, the Museum, then called the Dallas Museum of Fine Arts, the Museum of Modern Art in New York, and the Addison Gallery of American Art, Phillips Academy in Andover, Massachusetts, were the first public institutions to acquire a classic-period work by the greatest of all twentieth-century American artists or that this abstract expressionist masterpiece is now, by a long way, the most valuable object in the Museum's collection. It is also that, with the benefit of more than five decades of hindsight, if one were today to dream up the perfect collection of art made since World War II, it would have to start exactly here with Pollock, perhaps even with this very work. But when DMA trustee Stanley Marcus orchestrated the donation of *Cathedral* to Dallas from a New York friend, there was virtually no context for the painting either in the Museum or the city.

From its establishment in 1903 as the Dallas Art Association, one of the Museum's missions has been to collect and exhibit the work of living artists. A review of this history of activity reveals, however, that in the nearly fifty years before the Pollock gift, there was hardly a major work of new art collected and scarcely an exhibition mounted of a living artist of high stature in the history of modernism. In the 1930s and 1940s the Museum, to its great credit, had been supportive of the exceptional school of Southwestern regionalist painters known as the Dallas Nine. Besides regularly showing their work (and almost every year mounting a major exhibition of new art from all around Texas), the Museum acquired some of it for the collection, most notably in 1945 Alexandre Hogue's *Drouth Stricken Area* (1934), certainly the most important painting to have been created by a member of this distinguished circle of north Texas artists.

Although a few individuals such as Marcus (who also, in 1953, arranged through Neiman-Marcus to commission Rufino Tamayo's monumental mural *El Hombre*) and Elizabeth Blake

encouraged the Dallas Museum of Fine Art's interest in ambitious new art, the taste of the institution was quite conservative. (The contemporary interests of Jerry Bywaters, the museum's director from 1943 to 1964 and himself a painter and a member of the Dallas Nine, seem to have run more to architecture, the great Mexicans, and his fellow Texas artists.) The politics, too, of the city were conservative: in 1955, in the heart of the red scare years, civic pressure that was both politically reactionary and aesthetically antimodernist was successfully applied to the Museum's board of trustees to disallow the exhibition or acquisition of work by artists who were known to be communists or communist sympathizers. This state of affairs lasted less than a year before thoughtful and responsible members of the board, with counsel from the American Federation of Arts in New York, were able to reverse a policy so patently at odds with the principle of freedom of expression, but the position of the museum as a place where new art was welcome had been undermined. In 1956, a splinter group of arts leaders founded the Society for Contemporary Arts (renamed in 1957 the Dallas Museum for Contemporary Arts) and in 1959 this small but ambitious organization, under the leadership of Blake, appointed a professional director, Douglas MacAgy. Formerly a curator at the San Francisco Museum of Art (now the San Francisco Museum of Modern Art), the director of the California School of Fine Arts (now the San Francisco Art Institute), a special consultant to the director of the Museum of Modern Art, René d'Harnoncourt, and the director of research at Wildenstein & Co., MacAgy began a brief run presenting a lively and substantive exhibition program. Philosophically, culturally, and artistically driven, the exhibitions included the first René Magritte retrospective in America; a group exhibition organized by Katherine Kuh, the well-known contemporary art curator from Chicago; a collaboration with MOMA and the San Francisco Museum of Art on *The Art of Assemblage;* and MacAgy's own shows, *American Genius in Review: I,* which marked the first time that the 1920s-era paintings of Gerald Murphy, the Lost Generation idol, had been shown in public, and *1961,* a survey of the work of thirty-six abstract expressionist and early pop artists, presented in 1962, a memorable part of which was the first showing, outside New York, of Claes Oldenburg's *Store,* and the first museum-sponsored staging of one of Oldenburg's raucous performance pieces or happenings. By late 1962, the DMCA had lost its rent-free quarters and MacAgy's contract had been terminated by the board. Margaret McDermott, the president of the Dallas Museum of Fine Arts, with the support of trustees from the museum and from the DMCA, led a controversial effort to merge the two museums, amid general concern that there was insufficient support in the city for more than one to flourish. Harsh words had been said on both sides during the two organizations' independent existence, and strong views continue to be held to this day by some of the veterans. The terms of the merger, which was effected in 1963, included the combination of the full boards of each museum under the Dallas Museum of Fine Arts' name, McDermott's resignation and Bywaters's retirement (both tendered in the greater interest of accommodating the desires of the Contemporary Museum's trustees to have fresh volunteer and professional leadership), and the transfer of the DMCA's modest collection to a foundation that would hold it for the benefit of the new museum. The legacy of the union

is an institution in which the dynamic tensions of two agendas, one contemporary and one traditional, still survive. In the years following the merger, the energy and aspirations of a number of those who had been DMCA supporters, a particular example being Betty Marcus, were instrumental to the successes of the new museum. This heritage endures in the enthusiasm for contemporary art that informs the commitment of many of the Museum's current volunteer leaders, who are the source for much of the vision that has fueled the DMA's recent soaring institutional trajectory.

The appointment of Merrill Rueppel as director in 1964 marks the beginning of the Museum's serious development of a contemporary art collection. His own interest in abstract expressionism and his sway with the collector Algur Meadows are the sources of Dallas's very significant holdings in this area. At the same time, James A. Clark was building his extraordinary collection of European abstraction, highlighted by works of Piet Mondrian, Fernand Léger, and Constantin Brancusi, but also including younger artists such as Bridget Riley; much of this collection would come to the DMA by bequest in 1982. Over the decade of Rueppel's directorship he shepherded into the collection works—quite a few of them masterpieces—by Arshile Gorky, Adolph Gottlieb, David Smith, Robert Motherwell, Pollock, Mark Rothko, Lee Krasner, Franz Kline, James Brooks, Morris Louis, and Jules Olitski. Many were the gifts of Meadows, and his collection of abstract expressionism developed in partnership with Rueppel was enhanced by a bequest in 1981 that brought additional gifts of paintings by such artists as Richard Diebenkorn, Sam Francis, and Clyfford Still. During the first half of Rueppel's tenure, exhibitions of the work of Mondrian, Jean Dubuffet, William Baziotes, Mark Tobey, and David Smith were presented. In 1970 Rueppel appointed Robert Murdoch, formerly of the Walker Art Center in Minneapolis, to be the Museum's first curator of contemporary art, and during their several years of working together the Museum did exhibitions of George Rickey, Burgoyne Diller, Brooks, Sam Francis, and Max Ernst. In 1971, Murdoch very presciently afforded the young Richard Tuttle his first large-scale exhibition in a museum (the legacy of that project lived on in the DMA's presentation in 2006 of the major Tuttle retrospective organized by SFMOMA along with numerous works by the artist that reside in Dallas collections).

The appointment of Harry S. Parker III to the directorship in 1974 signaled that ambitions for the Museum's overall programs, collections, and facilities had grown dramatically. Parker and Murdoch, before the latter moved on in the late 1970s, expanded the scale of the contemporary exhibitions. They showed MOMA's *American Art since 1945* and the Whitney Museum of American Art's *Calder's Universe,* the latter including work the artist had done for Braniff Airlines, which was based in Dallas. They also showed the Meadows Collection, Robert Smithson's drawings, Carl Andre's sculpture, and Oldenburg's *Mouse Museum,* while initiating a *Projects* series with the work of the Dallas artist David McManaway. In 1980 Steven A. Nash joined the DMA staff from the Albright-Knox Art Gallery in Buffalo. Nash, as deputy director and chief curator, Parker, and Sue Graze, who

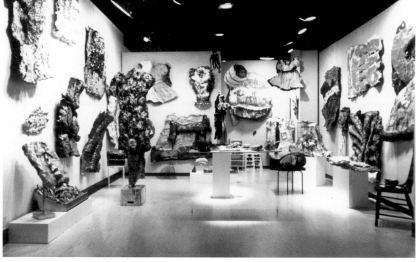

clockwise from upper left:

STANLEY MARCUS, DMA trustee, c. 1950s

RUFINO TAMAYO, *El Hombre (Man)*, 1953
Vinyl with pigment on panel, 216 × 126 in.
Dallas Museum of Art, Commissioned by the Dallas Art Association
through Neiman Marcus Exposition Funds, 1953

DOUGLAS MACAGY, Director of the Dallas Museum
for Contemporary Arts, c. 1960

MERRILL RUEPPEL, DMA Director, 1965

ALGUR MEADOWS, DMA trustee and benefactor, 1975

SUE GRAZE, DMA Curator of Contemporary Art, 1981

Installation view of CLAES OLDENBURG's *Store* at the
Dallas Museum for Contemporary Arts, 1962

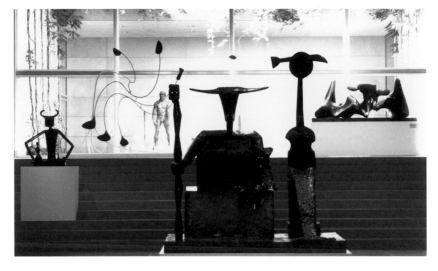

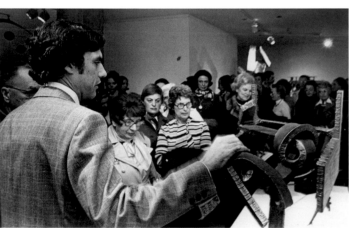

clockwise from upper left:

HARRY PARKER, DMA Director, 1987

Installation view of *A Century of Modern Sculpture:
The Patsy and Raymond Nasher Collection*, 1987

STEVEN NASH, DMA Deputy Director and Chief Curator, 1985

ANNEGRETH NILL, DMA Curator of Contemporary Art, c. 1992

RICHARD BRETTELL, DMA Director, 1991

ROBERT MURDOCH, DMA Curator of Contemporary Art,
lecturing in the galleries in the 1970s

RAYMOND and PATSY NASHER, 1965

had been Murdoch's assistant and was named to succeed him, charted the Museum's contemporary course during the exciting years of the late 1970s and early 1980s, the period in which the move from Fair Park to the downtown Arts District was planned. Conferring with the architect Edward Larrabee Barnes, they commissioned Oldenburg and Coosje van Bruggen, Scott Burton, Richard Fleischner, Ellsworth Kelly, and Sol LeWitt to make work to site in the new building and in its exterior courts and sculpture garden. Survey presentations of such well-known artists as William Wiley, Arshile Gorky, Joel Shapiro, Francesco Clemente, and James Surls were accompanied by a very active new series called *Concentrations* that began in 1981, was directed by Graze through the decade, featured shows by respected Texas artists (such as Nic Nicosia and Vernon Fisher), projects by nationally and internationally regarded figures (such as Richard Long), and introductions of promising younger artists (such as Jenny Holzer, Mary Lucier, Peter Fischli and David Weiss, and Kiki Smith). Twenty-five years after its inauguration, *Concentrations* remains an essential element of the DMA's contemporary art program, with some fifty editions (and counting) to its credit. In the new museum, Graze collaborated with Kathy Halbreich, the director of the Vera List Visual Art Center at MIT, to mount a major mid-career survey of the work of Elizabeth Murray in 1987. The museum also presented surveys of the work of Cindy Sherman, Lee Friedlander, and Philip Guston and the Whitney's Donald Judd retrospective, at just about the time that the artist's now internationally renowned Chinati Foundation project in the west Texas town of Marfa was crystallizing. Most ambitiously (and auspiciously), in 1987 Nash organized for the DMA and the National Gallery of Art in Washington a large-scale exhibition of the Raymond and Patsy Nasher Collection, among the handful of the most important holdings of modern sculpture in public or private hands in the world and one of Dallas's greatest cultural assets.

The years between 1974 and 1987 (when both Parker and Nash left the Museum), they, along with Murdoch and Graze, presided over a significant growth in and broadening of the contemporary collections. Among their acquisitions are important works by Jasper Johns, Mark di Suvero, Richard Serra, Dan Flavin, Alan Saret, Tony Smith, Carl Andre, Cindy Sherman, Robert Rauschenberg, Michael Heizer, and a substantial collection of late twentieth-century master prints purchased through the Nancy and Jake Hamon Fund.

In 1988 Richard Brettell, a respected scholar and curator of impressionist and postimpressionist art, was named director of the Museum. Immediately immersing himself in the contemporary program, less than a year after joining the staff he opened—in collaboration with Graze, Charles L. Venable, the curator of decorative arts, and the architect Gary Cunningham—a large-scale, ambitiously installed exhibition entitled *Now/Then/Again: Contemporary Art in Dallas, 1949–1989,* which showcased the DMA's holdings at the same time as the catalogue specifically pointed out what Brettell regarded as their lacunae. A highlight was the Museum's new acquisition, Chris Burden's *All the Submarines of the United States of America* (1987).

Graze resigned in 1990 and the following year Brettell appointed as her successor Annegreth Nill, formerly of the Carnegie Museum of Art in Pittsburgh. Brettell left the Museum in 1992 to be succeeded in 1993 by Jay Gates. Nill retooled the *Concentrations* series into *Encounters,* a concept that, over its six-chapter life, paired internationally known artists with counterparts from Texas, for instance, Damien Hirst and Tracy Hicks, and Cady Noland and Doug MacWithey, collaborated with the Modern Art Museum of Fort Worth to bring Walker Art Center's *Photography in Contemporary German Art* to north Texas, showed the Albright-Knox's Susan Rothenberg survey and an installation that Jenny Holzer created for the American pavilion at the Venice *Biennale*, and acquired work by Christopher Wool, Georg Herold, David Hammons, and Anish Kapoor. Gates took a personal interest in the presentation of *Dale Chihuly: Installations, 1964–94* and in the commissioning of the artist's *Hart Window* for the Hamon Atrium.

Nill stepped down in 1995 and, in 1996, Gates invited Charles Wylie from the Saint Louis Art Museum and Suzanne Weaver from the Indianapolis Museum of Art to join the staff as, respectively, the newly endowed Lupe Murchison Curator of Contemporary Art and the assistant curator of contemporary art. (Weaver was subsequently promoted and her position has recently been endowed as the Nancy and Tim Hanley Associate Curator of Contemporary Art.) Highlights of their accomplishments before Gates resigned the directorship in 1998 include the revitalization under Weaver's direction of the *Concentrations* series to feature such artists as Mariko Mori, Patrick Faulhaber, and Anne Chu, Wylie's undertaking of the organization of a major traveling exhibition of the recent paintings of Brice Marden, their commissioning of Tatsuo Miyajima to make a new work specifically for the DMA, and their purchase of Bill Viola's *The Crossing* and works by Mona Hatoum, Jim Hodges, and Rosemarie Trockel.

Although several collectors friendly to the DMA were active in the 1980s, notably Rosalie Taubman and Jessie and Charles Price, it was in the 1990s that the wider art world became alert to a great florescence of activity as Howard Rachofsky and Marguerite and Robert Hoffman built their now internationally renowned collections. The Rachofsky House, designed by Richard Meier, was completed in 1996 and assumed a semipublic role in the cultural life of Dallas as a venue for philanthropic and educational events and rotating presentations of the Rachofsky Collection, which, with the collaboration of Allan Schwartzman, the collection director, was quite clearly growing far more rapidly and adventurously than the Museum's own collection and was consciously considered by Rachofsky as a complementary (but not competitive) resource for the community, one that could be, in its nature, more dynamic and edgy than the Museum. To different degrees—depending on whose opinion is being solicited—underlying the situation was a sense, among collectors in Dallas, of pent-up frustration with the limits of the perceived capacity of the Museum to program and collect vigorously in the contemporary art arena.

In the fall of 1998, when the Museum's trustees were looking for a new director and the search committee and I were in discussions, the following conditions seemed to pertain. Dallas had one of the most active and informed communities of private collectors of contemporary art (by this time also prominently including Gayle and Paul Stoffel, Deedie Rose, and Nancy and Tim Hanley) and most of the collectors were supportively aligned with the Dallas Museum of Art and vocally keen for it to work at a level of ambition and vitality commensurate with other well-versed, committed museums across the country. They hoped (and this part was good for me) that their next museum director would be conversant and engaged with contemporary art, hopes that, thanks to my experiences at the Carnegie and SFMOMA, I could fulfill. The recent decision of Raymond Nasher to locate the new home for his renowned modern sculpture collection next door to the DMA's own significant modern and contemporary collections would, in short order, effect a synergy that would make Dallas an exceptionally interesting international art destination (that the Modern Art Museum of Fort Worth was simultaneously going forward with a major, new building designed by Tadao Ando added further to the attractiveness of metropolitan north Texas). One could make from a reading of the institutional history an excellent case for the existence of a mandate, based on the legacy of the DMCA, for the Museum to pursue—within the context of an encyclopedic museum—a modern and contemporary art program, encompassing the century and a half from realism and impressionism, through classical modernism and abstract expressionism and up to the present, which would be calibrated in its scale to balance with the level of program activity dedicated to the historical and culturally diverse aspects of the collection. Against that background, the future of the Museum was clearly exciting.

Marguerite Hoffman had been a member of the Museum's staff in the late 1980s and was acutely aware of the institutional paralysis that sets in when resources to support adventurous programming are so difficult to identify that the development of creative ideas atrophies. She urged her husband Robert to come see me shortly after I assumed the duties of the directorship in early 1999. He asked how the Museum might advance its contemporary activity if a significant amount of new funding, committed over a multiyear time frame, were to be made available for incremental exhibitions, publications, education, and acquisitions. I replied that I thought we could jump-start the program and sustain it at a level that would be well regarded in the art world and that the Dallas supporters could take pride in. Wylie, Weaver, and I set to dreaming and planning, and the Hoffmans, with the help of the Rachofskys and Deedie Rose, drew together a circle of supporters to fund the Contemporary Art Initiative. At about the same time, Anne Livet, a Texan living in New York, and Deedie Rose conceived of a partnership between the DMA and the American Foundation for AIDS Research (amfAR) with the idea of collaborating on an art auction benefit in which the organizing effort and the proceeds would be shared by the two organizations. Cindy and Howard Rachofsky enthusiastically assumed responsibility for hosting the first *2 x 2 for AIDS and Art,* which was successfully staged at the Rachofsky House in 1999; it has

since become the most prestigious annual event on the Dallas philanthropic social calendar and the largest source of funding for the Museum's contemporary art acquisitions program.

These new resources allowed the Museum to triple its contemporary pursuits without diminishing in the least its dedication to the more traditional aspects of its programming. Growth in the exhibitions schedule and the collection put a great deal of pressure on the spaces available for the presentation of contemporary art, which led to the temporary deinstallation in 2002 of the Oldenburg-Van Bruggen *Stake Hitch*, a large-scale, site-specific sculpture that was a popular Barrel Vault fixture for nearly twenty years. The newly available, architecturally distinguished space, with its accompanying, perfectly proportioned Quadrant Galleries (subsequently named for the Rachofskys, the Stoffels, the Hanleys, and Mary Noel and Bill Lamont), became the site of ambitious installations by artists, first Sigmar Polke (an exhibition that traveled to Tate Modern in London) and then Ellsworth Kelly, Lothar Baumgarten, Robert Ryman, and Richard Tuttle. Further enhancing the contemporary art spaces, Gluckman Mayner Architects in 2004 handsomely renovated the contemporary galleries at the south end of the Concourse, which were subsequently named the Marguerite and Robert Hoffman Galleries.

Major retrospectives of the work of Thomas Struth (organized by Wylie, the exhibition then traveled to the Museum of Contemporary Art in Los Angeles, the Museum of Contemporary Art in Chicago, and the Metropolitan Museum of Art in New York), Wolfgang Laib, Nicosia, Robert Smithson, and William Eggleston have been presented and, with the particular cooperation of collectors in Dallas, the Museum began actively leveraging the art resources in the community. As a result, the DMA has been able to organize exhibitions and secure traveling shows of works by Jasper Johns, Gerhard Richter, Joseph Beuys and Félix González-Torres, Eija-Liisa Ahtila, Kelly, Ryman, and Peter Doig. Dorothy Kosinski, the Senior Curator of Painting and Sculpture and the Barbara Thomas Lemmon Curator of European Art, drew deeply on the Hoffman Collection's Duchamp, Cornell, and Johns holdings to organize *Dialogues*, which brought those artists' work together with that of Rauschenberg, including the DMA's monumental *Skyway*. Weaver pushed the *Concentrations* series to a new level of ambition and experimentation in offering solo exhibitions to leading younger artists, such as Doug Aitken, Shirin Neshat, Matthew Ritchie, Jane and Louise Wilson, John Pomara, Anri Sala, Maureen Gallace, Matthew Buckingham, Jim Lambie, and Charline von Heyl; these exhibitions are frequently either the artists' first in a museum or a world premier of their newest work.

For the Museum's centennial in 2003, Weaver co-curated with Lane Relyea *Come Forward: Emerging Art in Texas*, a selection of fresh Lone Star talent that reaffirmed the DMA's one-hundred-year commitment to the art and artists of its region. Also for the centennial, Kosinski, Wylie, and Weaver organized *Celebrating Sculpture*, an exhibition that welcomed the DMA's new neighbor, the Nasher Sculpture Center, to the Dallas Arts District. (Steven

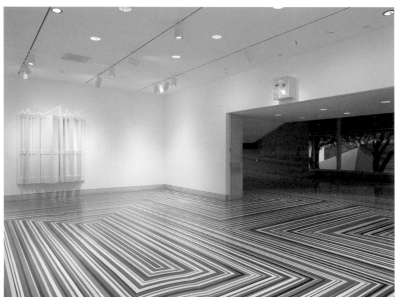

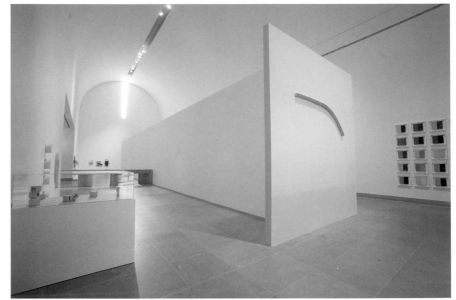

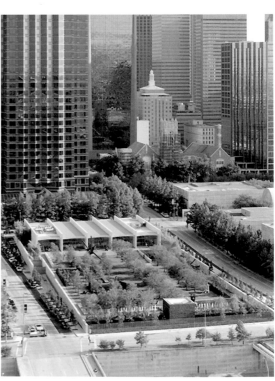

clockwise from upper left:

CHARLES WYLIE, The Lupe Murchison Curator of Contemporary Art, 2006

SUZANNE WEAVER, The Nancy and Tim Hanley Associate Curator of Contemporary Art, 2006

Installation view of *The Art of Richard Tuttle* in the Barrel Vault, 2006

The NASHER SCULPTURE CENTER, Dallas, designed by the architect RENZO PIANO and the landscape architect PETER WALKER, 2003

Installation view of the exhibition *Concentrations 47: Jim Lambie, Thirteenth Floor Elevator*, 2005

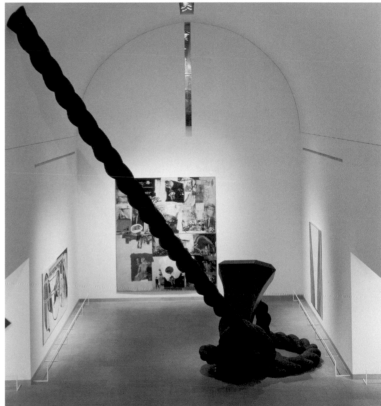

clockwise from upper left:

The artist SIGMAR POLKE with TIM HANLEY (President of the DMA Board of Trustees, 2001–2004) and NANCY HANLEY at the opening of the exhibition *Sigmar Polke: Recent Paintings and Drawings*, 2002

GAYLE and PAUL STOFFEL at the opening of the exhibition *Robert Ryman*, 2005

Installation view of *Stake Hitch*, 1984, by CLAES OLDENBURG and COOSJE VAN BRUGGEN, commissioned to honor John Dabney Murchison Sr.

ALLAN SCHWARTZMAN, consultant and Director of the Rachofsky Collection, 2006

Dr. DOROTHY KOSINSKI, DMA Senior Curator of Painting and Sculpture and the Barbara Thomas Lemmon Curator of European Art, and RAYMOND NASHER, 1998

Nash, who returned to Dallas after fifteen years at the Fine Arts Museums of San Francisco, was named the first director of the Center.) By drawing on loans from the community and the DMA's collection, paired with riches of the Nasher Collection next door, this exhibition showed off the city's great depth in modern and contemporary sculpture.

Augmented resources allowed the Museum to have a considerably larger presence in the contemporary art market, making possible such key acquisitions as the complete multiples of Richter, major paintings by Anselm Kiefer, Polke, and Richter, and important sculptures by Matthew Barney, Barry Le Va, Bruce Nauman, Charles Ray, and Robert Smithson, while still permitting the regular purchase of works by less established and younger artists.

In 2001, the Rachofskys donated nineteen important works of contemporary art, by far the largest gift of its kind that the Museum had received since the Meadows contributions a couple of decades earlier. Very happily for the institution, their generosity was not singular; the past several years have seen a new and (in Dallas's history) unprecedented beneficence on the part of the collecting community, which has resulted in the conspicuous enrichment of the Museum's collection.

The grand, utterly transforming moment came in 2005 when the Hoffmans, Rachofskys, and Roses joined to commit to the Museum by irrevocable bequest their entire collections, amounting to nearly nine hundred works (with future acquisitions to be included, as well). The circumstances of this gift are described from each participant's perspective in the interviews that follow in this catalogue but, it hardly needs to be said, the fortunes of the DMA as a center for postwar and contemporary art were so dramatically improved that the Museum could claim a new, eminent position in the global community of institutions with collections in this field. We pause now to celebrate the particularly salubrious circumstances that pertain at this moment in Dallas with María de Corral's *Fast Forward: Contemporary Collections for the Dallas Museum of Art*, an exhibition made possible by the thriving, collaborative collecting environment, driven by the shared curiosity to see how it all looks and works together, and informed by an underlying aspiration to move the institution forward dramatically in the area of contemporary art through the implementation of innovative strategies representing a way of collection development that is unique to Dallas.

The principal resources for information on the history of the Museum are: Jerry Bywaters, *Seventy-five Years of Art in Dallas* (Dallas, Tex.: Dallas Museum of Fine Arts, 1978), David Beasley, *Douglas MacAgy and the Foundations of Modern Art Curatorship* (Simco, Ontario: Davus Publishing, 1998), Dorothy Kosinski, *Dallas Museum of Art: 100 Years* (Dallas, Tex.: Dallas Museum of Art, 2003), DMA annual reports, and the institutional archives held in the Mildred R. and Frederick M. Mayer Library.

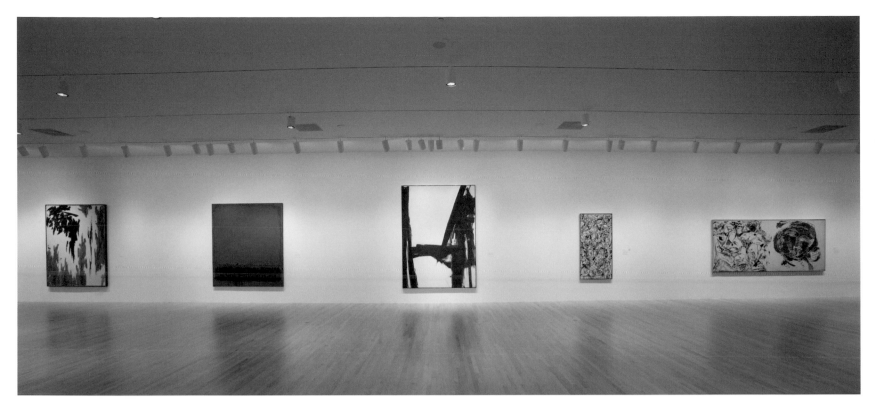

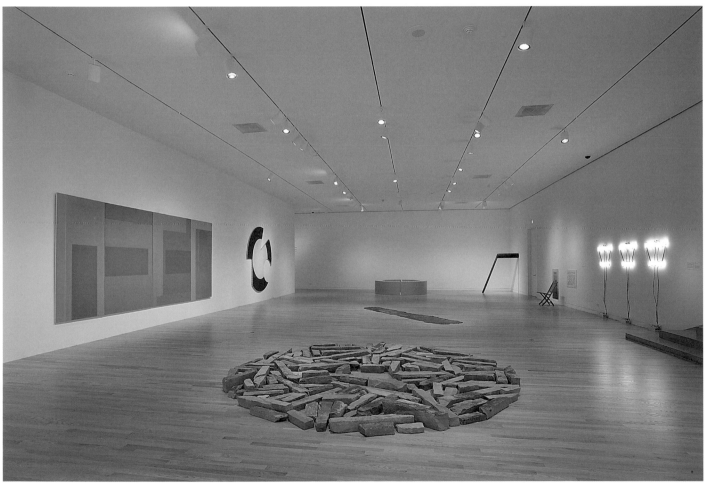

Installation views of the MARGUERITE AND ROBERT
HOFFMAN GALLERIES

By Way of a Sincere Confession

María de Corral

COLLECTING IS A MATTER OF CHOOSING, taking sides, accepting the risks involved in trying to manifest a particular conception of a time and offering it to the public for its interpretation. It is an unceasing process of writing, reading, and rereading a story, a desire to commit oneself to art and to the possibility of offering a view of the world that only artists can give us. Collections have their virtues and their defects, they are full of experimental paths, of trials and errors, of diverse propositions in both their language and their content. They breathe and transmit the difficulties of something that is living with us. They are home to thrilling works weighted with artistic tension and include other works whose value consists in bearing witness to a specific time in art. Collecting always has an element of adventure. There is no formula to determine whether something will continue to have value many years later, except perhaps to trust in one's passion for art and the conceptual rigor of its makers.

A year ago I received a surprising invitation from Jack Lane, proposing that I organize an exhibition of works that I would select from three large private collections that had been recently donated to the Dallas Museum of Art and from the Museum's own holdings. It came just on the heels of the Venice *Biennale*, of which I had been the co-director, when I had been looking forward to a break, yet the aura of Dallas and my long-standing friendship with Jack encouraged me to accept this new and important professional challenge. The selection of works from these exceptional collections has been, simultaneously, one of the most gratifying and the most difficult curatorial undertakings I have yet experienced in my professional career. It is gratifying because of the enormous number of marvelous works I have encountered and difficult because every time I chose one of them, it meant turning down others that were just as interesting.

Although the task was not easy, I was offered every facility in carrying it out and the unstinting support of so many people. At the top of the list is Jack Lane, the director of the Dallas

above: MARÍA DE CORRAL

Museum of Art, and his excellent staff, especially Charlie Wylie and Tamara Wootton-Bonner, who quickly and very efficiently responded to my numerous requests for information, paper-work, details, photographs, dimensions, plans, and help with the thousand-and-one other details that require attention for such an ambitious project.

I must make special mention of the marvelous collectors from Dallas, whose uncommon generosity has made this project possible. None of the mistaken clichés that float around Europe about collectors and museums in America can be applied to these model families, who have simply decided to share with their fellow citizens the pleasure of contemplating the exquisite artworks their resources have allowed them to acquire.

Robert and Marguerite Hoffman introduced me to art collecting in Dallas. They both responded with enormous generosity to my curiosity about how one goes about bringing together a collection like theirs, a collection filled with masterpieces. I also greatly enjoyed the exchange of opinions about the art scene and its evolution over the past twenty years. It is a pleasant surprise to find, outside the world of professionals, people who can enter into the artistic debate with such sensitivity and depth. I will never forget the sincere manner in which they dismantled preconceived ideas about relationships between collec-tors and artists and the clarity of the many ideas they shared with me that shed light on their philosophy of collecting and of giving. During my interviews with the other collectors, they all credited Robert and Marguerite Hoffman as the originators of the idea of the combined bequest.

Deedie Rose, on her own initiative (with, of course, the support of her good-humored husband Rusty, who has nonetheless diligently maintained a detached relationship with the art), has managed to bring together an interesting collection with neither stridence nor a single out-of-place element. Over many years of traveling around the world, I have rarely found a person as engaging or a collection as interesting and coherent as hers.

Last, but certainly not least, I would like to mention the unique duo of Cindy and Howard Rachofsky. The whole Rachofsky story is like a dream come true. The idea of the Rachofsky House, the negotiations with the architect, the building of the collection, the installation, swaps and exchanges, tips and acquisitions. What a fantastic process! The result? A brilliant frame for a splendid collection with nothing left to improvisation.

Allow me, without singling out any of the collectors, to share some of the most agreeable surprises I had while conversing with them:

I learned that they didn't compete with one another; instead, they cooperated and even told one another about possible opportunities.

I learned that the money to purchase works hasn't always flowed as freely as might have been desired. Sometimes it was necessary to sell one work in order to buy another, more appropriate one or to form a consortium, a trilateral group that allowed them to amass the work's asking price.

And, perhaps most gratifying, I encountered the most honorable of motivations: these bequests were made as gifts to society, not as a means to acquire fame or status.

IN ANY CHOICE, one must attempt to balance rational motivations and intellectual analysis with the emotions and passions. Here, however, in making my choices, I have tried to bring out certain moments in the history of art through the four collections. Especially, I have tried to reflect the spirit, criteria, and ideas of the DMA and of a group of collectors committed to art and to their community. Within the exhibition, I have generated numerous discourses in order to shed light on the different forms of our existence as presented in the art of the past sixty years. I have not tried to explain the history of art, but rather to offer the elements that will enable the viewers to create their own story. I do not believe in history; I do believe in stories, and I believe that it is important for visitors leaving the exhibition to find that the doors to their imagination have been opened, that they are asking themselves new questions, rather than that they have simply found a few answers.

At no time have I used artworks to support an argument or to demonstrate something. Instead, I have sought to bring an unbiased perspective and to place the artists and their works at the center of attention. Rather than elaborating a closed discourse, I have sought to offer threads that can be woven and interlaced in a variety of ways, over and over again, because art itself is a source of doubt and questioning; it need not be limited to clear statements or concrete objectives.

This introduction is called "By Way of a Sincere Confession" as an indication of the way I have sought, in this catalogue, to reveal my thinking and to share the stimulating sensations I have experienced while working on this project. It is not easy to explain in a single exhibition the meditated decision to reduce well over one thousand exceptional works to just a couple of hundred. That such a winnowing is possible at all is a reflection of the freedom that the Dallas Museum of Art accorded me and the generosity of the collectors who, one happy day in 2005, decided to create for Dallas a definitive and fundamental place on the worldwide contemporary art scene.

Interview with Marguerite and Robert Hoffman

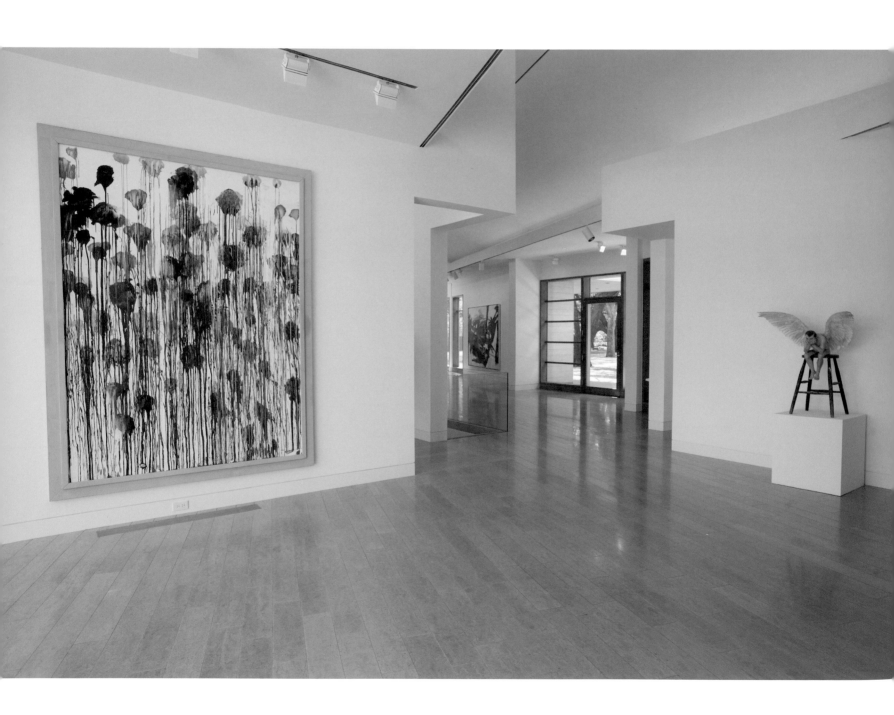

María de Corral

I'd like you to tell me about your beginnings, about the initial inspiration and stimuli.... Where did your passion for art come from? Do you remember your first acquisition?

ROBERT HOFFMAN I don't know where it came from, but I remember as a young teenager being aware of art. I know that by the time I went to college I had decided I would buy some art if I ever got any money. I bought my first art objects when I was still in college. They were several Jim Dine prints and an Otmar Alt colored pencil drawing. I still have them. I also took a number of art history classes and visited countless museums in the United States and Europe. The first actual course I took was supposed to be about twentieth-century art (recall this was 1966), but the professor was on sabbatical so a visiting lecturer (Mark Roskill) taught the course. It became just Picasso, Matisse, and Klee instead of a broad survey, although there was one optional lecture on Pollock. Since we studied Picasso, Matisse, and Klee in such depth from beginning to end, I bet that is where I developed my overwhelming desire to see a lot of an artist's work before reaching any conclusions about it or buying it. I am Mr. Research. We have departed from that process—of doing lots of research—only a few times, [for the work of] Janet Cardiff, Ron Mueck, Rachel Whiteread, Laurie Anderson, and Steve Wolfe. None of those pieces was very expensive when we first bought them, although they may be worth a whole lot more now.

How has art influenced your lives? In what way has the contact with artworks changed you?

RH I find art to be a fundamentally spiritual experience. Although it is clearly visual, for me it is really about how someone else makes sense of the world and their place in it. With the best art (and I am certainly including all art, not just modern and contemporary art), the viewer connects with the artist

in such a way that the two agree to share their humanity, their hopes, fears, and sense of their mortality. I find myself increasingly caring about older works and discovering how modern they can be. That experience then changes what I demand of contemporary art.

Putting together a true collection means creating something with its own viewpoint and not just buying guided by mere taste. When did you start to think of the works you owned as a collection?

RH By around 1980 I owned enough different things of substance that I thought reflected my view of the world that I felt I could say I had a collection. My process for buying things was not much different then than now, although the resources I could commit were not at the same level. But I still have several pieces from that period that still look appropriate to the collection today.

Would you qualify your way of collecting as partial, subjective, and independent?

RH While we are certainly partial to paint and good craftsmanship, I think our methodology is primarily independent. We make our own decisions, although we do bounce ideas off Mark Rosenthal, and we ultimately decide if something is strong enough to fit in with what we already have.

MARGUERITE HOFFMAN Robert and I enjoy collecting as a couple. It is a process that we find fascinating and it has allowed us to get to know parts of each other that might not otherwise have been knowable.

Given how opinionated we both are, it is one of the great wonders to me that we have so easily agreed on almost every acquisition that has been made. We each bring different orientations to the activity, which is what ultimately saves us, I suspect. Robert will always be known for his encyclopedic understanding of each artist's body of work, the historical context in which every piece of art was created, the current state of relevant art criticism, the ins and outs of the market, and the mysterious placement of all the books in our art library. Those are not areas in which I would be foolish enough to challenge him.

My strength as a collector is different. My selection criteria are much more instinctive than Robert's and could perhaps even be described as a bit primitive. If I am to be won over, it is usually in a heartbeat and with little regard to outside influence. This personal reaction, which is far from perfect, has prompted us to look at and acquire some exceptional paintings and sculpture. That having been said, I question whether that sureness of mind would happen if Robert weren't standing by my side.

I see in your collection a decision to concentrate on certain artists, certain movements, and even on a certain period, almost as if there were a need to focus, or perhaps an acceptance that it is impossible, and even unnecessary, to cover everything.

RH I think we buy things that relate to the sense of spirituality mentioned earlier. We know we can't cover everything so we try to buy the best examples we can afford of what excites us. We'd really like to add a Giovanni Bellini and a Hans Holbein, but we can't seem to find just the right ones for us. I guess I'm saying that we are not particularly market driven; we want to live with objects that satisfy our need to be in touch with the big issues affecting our emotional lives.

You own numerous works by certain artists, including Joseph Beuys, Robert Gober, Jasper Johns, Ellsworth Kelly, Gerhard Richter, and Cy Twombly. Why, and how have you done this? Is it to show the artist's evolution or to seek out what is most characteristic or essential?

RH For some artists (for example, not Rothko or Kline) we have found that it has taken several of their objects to understand the extent of their voice. Once we bought something by certain artists that spoke to us, we wanted more of the good stuff and, therefore, found ourselves occasionally seduced

Installation view including works by JOSEPH CORNELL from the Hoffman Collection in the DMA exhibition *Dialogues: Duchamp, Cornell, Johns, Rauschenberg*, 2005

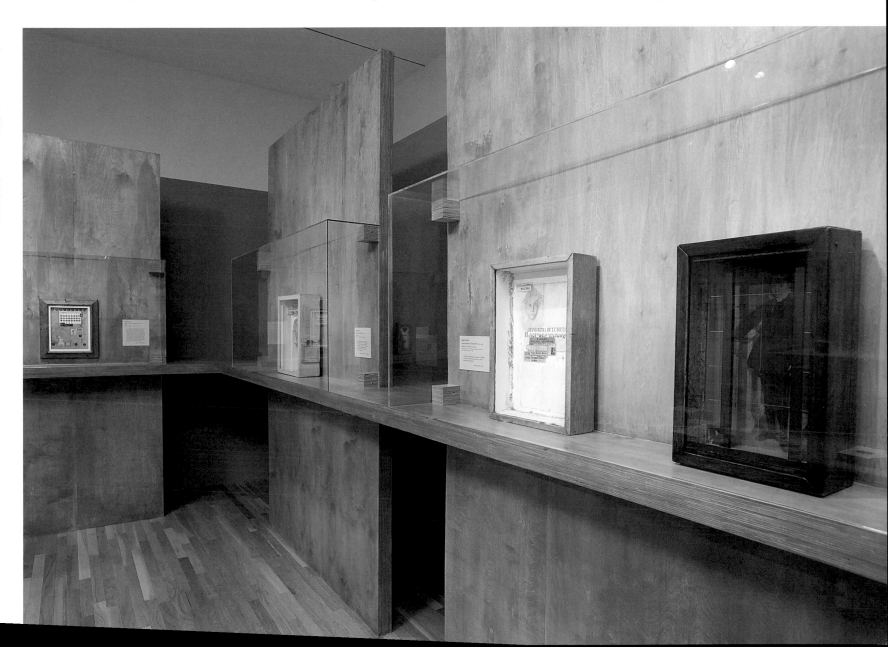

when we saw something else by them. It's sometimes like eating peanuts; it's very hard to just eat one.

In the specific case of Joseph Cornell and Vija Celmins—two artists that you have collected extensively—what draws you to their work?

RH Cornell is just different from anybody else; he saw the world with different eyes and a very different mind. It is amazing to share so much obsession with anyone else, let alone a great artist. Vija's work is also clearly obsessive, but what I like about her is that she focuses almost entirely on things we think we already know and, consequently, don't really ever look at. She forces the viewer to re-examine his assumptions about how he perceives the world. I can never look at an ocean, a night sky, or a spider web the same way again.

How has your collection changed over the years?

RH It really hasn't changed too much, although we ended up adding a lot of key 1950s pieces. I've liked Twombly for decades, even when I couldn't afford it. The same for Johns, Kelly, Guston, and Diebenkorn.

How would you describe the main lines that define your collection today?

RH There are no guidelines, but whatever we buy has to be aesthetically strong enough to hold its own in the context of what we already have.

I know that art criticism interests you. Does reading and following it influence your purchasing decisions?

RH New acquisitions are a result almost always of looking and researching. Art criticism can play a part in the research process, but I am not aware of its ever having been a principal factor.

What is the philosophy behind your purchases?

RH The overriding philosophy behind our acquisitions has, for some time, been positively answering the question "Will it somehow change how we view the world?"

Do you consider contact with the artist important when putting together a collection?

RH I have been privileged to know artists whom I think might be unusual or interesting, but it is a big mistake to connect artists personally with their work. Twombly and Johns might be interesting to talk with, but I don't like their work more or less based on those conversations or how nice they are to me.

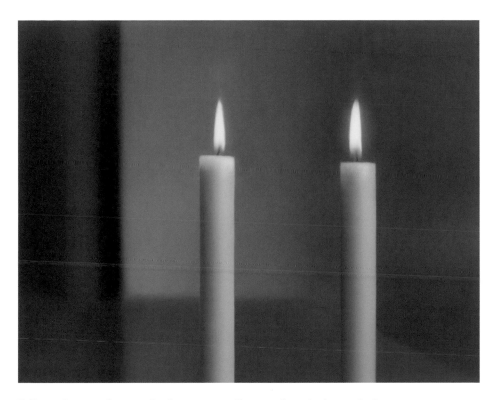

GERHARD RICHTER, *Two Candles (Zwei Kerzen)*, 1982
Oil on canvas, 43¼ × 55¼ in.
Collection of Marguerite and Robert Hoffman

*Tell me three or four works from your collection for which you feel
a special fondness.*

RH Diebenkorn's *Ocean Park 113*, Twombly's *Sunset*, Cornell's *Object* 1941,
Johns's *Water Freezes*.

MH I agree with Robert on Twombly's *Sunset* and the Cornell box *Object* 1941.
Looking deeply at those works requires a change in gear for me and I am never
disappointed to enter those special worlds. Our Rothko and Kline always take
my breath away because of their gravitas and sheer power. And, of course,
for very personal reasons, the Richter double candle painting [*Two Candles*]
is an exceedingly important painting for me. Robert and I have always seen
it as somewhat of a double portrait of our lives, separate objects standing
together burning as brightly as possible with our passions.

What is your view about the current situation of the world of creativity?

RH I think the current state of creativity is pretty much the same as it has
been for a while, with the one difference that it is truly global, and that is a big
difference. Also the art market is so overheated it makes aesthetic judgment
more challenging because there is a natural tendency to like what's hot. We
tend to avoid those situations, but you do feel like an idiot sometimes. On the
other hand, it does present buying opportunities, such as the Artschwager
we recently acquired for a relatively reasonable price because he is not as much
in favor right now.

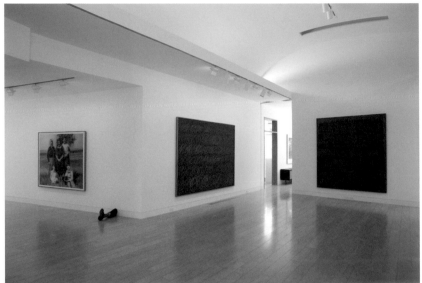

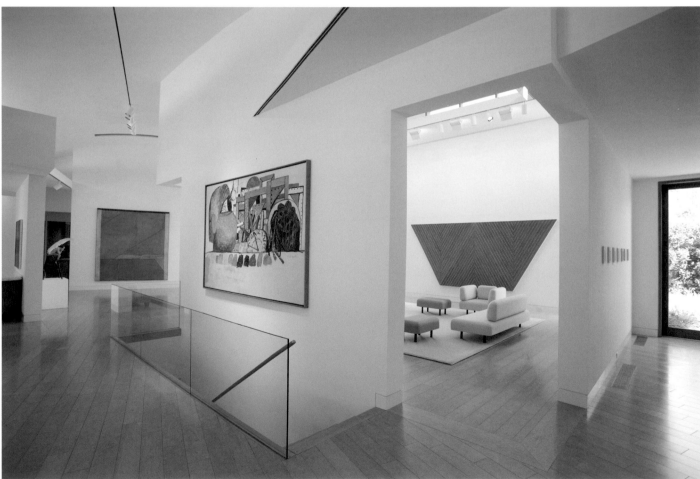

Installation views of the HOFFMAN gallery and a portion of the brick
wall designed by SOL LEWITT for the Hoffman garden

To end, I would like to know how the idea of donating your collection to the DMA came about. I truly believe it is a marvelous initiative, sure to turn Dallas into the focus of attention of the U.S. art community.

RH Marguerite will have a good answer for this one.

MH When Robert and I married, we each had a passion for art, but for various reasons, neither of us was associated with the DMA in any real way. This was a great sadness for me, so I began a quiet campaign to turn Robert's attention back toward the Museum and toward the role we could play in making the institution better. I had great help in this effort from Howard and Deedie and also from the arrival of Jack as our director. Robert and I were both impressed with Jack's track record in helping institutions reach their potential and thought his experience provided a wonderful opportunity for the DMA.

During all this time, we were very actively collecting and it soon became clear that we needed to be mindful of what would happen to our collection in the event of our deaths. It sounds ghoulish, but we were traveling a lot and we had young children so we were constantly updating our wills, and it forced us to confront the issue. We felt strongly that our collection was a reflection of the ideas and experiences that we had shared together, it represented a part of us as a couple, so we wanted it to stay together and not be parceled out. The works seemed to belong together and have a certain power or resonance that would be disturbed if they were separated. We also felt strongly about trying to make a difference for our community. Living with these works has been extraordinary for us and we wanted others to have access to the same experience. So, there are the first two elements: a desire to become closer to our city's major art institution and our decision to give the collection away intact at our death.

The third part of the equation was the work that was being done by the Museum staff and key trustees around the thorny issue of how to provide adequate financial support for the Museum's future. As plans for a major campaign evolved, Robert and I got more engaged and began a series of conversations about how we could use what we had been so lucky to acquire to leverage other gifts in the community. Because Providence has declared that Dallas has the nicest and most generous collectors in the universe, it was easy to excite the Rachofskys and Roses and others to join this idea of not only "raising dollars" but also "raising art" for our museum. It has taken a lot of work and we are not finished, but I believe we have collectively done something unique and very wonderful for our city. I am extremely proud of our actions and the impulses that propelled them into reality.

Spring 2006

Interview with Cindy and Howard Rachofsky

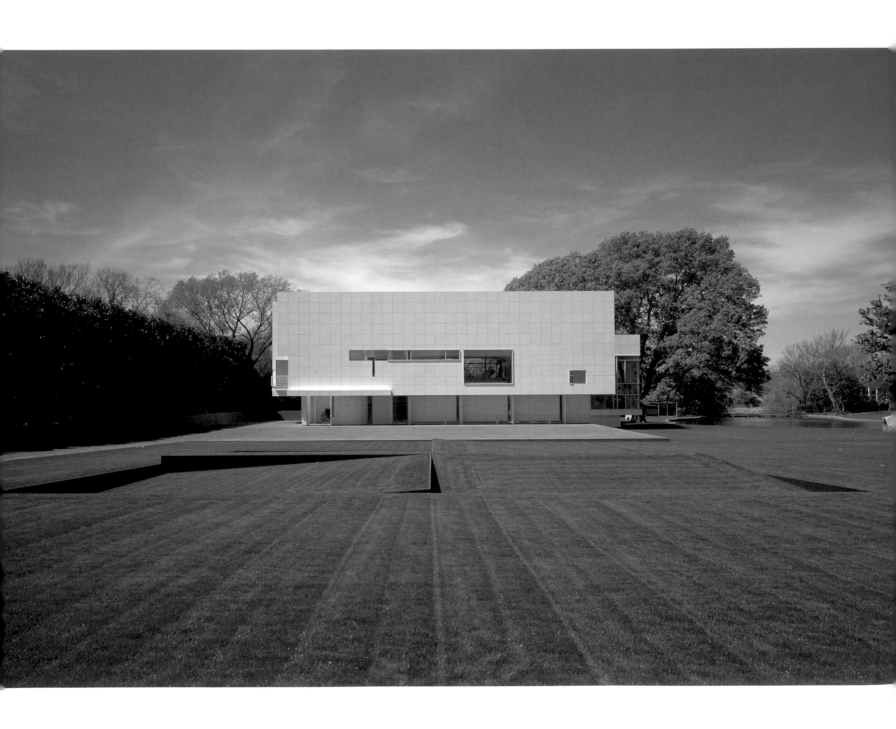

María de Corral *How did you begin collecting? And is the collection tied to the Richard Meier house?*

HOWARD RACHOFSKY First, may we talk about the house? I had collected art in a modest way since the early seventies, primarily modernist prints, but I don't think I could characterize it as a collection until the house became a focus of mine. That was in 1983, when I first met Richard Meier, shortly after he had completed the High Museum in Atlanta. I had seen the High right after it opened, and was taken by its beautiful forms and incredible quality of light. It was a beautiful day and it was a beautiful building.

And, Howard, you didn't have to play the trick of saying that you wanted him to build a private museum?

HR Not at all. In fact, I said I would love for him to build a house. But, between our first conversation and our meeting in New York some weeks later, he won the commission to design the Getty museum. I assumed that he wouldn't be interested in doing such a small project as the house. But, surprisingly, he said he loved to do houses. By that point in his career he had done maybe thirteen or fourteen houses, and he liked them because they were like laboratories, in which he could experiment. I worked with Richard and the designers in his office for about a year developing a program, but when we took bids on the project it was too expensive to undertake and the project was put on hold for several years. Then, in the summer of 1990, I called Richard again and said, "I'm coming to New York. May we meet?" We had a breakfast meeting and I told him: "I still want to do a house. I can't get it out of my mind and I really want to do it. But the original house you did was really not as much about art and I've become more interested in collecting art, particularly contemporary art. I would like to have a building that speaks more as an art exhibition space rather than a traditional residence." So,

facing: The RACHOFSKY HOUSE, designed by the architect RICHARD MEIER. In the foreground, *Tilted Planes of Grass and Steel* by ROBERT IRWIN, 1999

above left: The architect RICHARD MEIER

above right: HOWARD and CINDY RACHOFSKY

the process began in the fall of 1990. We broke ground in 1993 and finished the building in 1996. We are celebrating its tenth anniversary this year.

Returning to the modest origins of your collection; in the seventies you hadn't defined your art preferences yet.

HR No, they were not well formed. I became friendly with a dealer here in Dallas who dealt primarily in prints. Through him, I collected multiples of modern masters, Picasso, Matisse, Calder, Miró, Chagall—

That's how it started?

HR That's how it started.

Do you still have those works?

HR No, no. That was like another life. The first significant painting I purchased around 1980 was a big Protractor painting by Frank Stella that is still in the collection. That was the first expensive, if you will, work of art. In the eighties, the collection was primarily a little of this and a little of that. I became friendly with dealers at the Knoedler Gallery and the Emmerich Gallery, and I bought work by artists represented by those galleries: Helen Frankenthaler, Adolph Gottlieb, a little Rothko on paper, Robert Motherwell … it was more of a color field, late abstract expressionist kind of collection. Throw in a late Arp sculpture and a Barbara Hepworth…. They were nice works of art, but it wasn't really a cohesive collection in my view.

Has there been anyone … an advisor who has worked with you in the collection?

HR Yes, a gentleman I met almost ten years ago, Allan Schwartzman, whom I characterize as the guiding force for the collection. He doesn't have an official title, but we call him the director/curator of the Rachofsky Collection. He's worked with us for almost ten years and became a great personal friend along the way. I think we've all grown a little bit. Allan had been a critic, a curator, a writer and was a former art dealer, so he had a wealth of experience. I don't have an art history background so he helped me begin to get some context and some understanding. We spent the first six or eight months of our relationship not buying anything—just going and looking. And talking about what I liked, what I didn't like, what made sense, and what would resonate most in the house. Allan has served as my art historical reference, steering me in ways that have given me a chance to read, to learn, to work, and to understand what really makes sense. As we began to work together, the relationship evolved into more give and take, and less about him just saying: "I'll go find a this and a this and a this … and we'll put it together."

But your collection also has evolved or has it just started moving in different directions?

HR Well, when we talk about the collection, we talk about two broad themes, but they're so overarching they cover virtually everything. First, works that resonate within the context of this house, which really deals with perfect form and minimalism. In our view, we characterize the work of the Italian artists of the sixties and seventies as conceptually based work that really fits that sort of idea, as well—art you really *think* about, not just art with which you have a visual experience. Second, because of an interest in figurative work, the collection has also taken on the postmodern issues of cultural, sexual, and racial identity and … what the world looks like now. It is a collection that's still living and not just a time capsule, so we've continued to collect works by younger artists who are exploring these kinds of ideas.

What led you to collect this Italian art?

HR We had been looking to create a historical lineage for the minimal art that had formed the core of the focus of the collection, at that phase. This initially led us to Ad Reinhardt and soon thereafter to Lucio Fontana. Once we had begun to look at Fontana, we realized that there was a wealth of great art that was made in Italy in the postwar period that had not been collected very meaningfully in this country.

So, I guess Fontana is a cornerstone of the collection?

HR The key to my involvement with Italian work and what led us to *arte povera*.

Do you or Cindy have "favorite children" in the collection?

CINDY RACHOFSKY The Jeff Koons.

That's one of your favorites? Your favorite child?

CR My most favorite child.

And you, Howard, do you have one?

HR I just don't think I have a single one. I have to be truthful. It's almost as if it's the one I've encountered most recently that sort of suddenly comes to the surface. We just hung a painting at home last week that we bought fairly recently. We put it over Cindy's desk and it looks spectacular. The artist's name is Michael Raedecker.

How would you say that art has influenced your lives over the past few years?

HR I think it has become our lives. We have become immersed, not only in the collection, but in the idea of collecting and the idea of interacting with people who also find interest in the visual arts. I think it's become the center of our lives. Besides our *real* children, of course. [*laughter*]

Europe does not have the generous, collaborative attitudes that seem to exist in your community. As I understand it, you are not in competition with other members of the group who so generously support the Dallas Museum of Art. Correct me if I'm wrong.

HR I don't know that we've ever looked at it competitively.

CR I think some people look at it competitively. Not the three of us [Hoffman, Rose, Rachofsky].

HR Oh, the art market is competitive and it's going to have to be, everybody is looking for great things. But I'll give you a story that I think is really interesting. Robert and Marguerite Hoffman flew to California to look at a painting they were interested in buying. It was in a private residence and four or five

Installation view, in THE RACHOFSKY HOUSE garden, of JEFF KOONS, *Balloon Flower (Magenta),* 1995–1999

pieces were to be sold. They flew out, saw the piece they were interested in, a Frank Stella, and bought it. When Robert got back, he called me and said, "We just bought a painting from a man who also owns something that you need to look at. If the dealer hasn't called to tell you it's available, you should call him." [This was] the 1963 Kounellis. So we flew out shortly thereafter, admired the work, and agreed to buy it. So, knowing the nature of our collection, Robert actually found the piece *for* us. We have also bought a painting with the Hoffmans—the 1968 Gerhard Richter *Stadtbild Mü.* It was a very expensive painting that would have been beyond our financial wherewithal, but in collaborating with the Hoffmans and the Dallas Museum of Art, we found a way to work collectively to buy it. I'm glad we did. You know, it's amazing what happens when you think collectively and not just personally.

As much as I would like to give us credit for being great renaissance people, I think part of it had to do with having the stars line up and having some people who are already friends by virtue of common interests. Each collection had its own path. It wasn't a matter of "if Robert [Hoffman] has that, then I have to have one, or I have to go find a better one"—whatever that means. Or "if Deedie [Rose] has this, then I have to do this." I think our collections each have their own identity, which makes ours a collaboration, not a competition.

Has your decision to give the collections to the Museum changed your way of collecting or your ideas of collecting?

HR To a degree, I would say, yes, in two ways. First, you feel a certain responsibility when you're continuing to collect on behalf of a museum. Even though you're not a curator and you're not on the payroll and even though we've always sought out works which we think are important and good works. Nonetheless, when you feel that additional responsibility, it makes you think twice. At least in terms of collecting historical material, you ask yourself: Is this work good enough to be included in a collection that's going to have an infinite life? Second, it has allowed us the opportunity to leverage our financial capabilities by buying work jointly—sometimes with the Museum. In today's frenetic art market, this is a significant advantage.

Do you think now that there is a big difference between a private and a public collection? If it is private, you can really take greater risks, acquiring more risky things?

HR I think there could be. I think part of what maintains a private collector's interest is to continue to look at new and different artistic ideas. At some point in time the Museum may decide that this is material they may not want to retain for the permanent collection. Deciding whether or not something should be within the bigger collection must be done in the future, with the curatorial perspective of, you know, fifty years of hindsight. We continue

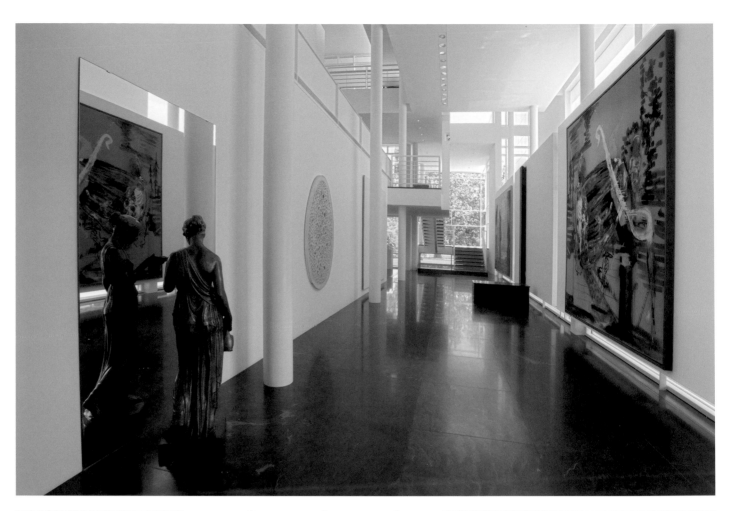

Installation views of the RACHOFSKY HOUSE

to collect works that make sense within the context of our collection as it has evolved, as we view it now. That's still the primary criterion.

I know that you [Cindy] have played a very important role with this house. Do the two of you ever fight about acquisitions of certain pieces?

CR Do we fight? No, we laugh.

Do you have differences of opinion?

HR A lot.

CR We do. But we laugh about them more than we fight about them.

What was the idea behind including the Rachofsky House in the gift?

HR The house from the time it was first opened was clearly not a private space. Yes, we lived here for a period of time, but in reality this was a place for the community. Since the house opened we have used it to proselytize for the enjoyment and experience of contemporary art and architecture, and it seemed perfectly appropriate that the house would continue under the auspices of the Dallas Museum of Art to preserve this legacy.

People in many other countries would have nothing but admiration for your generosity, but how does that happen?

HR This was not Cindy's and my idea. The general idea was envisioned by our great friends, Marguerite and Robert Hoffman. On a New Year's weekend getaway at the end of 2000, Robert and Marguerite approached us with the idea. They were prepared to give their collection to the Museum as part of a Capital Campaign Challenge that they were leading to guide the Museum into the twenty-first century. Robert said, "We're prepared to do this…. Would you be interested in joining us?" And it took us about fifteen seconds to say, "Yes, yes, bring on the good wine!"

I find this very moving, Howard.

CR But, the house came later. I mean, the house was not part of the original conversation with Robert. It was your idea after that to say—

HR and, we'll throw in the house while we're at it.

CR That is precisely how it happened.

I think the idea of giving the house and the garden is fantastic. Now that I'm thinking about which pieces to take for the Sculpture Garden at the Museum,

I have decided that I'm not going to take any from the garden because they're much better here than anywhere else. People should come here and look at them—the way they are installed makes them extraordinary.

HR That's been our hope.

I want to ask you, do you enjoy meeting the artists whose work you like?

HR Absolutely, absolutely. Luckily, a lot of the artists that we collect are living, and we've had the good fortune of meeting quite a few of them.

What kind of relationship do you have with the artists?

HR We consider as very good friends Tony Oursler, Jim Hodges, Mark Quinn, Bob Gober, Donald Moffett, Kiki Smith, Janine Antoni—we had the pleasure of having Chuck Close here for dinner last week.

CR I don't think it changes the way we buy art, but it certainly makes it more interesting. I think you have a different relationship with the pieces when you have had an opportunity to talk to the artists about them, or not even about the piece, just talking with the artist. Once, we had the opportunity to meet Marisa Merz, the wife of the late progenitor of *arte povera* and a great artist in her own right. The way I look at her work is different now from knowing her and from being around her. It's more precious and very dear. It's more so because of knowing her than it might be otherwise.

And what artistic tendency do you find most stimulating today?

HR We now have movements in every city on the globe: the Leipzig school, the Berlin school, the London school, the Los Angeles school, and maybe there's a Dallas school too, I don't know. I think the tendency, if there are tendencies, is to be more pluralistic. It's almost as if there's now an unlimited freedom for everything to be artistic expression, and artists are doing everything with all available media to create their work.

Would you like to add anything, Cindy? About the donation, the relationship with the Museum, or…?

CR Besides the fact that the Museum is the beneficiary of three wonderful collections and this house? I hope, and Howard would agree, that this encourages others to do the same thing for their museums. It's not just a matter of giving art, but rather about sharing and creating a legacy for future generations.

April 2006

Interview with Deedie Rose

María de Corral *How did you begin to create your collection of contemporary art?*

I bought my first piece of art when I was first married in 1964. It was by
a student. My husband and I were living in Boston and we had no money—
I'm sure that was the first time that he was appalled at what I was doing,
but it was not the last time.

And then? How did you progress?

I started going to galleries in Dallas and just looking. And then I became
a docent at the Museum. I don't even know why; it's one of those things that
you end up where you need to be. Docent training was every Monday,
and almost every time, I would say to Rusty, "Well, I'm not really going to like
today because they're going to talk about Japanese art. And I don't really
like Japanese art." At the end of the day I'd come home and say: "I love
Japanese art!" There was never a day—never—that I didn't come home
totally fascinated. Now those aren't areas where I've collected, and I don't
know why I collect contemporary art except I love being right in the
middle of things that are happening right now, seeing what artists have
to say about the human condition today.

Would you say that you have a God-given feeling of either taste or intuition?

I think it's both. It's that age-old question of what is nature and what is nurture.
I grew up in Fort Worth and at the time there was no Kimbell Art Museum—

Was it very provincial?

It was probably fairly provincial. There was the Modern Art Museum of
Fort Worth, which did have a small collection, but it was just in a back room

somewhere. I had never been to the Dallas Museum of Art. I think both the nature and nurture parts came from my father, who was a builder and shared an office with my uncle, an architect. My father was visual. He built our house, and the pieces of furniture he put in it were classics from that era. I discovered that about six or seven years ago, when we moved my mother out of the house my dad had built. I said, "Mother, we're just going to get rid of all this old stuff in your house and get you all new things." My friend Emily Summers said, "Oh, no! These are the very same mid-century designers that you are buying for yourself," and there they were; I had lived with them all my childhood in my parents' house. We ended up restoring and recovering a lot of things my mother had. What was so amazing to me, and made me cry, was to realize that the interests I had in these visual things came right from my father, who had died a long time before. It was just such a wonderful revelation to me.

In your collection, I see two phases with different meanings for me: the first has works that are much more intimate, emotional, and intellectually very close. The more recent phase has artists that represent very distinct movements, attitudes, and proposals. Does this have to do with a psychological change, a change in interests, an openness, or were you thinking more in terms of each work than of the whole collection?

The works that are intimate and emotional often connect with nature, and I respond to those intuitively. Other works are starting to form a collection— the Blinky Palermo, for instance—and provide a more intellectual component. The change that has occurred for me is in all the reading, looking, and listening to other people—teachers—who have helped me see things I never understood before. Being a part of the Museum, being intimately involved with it, and learning from people there has been very important to me. Also, having a consultant is something I fought for a long time. I felt that art is too important to me, too personal, to have somebody from the outside who tells me what to buy. But when I started wanting my art to be available for other people, I knew I wasn't doing a good enough job. If the art was ever going to go to the Museum, I needed to have help. Allan Schwartzman is an outside eye looking at what I'm doing and showing me things I would never see otherwise.

How has art influenced your life? How has contact with artworks changed you?

I would say that the visual arts are very important to me. By the visual arts I mean an area that stretches from art to architecture to landscape architecture and now urban design. I really think all those visuals affect the way people live and think and work because, in my life, they have. I am a happier person. I work more efficiently and more joyfully in this house than

if I were in another house. I think the way cities are designed can lead people to have a better community, to work better, and maybe even, dare I say it, to be better people. For me, I know that's true.

Yes, but in your case, you have to accept that it has required a tremendous effort on your part to broaden your knowledge and also acquire depth. This has not happened by accident. You have really worked hard at it, haven't you?

I have worked at it, though I could have worked a lot more. Howard Rachofsky or Robert and Marguerite Hoffman really inspire me. They're much more studious and intellectual about it than I am. I'm probably more intuitive because that's all I've got. But I have worked—only I wouldn't ever call it work—I have devoted time to it.

I really love the coherence of your collection. I think it's wonderful. Do you find it difficult to choose—to decide what is essential? And are you concerned that a new purchase fits well into the existing collection?

Yes and no to the first question. Sometimes it is difficult for me to make a choice—and it's often because of the price of the piece. Should I spend that much money on a piece? There are times when it's very easy to make a choice. It doesn't matter if it fits in or if the Rachofskys or the Hoffmans might have covered that in their collection, I just want that piece, and I want it to be here with me so that I have the privilege of living with it for a while, because I never consider this my art. I've always considered that I am privileged to take care of it for a while because these pieces have meaning and someday they should have meaning to somebody else. And it's often why my house is opened up to people.

That brings us to the very crucial question of the interview: when did the magic of the donation come to your mind? The idea that this was no longer going to be your collection, but it would eventually go to the Museum.

Not in the very beginning, when I bought a student's work, because it was never good enough and it was only for me. But after I worked in the Museum and art became a bigger part of my life, I had a desire to someday have something good enough to go to the Museum. I never voiced that to anybody—it seemed presumptuous.

Not even to Rusty?

No. It was just a part of me for a long time. It became concrete when Robert and Marguerite told me what they were going to do. A couple of weeks before, at New Year's, they had been in Napa Valley with Cindy and Howard

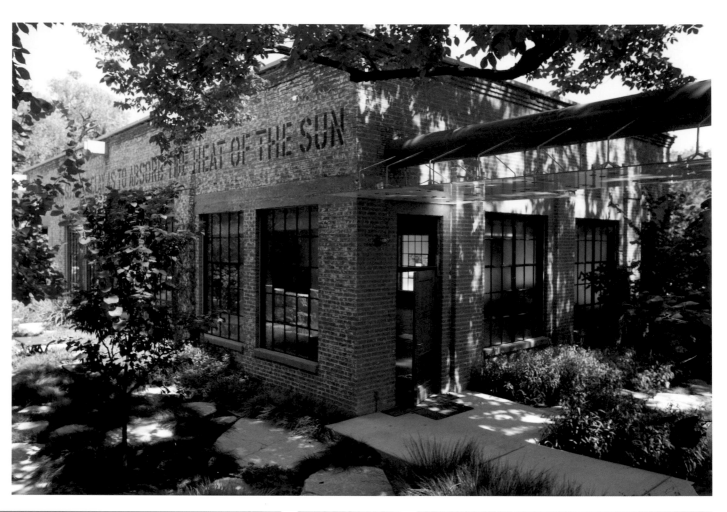

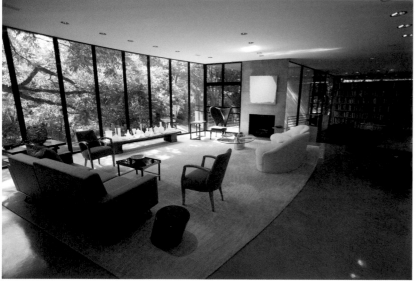

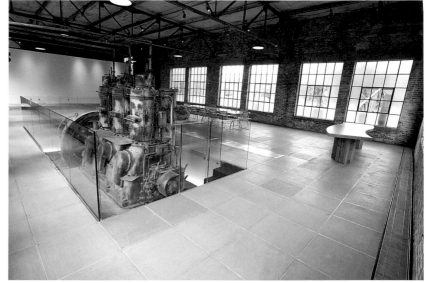

clockwise from top:

Installation view of the ROSE PUMP HOUSE, with *(HEAT) WATER + CLAY LADEN WITH SO MUCH CLAY AS TO ABSORB THE HEAT OF THE SUN* by LAWRENCE WEINER, 1991 (installed 2005)

The PUMP HOUSE, renovated by the architect GARY CUNNINGHAM

The ROSE residence, interior

facing, top:

Installation view of the ROSE residence with *Wall Drawing #310* by SOL LEWITT, 1978

facing, bottom:

The ROSE residence, exterior

Rachofsky and had talked to them about doing the same thing, and they agreed. And I thought *this* is a dream come true. First of all, for those two couples—because I think their collections are just unbelievable and for both of them to say they were going to make this kind of bequest to this museum, that I loved almost as much as a child, and for me to be able to be a part of this gift as well. It was just … it was a great moment.

Do you feel that a heavy weight has been taken off your shoulders? About the ultimate destiny of your collection?

I don't know that a weight has been taken off—it's more like a burst of joy. It was as if this wonderful thing had come to fruition and, really, I think we all feel that way.

Are you interested in meeting the artists and getting to know them?

Yes, and in the beginning I wanted to like the artists. That seemed important. That isn't important anymore. I would love to get to know an artist because I think it would be adding to my art historical background. But I think great things that speak to one come from all different kinds of people, and it may not be a person that I like or necessarily admire.

I'm going to tell you a story about Chris Burden's *All the Submarines*. It is in the DMA collection, and I helped raise the money for it. I put together a group of friends to buy it. Not all of them were really interested in contemporary art. The toughest one in the group said, "I want to read about this artist." He really wanted an intellectual understanding of the artist and what the artist was doing. I gave him a book. Several weeks went by and I didn't hear from him. Finally, he said, "Deedie, I have read this book and this guy was a nut!" Fortunately I had just been reading about Isaac Newton, and I said, "Yes, but so was Isaac Newton." "OK," he said, "I give up." Because that was the perfect answer, really, to Chris Burden. Someone might appear to be insane to others, but unbelievably great things can come from the mind and the hand of that artist.

How has your collection evolved over the past years?

Four years ago we had a fire in our house and had to move out for nine months. It was just devastating. I was worried that I had lost all the art. I didn't lose very much at all. Very lucky! Inge-Lise Lane, who is an art conservator, organized the restoration and the cleaning of everything, and when we moved back in, she helped me reinstall it over a two- or three-day period. Jack Lane came over the third night. Jack, after looking around at everything, said, "Deedie, you're probably not going to want to hear this, but this fire was good for your collection," and I said, "Jack, I know that."

Because the fire purged it?

Yes. When we moved back in, I didn't rehang as many things. We edited. What I did re-install were things that really meant a lot to me. I'm very bad when I buy new things, I'll just bring them in and start loading the house down, and that was not a good thing. It was like a forest fire. In the beginning, it's devastating: animals are killed, living things are killed, and beauty is destroyed for a while, but it enables the forest to have a new life. And that's exactly what that fire did for me. It enabled the art to have new life.

I'd like to know more about the role of the advisor. What role does he play in your collection—someone with whom to constantly contrast one's opinion or someone who picks out the work you wish to buy?

I think he is my eyes out there in the world when my eyes can't be there. And, even if we go to an art dealer together, his eyes are smarter than mine. They are more perceptive than mine.

Or better trained?

They are better trained. So I count on his eye being out there looking all the time. I trust him to know me by now, to know what I'm looking for, and to help me think through things. I want him to bring me a lot more than I'm ever going to be able to buy, which he does. And to help me think about it.

I know that architecture has played an important role in your life and in the collection. Can you explain this passion?

I grew up with a father who was an engineer and a general contractor, a builder, and he worked with my uncle, who was an architect. I loved building and buildings, the smell of sawdust, being on construction sites. I love the process and I love working with architects. Great architects have to have both sides of the brain exquisitely developed. They have to be both artist and engineer. They also have to be great communicators. I think architects do consider themselves artists. And to a degree, they are, but architecture is a different activity from art.

Speaking of architecture: since you have the new building—the Pump House—has the collection, or your idea and manner of collecting, changed?

Yes. For one thing, I can do some video art now. The Pump House space is perfect for showing certain things that I couldn't have done in the house, so that has opened up a whole new realm of possibilities.

April 2006

Interview with John R. Lane

María de Corral

How did art become a part of your life?

There was a remarkable art history program at Williams College, where I was an undergraduate, and Rusty Powell, who was my roommate there (he is director of the National Gallery of Art now), urged me to take a course from Lane Faison, a particularly distinguished professor who was an enthusiastic advocate of modern art and also served as head of the college's art museum. Deeply committed to the primacy of experience afforded by encounters with original works of art, he was very obviously in love with the role of directing and curating an art museum, and charismatic, drawing a surprising number of Williams students into careers in the art world, especially museum director aspirants. Another distinguished Williams professor, Frederick Rudolph, who taught American cultural history and made a point of putting arts and educational organizations into a social framework, was also an important influence because he provoked an interest in the institutional context for the aesthetic pleasure that I was taking from being around works of art. The 1960s was a great time at the Museum of Modern Art, and, as a student, I would go down to New York to see the shows of the founders of modernism and the retrospectives of the heroic generation of abstract expressionists, such as Pollock, de Kooning, and Motherwell. These early experiences were extraordinarily eye opening and stimulating for a young person from an Idaho ranching and ski resort background, who heretofore really had no connection with art or museums.

Could you speak about the DMA collection? Which are in your opinion its strong points?

The DMA's history goes back over a hundred years now, among its founders were several artists, and it was, from the beginning, part of the organizational mandate to collect the work of living artists. In the early years that

facing: DALLAS MUSEUM OF ART, designed by the architect EDWARD LARRABEE BARNES, 1984 and 1993, and the Dallas Arts District, aerial view

above: Dr. JOHN R. LANE, The Eugene McDermott Director of the Dallas Museum of Art

translated largely into the work of regional artists but there were also some things by national and international figures. For instance, the second item to come into the collection was a Childe Hassam painting. But really, the modern and contemporary part of the collection didn't begin to take on a serious form until the 1960s. When the lively but short-lived Dallas Museum for Contemporary Arts merged with the Dallas Museum of Art, the limited number of interesting works it had collected came as a dowry. Ninety per-cent of our some twenty-five thousand artworks joined the inventory since then, so it's actually a history of forty years of collecting activity, not one hundred. Since the 1960s there has been serious interest by private collec-tors here in modern and contemporary art, with the great names up through the 1980s being Patsy and Raymond Nasher, James H. Clark, and Algur Meadows. But it has been over just the past decade or so that a greatly accelerated level of acquisition activity has emerged, in both the Museum and the community of private collectors.

Besides abstract expressionism, which is very strong here and includes a 1947 Pollock "drip" painting, *Cathedral*, that came into the collection in 1950 and remains, after half a century, our most prized masterpiece, another long suit is German contemporary art. One of the important acquisitions we have recently made is the complete editions of Gerhard Richter. Since there are some twenty paintings in private collections in Dallas, the Museum wanted to complement that richness with a different facet of the artist's work; so now this city can mount from its own resources a survey of Richter's career. We've added multiple works by Sigmar Polke, Martin Kippenberger, and Thomas Struth, and significant individual works by Anselm Kiefer, Rose-marie Trockel, Thomas Demand, etcetera, that reflect postwar German culture, which has been, in my view, one of the really important centers of artistic activity during the late twentieth century.

We are also pursuing a specific strategy in collecting contemporary sculp-ture, which is the direct result of the magnificent benefaction to Dallas that was made by Raymond Nasher when, in 2003, the Nasher Sculpture Center opened next door to the DMA to show one of the world's great classic modernist sculpture collections. The Nasher Collection, joined in proximity with the Dallas Museum of Art's own twentieth-century holdings, has made this city a destination of international significance for modern and contem-porary art. The contemporary part of the Nasher Collection contains works by artists who, with a few exceptions, had emerged on the artistic scene by the 1960s or early 1970s, so at the DMA we have consciously focused on adding sculpture by younger artists from the 1970s, 1980s, 1990s, and into the new century, so that there would be, in Dallas, a continuum from the beginnings of modernist sculpture in the late nineteenth century up to the present. Recent acquisitions of work by artists such as Robert Smithson, Barry Le Va, Charles Ray, Thomas Friedman, and Matthew Barney would

DALLAS MUSEUM OF ART, Flora Street entrance, designed by EDWARD LARRABEE BARNES, 1984, and renovated by GLUCKMAN MAYNER ARCHITECTS, 2003

DALLAS MUSEUM OF ART, Jake and Nancy Hamon Building expansion, by EDWARD LARRABEE BARNES, 1993

be instances of this initiative. Another related area in which we have significant holdings is that of large-scale installations and media pieces. We are blessed with extraordinarily beautiful gallery spaces designed by Edward Larrabee Barnes that are wonderfully embracing of this kind of work.

I ask my next question because Europe and the United States are so different that sometimes the Americans don't understand Europe and, of course, in Europe we don't know what happens in the States. Private collections are shaped by a specific taste that favors certain expressions; collectors can choose to follow the career of one artist rather than another and with no need to justify those decisions. A private collector takes risks and makes leaps that an institution could not allow itself. What do you think is the difference between a public and a private collection?

In my museum life I have tried hard to help bring the private collectors in a community together with its museum in such a way as to develop a shared view of what, in the long-term, the community's public collections could look like. The private collector can act quickly and decisively, can take bigger risks, and can, with brilliant obsession, pursue a particular vein of artistic endeavor. A museum has other responsibilities, especially if it is mindful of what's going on in the private collections that are likely eventually to be given to it. So, I think that the museum should do different things. It can acquire works of a scale that would be difficult to accommodate in a collector's house. There are some subject matters that raise issues more suitable for consideration in a museum than in domestic circumstances. The perspectives of a museum staff are often different from the sensibilities of private collectors, and curators' choices add flavor and diversity to the total body of works of art entering the community. I don't kid myself: what private collectors can accomplish with the resources that they can bring to bear—when coupled with their energy, intelligence, and information-gathering capacities—is impressive, especially in light of the limited funds that the museum has available for collecting, but when you put it all

together—the private and the public—and have it work in concert, the combined collecting enterprise of the community can be very powerful. That's why I like to think of what the Museum is doing as being supportive of and complementary to rather than competitive with its private collector friends.

What do you think of the differences between Europe, where museums are public, and the United States, where they are private and are the responsibility of the community?

Well, of course, the European model is that most of the funding comes from government sources and there are few nonprofessional voices offering guidance to the arts institutions. Museum directors and curators can do largely as they please with whatever amount of funding they have been provided. The problem is that, by and large, there isn't that much money. In the U.S. stewardship model, the professional staff has a lot more engagement with its board of trustees and, in this governance structure, one must always be mindful that it is the trustees who are ultimately responsible for the welfare of the institution. So there's a dialogue between the volunteer leaders and the professional staff in an American museum that is fundamentally different from the way things generally work in European institutions. In Germany in the 1970s and 1980s a proliferation of Kunsthalles, art museums, and art schools was made possible by government investment and it seemed as if the staffs of these institutions were able to travel liberally and to program lavishly at will. The Germans were very successful in promoting their visual culture and I think that a lot of us watching in America then were envious. But today, in a climate of significantly diminished government patronage, how many of those same German museums still have such active exhibition programs and galleries brimming over with terrific new art? Significantly, many of the works they had been showing on their walls turned out to be on loan from collectors with decidedly independent perspectives and who have since removed their property. Today, in the United States, however, where committed individuals provide most of the support for museums of contemporary art, there is a programmatic vitality and vigorous development of the collections. Think about the amazing growth of the holdings at places such as the San Francisco Museum of Modern Art or here in Dallas or at the Whitney and MOMA in New York. As much as I respect the European model and appreciate the mostly unfettered flexibility that my colleagues there have to define their programs, I think, in the end, the American model in which motivated, engaged private individuals take a lot of responsibility for providing the funds and the art that allow the museums they care for to flourish for the public benefit is much more powerful.

DALLAS MUSEUM OF ART, view of the sculpture garden designed by EDWARD LARRABEE BARNES and the landscape architect DAN KILEY, 1984, featuring ELLSWORTH KELLY's *Untitled*, 1982–1983

I might observe another interesting difference between the European and American institutional contemporary art worlds, namely that in the United States there are a fair number of places like the Dallas Museum of Art that are not only involved with modern and contemporary art, but are, at the same time, encyclopedic museums with diverse historical collections that know no temporal or geographic boundaries. These institutions offer a different context from that of museums devoted specifically to the art of our own time, and many of the artists I know love being in a museum where there are—for instance, as in Dallas—important traditional paintings, great decorative art objects, masterworks of African and Indonesian tribal arts, and exceptional South Asian and pre-Columbian objects. Whether or not these collections are specifically relevant to an artist's work, they seem to be stimulating, enriching, and convey the sense that living artists are part of a long stream of human aesthetic endeavor. Dallas is hardly unique in this way in the United States, where there are a number of great museums, including the Metropolitan Museum of Art, the National Gallery of Art, the Art Institute of Chicago, the Philadelphia Museum of Art, and the Los Angeles County Museum of Art, that also pursue serious programs in modern and contemporary art within a broader, encyclopedic framework. A wondrous but rare example in Europe is the Landesmuseum in Darmstadt, where the great Joseph Beuys installations are rendered exquisitely more meaningful in being surrounded by other layers of cultural activity in the form of a significant collection of natural history artifacts.

What do you think has been the largest change in museums since you became a director?

One word: audiences. And I say this in the sense that, when I came into the profession in the 1970s, the generic mission statement for American art museums was to "collect, preserve, exhibit, and interpret works of art." The big change that has occurred was crystallized by a report called *Excellence and Equity*, published by the American Association of Museums in the early 1990s. The chair of the committee that wrote the paper was Bonnie Pitman, now my colleague as the deputy director of the Dallas Museum of Art. She is a real champion for change in art museum practice, and I am very proud that, under her leadership, the DMA has become a national force in igniting the power of art to change people's lives. *Excellence and Equity* acknowledged the idea that museums do collect and preserve and exhibit and interpret, but it asked the critical question, "for whom?," which had been left out of common museum thinking. Well, it certainly isn't just for the museum director and the staff members and it isn't just for the members, patrons, and trustees. In a democracy, our museums are a great resource that should be in the service of the broad public. While

Excellence and Equity was the document that clearly articulated this idea, change had been on the way for some time. Shows such as the first Tutankhamen exhibition, organized in the mid-1970s, brought in huge crowds and a much wider public than the traditional museum audience. A lot of those new visitors liked the experience and returned, and museums became far more popular destinations for the pleasure of looking at art, for learning about art, and for social and cultural engagement.

Allow me to mention another interesting change, which is the prominent place that modern and contemporary art has recently taken in what has become an increasingly visual or image-oriented culture. It wasn't very many decades ago that the number of museums seriously active in the modern and contemporary art field was limited and, with a few notable exceptions, mostly concentrated in New York. Today many North American museums are involved in this area at a quite sophisticated level; not just institutions specific to modern and contemporary art, but also encyclopedic museums, like Dallas, that have successfully made the art of our own time a vibrant part of their curatorial programs.

Do you consider contact with artists an important part of forming a collection?

Yes, it can be extremely helpful to have the involvement of the artist, particularly if you are forming a body of his or her work as, for instance, we are doing here with Robert Ryman, or you are commissioning new work that has specific space and technical requirements, such as we have recently done with Tatsuo Miyajima. Also, when you are trying to shape the collection or work on exhibitions, just as important as direct contact with artists is an excellent relationship with the galleries that are the primary dealers. They are deeply committed to their artists, they are highly informed, and they are in a position to provide the museum and its collector patrons with access to works of exceptional quality. The best gallerists are persons of culture as well as persons of the market.

Have you had meetings or relations with artists in such a way that those encounters, that personal experience or process of communication, can be appreciated in the collection?

Actually, many of the relationships that I have enjoyed with artists began with the preparations for the *Carnegie International* exhibitions we did in Pittsburgh in the 1980s. Happily, you were a valued advisor for one of those shows, María, and I also had the benefit of other highly informed and generous European colleagues, among them Nicholas Serota, Rudy Fuchs, Kasper

clockwise from upper left:

The artist MATTHEW BARNEY and JACK LANE, Director, with the installation of Barney's mixed-media work *The Cloud Club*, 2003

MARGUERITE HOFFMAN, the artist ELLSWORTH KELLY, and ROBERT HOFFMAN, 2004

BONNIE PITMAN, Deputy Director, 2005

JACK LANE, Director, the artist SIGMAR POLKE, CHARLES WYLIE, Curator, and CINDY and HOWARD RACHOFSKY, 2002

The artist LOTHAR BAUMGARTEN and JACK LANE, Director, in the Barrel Vault installation *Lothar Baumgarten: Carbon*, 2004

JACK LANE, Director, INGE-LISE ECKMANN LANE, and the artist ROBERT RYMAN, 2005

clockwise from upper left:

CINDY RACHOFSKY, Trustee; MARGUERITE HOFFMAN, Chairman of the Board of Trustees; and DEEDIE ROSE, Trustee and Past President, at the Centennial Campaign thank-you event, 2005

WALTER ELCOCK, President of the Board of Trustees, announcing Centennial Campaign pledges of art and funds at the Centennial Campaign thank-you event, 2005

JACK LANE, Director, acknowledging donors at the Centennial Campaign thank-you event, 2005

MARGARET MCDERMOTT, Benefactor Trustee, holding up a sign showing the number of dollars raised as of the Centennial Campaign thank-you event, February 10, 2005

RUSTY and DEEDIE ROSE, hosts of the Centennial Campaign thank-you event at their PUMP HOUSE, 2005

König, and Jean Christoph-Amman. You all really reshaped the way I thought about recent art, both American and European, and introduced me to many extraordinary artists, of whom Sigmar Polke has been the most special to me personally. We acquired the first important Polke work to enter a U.S. museum for the Carnegie; when I moved to San Francisco, trustee collectors bought and committed to SFMOMA the remarkable suite of five paintings on a Native American theme he created for the 1988 Carnegie show. In Dallas we've brought together a significant body of his work too. The artist did his only American paintings retrospective to date with us at SFMOMA in 1990, and in 2002, he collaborated with Charlie Wylie and me in Dallas to make a grand, site-specific installation that, in my view, stands as the most compelling commentary yet by a visual artist on the current culture wars and armed conflicts between the secular West and the Islamist Middle East. I have also been especially rewarded at various points over the years by working with, among other terrific artists, Gerhard Richter, Anselm Kiefer, Lothar Baumgarten, Martin Kippenberger, Ellsworth Kelly, Robert Ryman, Richard Serra, Jeff Koons, and my fellow Idahoan, Matthew Barney.

Well, coming to the main point: in regard to the donation of the Hoffman, Rachofsky, and Rose collections, I would like to know more about the process. From the point of view of a European, this kind of engagement with the museum is not easy to understand. Can you please explain how it works and how this donation is going to change the museum in the future?

This museum had a contemporary art program well before I came to Dallas. It was not always the highest priority, but it was a commitment. Recently, a circle of collectors has developed in this city who are very informed and very ambitious for their own collections, but who also wish their museum to become an important place for contemporary art. The decision that Raymond Nasher made to turn his and his late wife Patsy's great private collection of modern sculpture into a public collection, to build a truly superb gallery pavilion and garden designed by Renzo Piano and Peter Walker, to finance it all himself, and to do that next door to the Dallas Museum of Art, was, I think, a turning point in the recent history of Dallas. In 1998, when I was talking to the Board of Trustees here about the possibility of coming to be the director, the prospect of the Nasher Sculpture Center was the factor that made me believe something remarkable could and would happen in Dallas. When Ray went forward with his project, it was inspiring to others in Dallas, who were thinking very seriously about the public dimension of their own art collections. I think it helped them to appreciate that the city could have a special destiny as a center for modern and contemporary art if they were willing to invest in its realization.

The specific form this took originated with Marguerite and Robert Hoffman. They had agreed to be the chairs of the Centennial Capital Campaign, which was a major effort to raise a large amount of funds for the Museum's operations and programs on the occasion of our one-hundredth anniversary. In strategizing ways to encourage Dallasites to be generous to this campaign, they decided to present a challenge to the community: if the financial goals were achieved, they would irrevocably commit their great collection of modern and contemporary art to the Museum. All of us who were close to the situation were amazed by this extraordinary act of generosity and further happily astounded when their collector friends Cindy and Howard Rachofsky announced that they wanted to join the Hoffmans in this challenge. We vigorously pushed forward with the Centennial Campaign and raised a lot of money, but the events of September 11, 2001, and an economic downturn frustrated our efforts to reach our original goal. When we got to the point in early 2005 where we thought we needed to announce the successes that had been achieved, I had a sense, from things the Hoffmans and Rachofskys had said, that their heartfelt intentions were for their collections to come to the Museum regardless of whether their challenge had technically been met. So, just a couple of days before the announcement party, I asked Deedie Rose if she would, as their friend and fellow trustee, have a quiet word with Marguerite and Robert to ask: "Would you be willing to declare victory, and on the occasion of this special event celebrating the financial success of the campaign, say, 'The challenge has been met and our collection will come to the Museum'? Furthermore, would you be willing to see if the Rachofskys would do the same? If you are, we can have one of the really extraordinary evenings in the history of Dallas's philanthropic

Installation view of *Sigmar Polke: Recent Paintings and Drawings*, 2002

and cultural advancement." I think what happened then was that the Hoffmans said, "Well, yes, we'll do that but only if you, Deedie, will also commit your collection." So there she was, stuck. (But she told me that she was happy to the point of tears and thrilled to have been drawn in this way into the collection gifting circle.) Suddenly we had a third wonderful collection coming to the Museum! I knew all this was worthy of regional, national, and international news, but I was unprepared for the extraordinary response of collectors, dealers, art journalists, and museum colleagues from around the world to the announcement. They understood that something really remarkable had gone down in Dallas. I suppose they realized that, when you joined these three private collections with the Museum's existing collection and then added in the presence of the Nasher Sculpture Center, the total summed up to something in contemporary art that was so much more important than had ever before existed in Texas, something that would make Dallas a destination of international stature. If you looked at the other American encyclopedic museums, aside from the Art Institute of Chicago, there probably wouldn't be another one of them now with Dallas's strength in contemporary art. Since the announcement, there has been a more precise appreciation in sophisticated circles of what is so special: how relatively young the collectors were when they made their commitments (usually these kinds of gifts come late in a donor's life or by bequest); how they are all good friends who are not really competing with one another in their collecting, but actually collaborating among themselves and with the Museum (there are works of art that are jointly owned by the collectors and by the Museum); and how the gifts were structured so that works added

Installation view of the exhibition *Lothar Baumgarten: Carbon*, 2004

to these very active collections in the future become part of the commitment. It's almost unheard of that there is this spirit of generosity and collegiality in a collecting community and, in other cities, it has captured the imagination of trustees and directors who are deeply concerned about collection development for their art museums.

Do you want to talk about other collectors who have expressed their intention to become part of this bequest. Could you tell me about private collections in Dallas?

What is unique about the Dallas situation is that the collectors and the Museum are striding together into a future far more interesting and rich than if we were each marching in his or her own direction. The particular circumstances I have described were invented by the Hoffmans, Rachofskys, and Roses, the collectors who have led this benefaction. I know that other Dallasites have caught the spirit of their civic leadership, passion for art, and generosity and have embraced the pleasures that exist in contemporary art collecting and the international life that surrounds it—the artists, art dealers, museum people, other collectors, and the frequent gatherings for art fairs and exhibition openings. So there is a very nice, widening circle of other individuals and families in Dallas who are collecting contemporary art and are also generous in supporting the Museum. They are making outright, fractional, and promised gifts and are thinking seriously about the Museum as the eventual beneficiary of their entire collections.

I believe that this sort of supportiveness is something that is special to Dallas, for there is in this city and in Texas a real pride in the place where you live and a sincere and vigorous commitment to its improvement. I haven't experienced it at quite the same level in any of the other communities where I've been a museum director, although they've been very generous places. Maybe it has something to do with Texas having once been its own country—it was an independent republic between 1836 and 1846—and, while there are different areas of the state that seem individually to be about the American West, or the Midwest, or the old South, or Mexico, what gives all this diversity a center is a shared political, economic, social, and artistic history that, since the middle of the nineteenth century, has brought the parts together to make a unique culture, one characterized by an unrelentingly positive aspiration to make everything bigger and better.

April 2006

Mark Rosenthal

Action/Reaction

WITH A COLLECTION SO RICH as to offer a virtually complete view of the art developments in the post–World War II period in America, the Dallas Museum of Art is poised to join a rarified number of institutions. Notwithstanding the frequently heard observation that museum collections throughout the world tend to look similar, each telling the same story with equivalent works by the same artists, the comment is not applicable to collections spanning the era from abstract expressionism through pop art. In that field, few institutions can present a cohesive survey, let alone an overview, simply because most do not possess enough examples of the period; nor is money abundant enough now to permit the purchase of major works from this era. The Dallas collection will join an elite group. Indeed, given the particulars of each museum's holdings, a fresh experience of art history will result from a view of the Dallas collection.

The evolution from the 1940s through the 1970s in the United States in large measure follows a familiar path, that is, each art historical action is followed by a reaction. "Action" has a double meaning in this context: the term *action painting* is often applied specifically to the work of artists who were in New York City during and just after World War II, artists who were also known as the abstract expressionists. These same artists performed a historical action, a kind of throwing down of a gauntlet, a challenge to earlier European and American art and a challenge in terms of the development of painting in the United States, to the artists who followed them.

The postwar outlook included a conscious rethinking of earlier European examples. Artists wanted to confront and reinterpret the masters from the continent, while putting aside what was seen as the provincial approach of art in America during the period between the two world wars. Surrealism, though in its late stages, had not yet faded, especially because a number of dada and surrealist artists (including André Breton, Marcel Duchamp,

Max Ernst, and Yves Tanguy) had moved to the United States. The aesthetic approach of surrealism, comprising, in part, an emphasis on personal exaltation, the individual subconscious, the celebration of non-Western modes of expression, and a generally romantic point of view, exerted a powerful appeal to abstract expressionists. Also, in the air, of course, and watched carefully by many of these artists, was work of the ubiquitous Pablo Picasso, whose reinvention of figurative traditions never ceased to be a challenge. Abstract art from Europe was still very much of the moment and for similar reasons as Piet Mondrian was living in New York City.

The Americans often placed great importance on individuals who represented their personalities through abstract personal gesture and touch; hence dramatic, physically expressive paint handling and application was the mode of the day. The canvas was the field in which an artist would live, act, and demonstrate that personality. Style was considered an expression of individual psyche. Such aspirations required commensurate and extravagant scale, well beyond what had been seen before. As in earlier abstraction, a certain predilection for spiritual content could often be found in the words and works of these artists. The theoretical conceit that abstraction was the style of utopian societies, as evidenced at the Bauhaus school in Germany and among the De Stijl artists in Holland and the Constructivist groups in Russia and Germany, also played a role for certain Americans interested in Marxism and socialism. The prevailing ambition of the American group was grand, even grandiloquent, its sights set on the synthesis of surrealism and abstraction. This goal was achieved, to an extent, as the practices of the two supposedly opposing poles were propelled to innovative levels of accomplishment.

As currently constituted, the collection at the Dallas Museum of Art offers a good basis on which to understand the abstract expressionist *action*. Two spectacular paintings by Jackson Pollock anchor this area of the collection and show precisely the convergence of abstraction with surrealism. Joining these are pairs of major oils by the New Yorkers Mark Rothko and Robert Motherwell, and single great paintings by Arshile Gorky, Franz Kline, and Lee Krasner. In addition, Dallas owns another pairing by Sam Francis, a single painting by Richard Diebenkorn, and a beautiful group of tempera works by Mark Tobey, all of whom exemplify the more suave, controlled approach to abstract expressionism that was practiced on the West Coast. The two canvases by Morris Louis demonstrate the overlapping style known as color field.

In the future, whole new ensembles by Willem de Kooning and Philip Guston will provide impressive breadth to the post–World War II sphere. The addition of major paintings by Rothko, Diebenkorn, and Kline will result in stunning groupings by these artists, and

an oil by Ad Reinhardt will augment the presentation. Dallas will enjoy a preeminent position with its holdings of sculpture by Joseph Cornell, who not only typifies the fascination with surrealism but also is a bridge to the art of Jasper Johns and Robert Rauschenberg, who admired him enormously.

Following the action of the New York School came the first American reaction, at the instigation of Johns, Rauschenberg, and Cy Twombly. Though they established their artistic careers in New York, this trio was at heart a Southern crowd (Johns from South Carolina, Rauschenberg from Texas, and Twombly from Virginia). Whereas the abstract expressionists wore their machismo on their sleeves, Johns and Rauschenberg were distinctly more circumspect. In their art, touch was an equivocal enterprise. Touch seemed to exist for the sake of sheer visceral beauty more than as an autograph or evidence of personality; paint handling could even be interpreted as an act of appropriation, as if a *sign* for the abstract-expressionist approach. Twombly reacted differently; his was a highly personal approach to the application of paint and to gesture, much in the spirit of Gorky, Pollock, and especially de Kooning.

Johns and Rauschenberg gave an early indication that the synthesis of surrealist subject matter with the practice of abstraction would not prove sufficient to express an all-encompassing reaction to earlier European art. In their hands, art would now have a quite

recognizable or even prosaic subject matter—for instance, Johns's *Flag* or Rauschenberg's *Monogram*—and, for good measure, be saturated with irony in place of the abstract expressionists' idealism. Works by Johns and Rauschenberg made during the 1950s and early 1960s set the stage for the development of pop art, in which immediately recognizable themes became prominent. Heretofore, the DMA could present these three artists with a few, albeit spectacular, works, in particular *Device* by Johns and *Skyway* by Rauschenberg. The future holds magnificent riches: the Johns painting will be joined by three more canvases from other periods of his career as well as major drawings and a large group of graphics by this unparalleled innovator in prints. There is nothing by Twombly at all in the Dallas collection now, but in the future the Museum will house a most impressive assemblage of his work, comprising three major paintings and an equal number of sculptures.

Pop art represented the full flowering of the reaction to American abstract expressionism. Along with the rejection of abstraction, pop artists exhibited their overly common, even banal subjects in a flatly painted manner. Unlike their forebears with their elevated aesthetics, the pop artists embraced everyday life with unnerving gusto. Instead of seeing the artist as a romantic outcast, pop artists embraced a thorough rapprochement with society. The stars of pop included Jim Dine, Roy Lichtenstein, Claes Oldenburg, James Rosenquist, Andy Warhol, and Tom Wesselmann. Here, again, the Dallas collection will be augmented significantly, for there were only single works by Dine, Oldenburg, Rosenquist, Warhol, and Wesselmann in the collection. In the future, the Oldenburg holding will be enhanced by a key

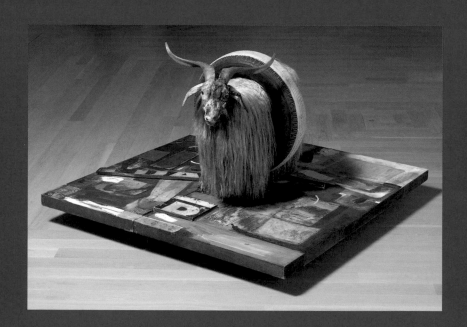

ROBERT RAUSCHENBERG, *Monogram*, 1955–1959
Combine: oil, paper, fabric, printed paper, printed reproductions, metal, wood, rubber shoe heel, and tennis ball on canvas, with oil on Angora goat and rubber tire, on wood platform mounted on four casters, 42 × 63¼ × 64½ in.
Moderna Museet, Stockholm

early sculpture, and Warhol will be shown with two more signature paintings, from early and late in his career, leaving the representation of Lichtenstein still to be addressed.

With the trove of future gifts of works of art added to the existing collection of the DMA, the city of Dallas will be in a remarkable position. Joining the singular holdings that currently exist of the work of Francis, Motherwell, and Pollock, the Museum will in the future have memorable overviews of the work of Cornell, Guston, Johns, Rothko, and Twombly, as well as dramatic groupings by de Kooning, Diebenkorn, Kline, and Warhol. This treasure-house will provide the sort of resource only a few cities in America can offer. Multiple stories within the art historical span from abstract expressionist through pop art, stories about the development of individual artists and movements or about symbiotic relationships, will be open to delineation and with major works. (This is not even to speak of the prospect of delineations of relationships with concurrent movements in Europe, discussed elsewhere in this volume.) Given the richness that Dallas will possess, diverse readings of art history will be possible. Indeed, because the curators will have at hand the makings of almost any meal they choose to provide, many generations of curators and audiences have a delectable future awaiting them.

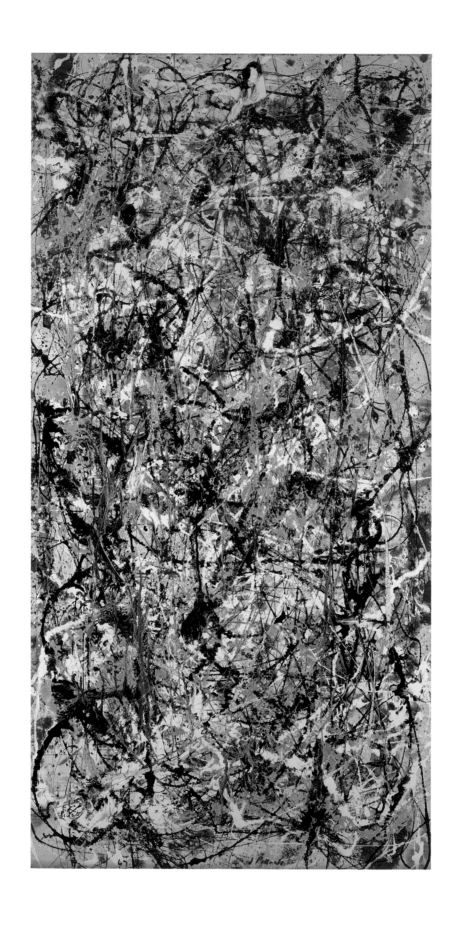

JACKSON POLLOCK, *Cathedral*, 1947
Enamel and aluminum paint on canvas, 71½ × 35 1/16 in.
Dallas Museum of Art, gift of Mr. and Mrs. Bernard J. Reis, 1950

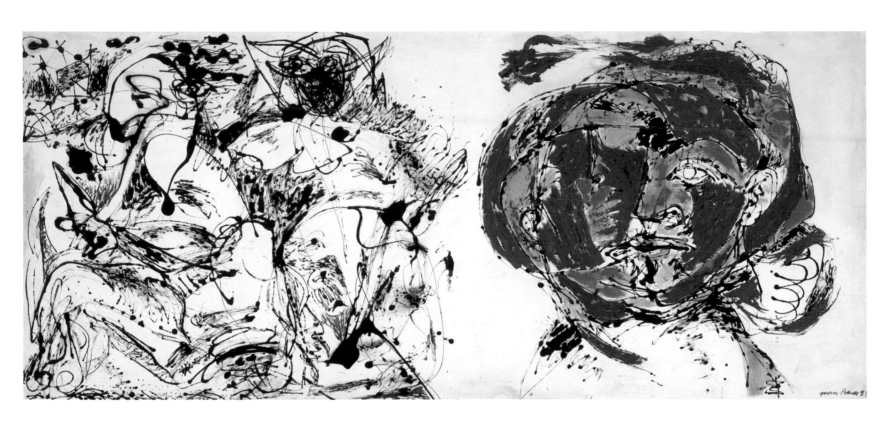

JACKSON POLLOCK, *Portrait and a Dream*, 1953
Oil on canvas, 58½ × 134¾ in.
Dallas Museum of Art, gift of Mr. and Mrs. Algur H. Meadows
and the Meadows Foundation, Incorporated, 1967

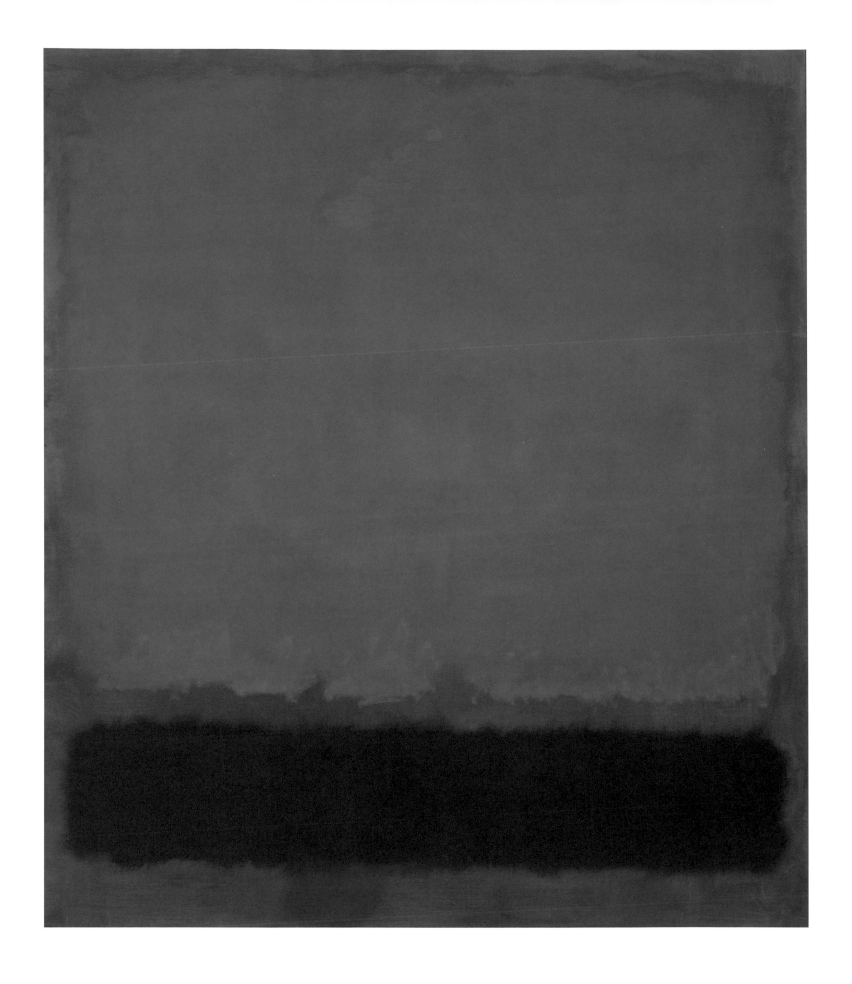

MARK ROTHKO, *Orange, Red and Red*, 1962
Oil on canvas, 93⅛ × 80⅛ in.
Dallas Museum of Art, gift of Mr. and Mrs. Algur H. Meadows
and the Meadows Foundation, Incorporated, 1968

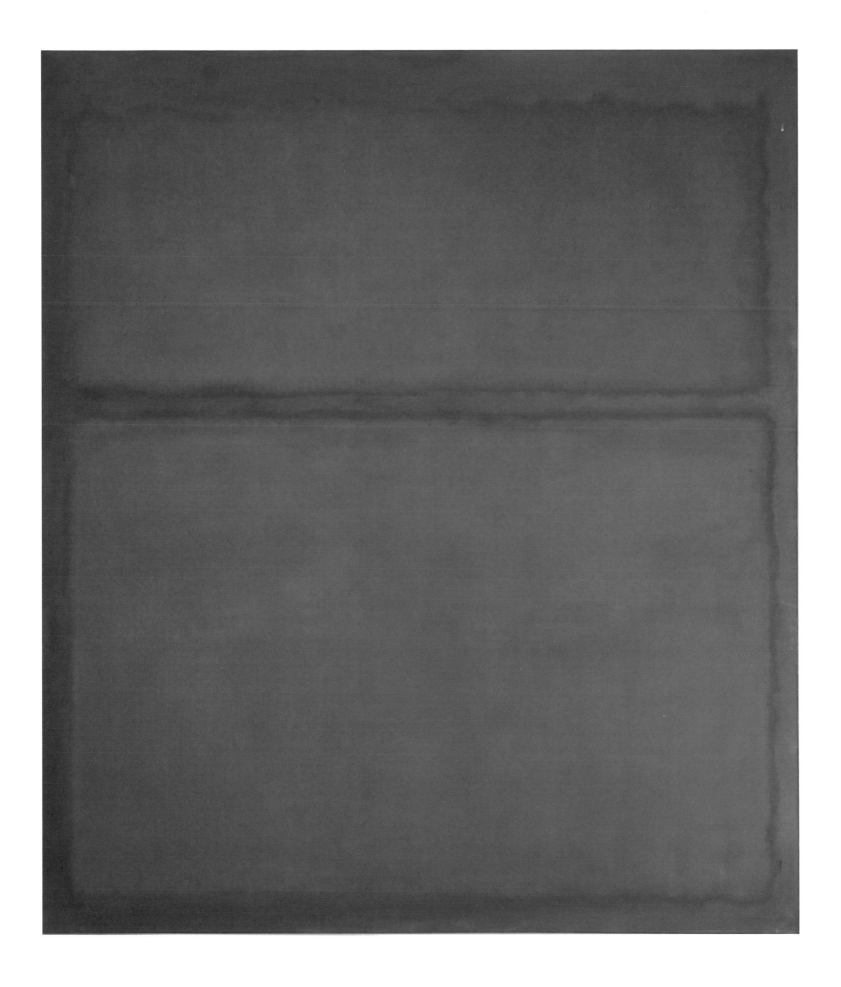

MARK ROTHKO, *Untitled*, 1961
Oil on canvas, 93 × 80 in.
Collection of Marguerite and Robert Hoffman

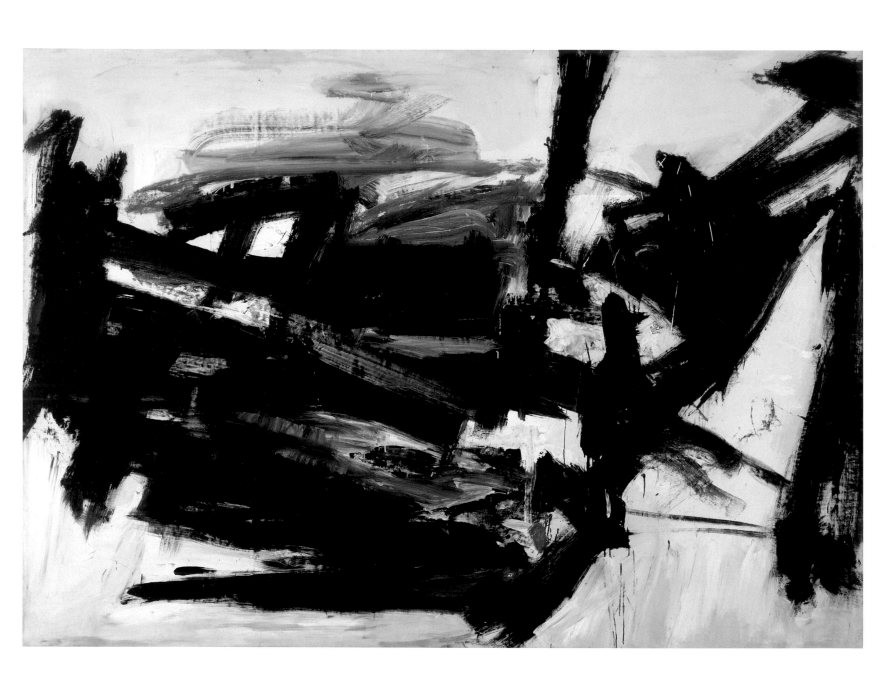

FRANZ KLINE, *Lehigh*, 1956
Oil on canvas, 81⅛ × 113½ in.
Collection of Marguerite and Robert Hoffman

FRANZ KLINE, *Slate Cross*, 1961
Oil on canvas, 111¼ × 79¼ in.
Dallas Museum of Art, gift of Mr. and Mrs. Algur H. Meadows
and the Meadows Foundation, Incorporated, 1968

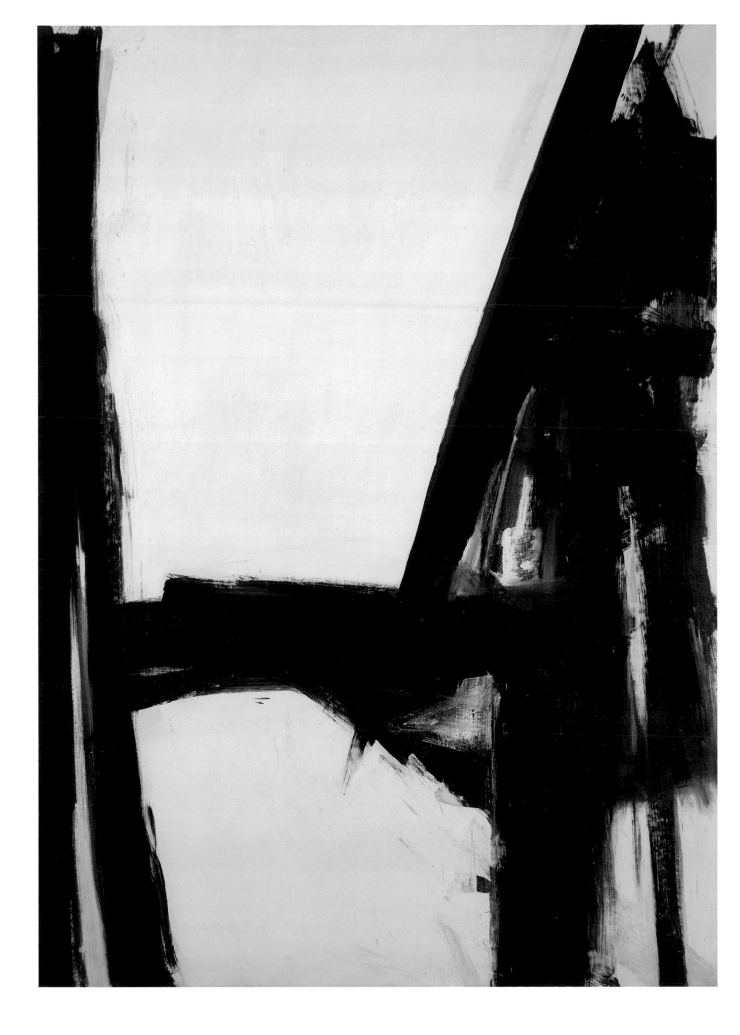

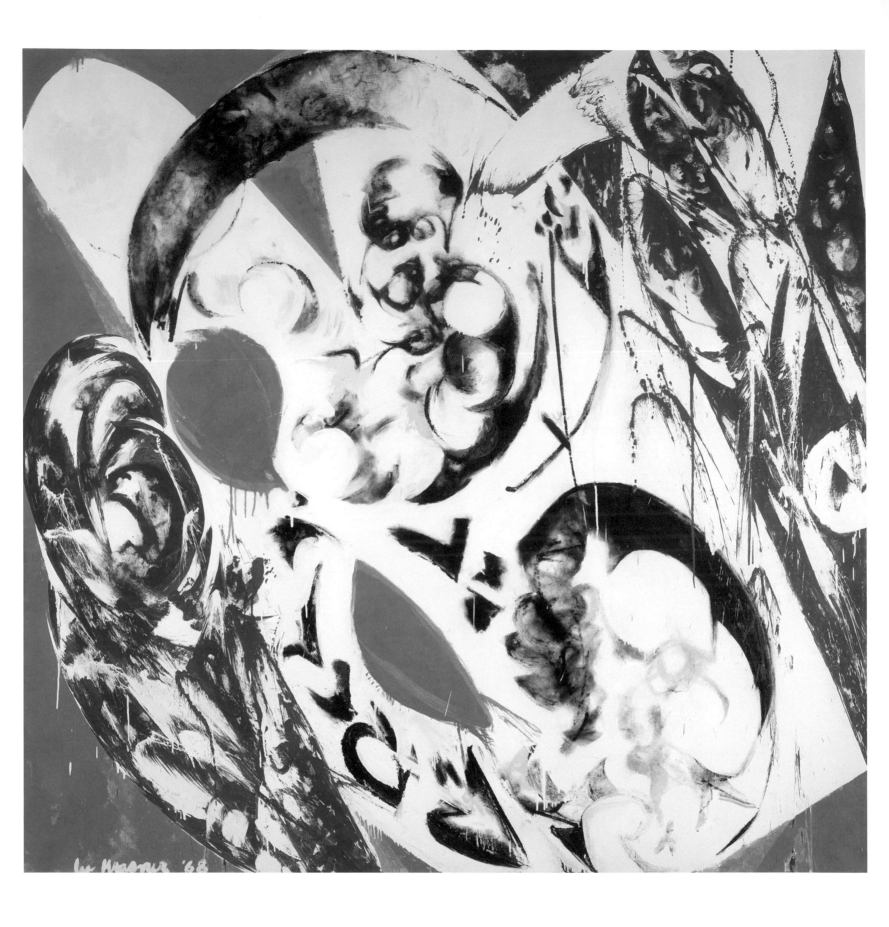

LEE KRASNER, *Pollination*, 1968
Oil on canvas, 81¼ × 83 in.
Dallas Museum of Art, gift of Mr. and Mrs. Algur H. Meadows
and the Meadows Foundation, Incorporated, 1968

JAMES BROOKS, *K-1952*, 1952
Oil on canvas, 81¼ × 71⅞ in.
Dallas Museum of Art, gift of Charlotte Park Brooks, 2005

MYRON STOUT, *Untitled*, 1950
Oil on canvas, $35\frac{3}{4} \times 17\frac{3}{4}$ in.
Dallas Museum of Art, General Acquisitions Fund, 2003

ARSHILE GORKY, *Untitled*, 1943–1948
Oil on canvas, 54½ × 64½ in.
Dallas Museum of Art, Dallas Art Association Purchase,
Contemporary Arts Council Fund, 1965

CLYFFORD STILL, *Untitled*, 1964
Oil on canvas, 92 × 68¾ in.
Dallas Museum of Art, gift of the Meadows Foundation,
Incorporated, 1981

SAM FRANCIS, *Untitled (Black Clouds)*, 1952
Oil on canvas, 77½ × 59½ in.
Dallas Museum of Art, gift of Mr. and Mrs. Algur H. Meadows
and the Meadows Foundation, Incorporated, by exchange, 1985

PHILIP GUSTON, *Summer*, 1954
Oil on canvas, 63 × 60¼ in.
Collection of Marguerite and Robert Hoffman

PHILIP GUSTON, *Studio Landscape*, 1975
Oil on canvas, 67 × 104 in.
Collection of Marguerite and Robert Hoffman

ROBERT MOTHERWELL, *Elegy to the Spanish Republic 108
(The Barcelona Elegy)*, 1966
Oil and acrylic on canvas, 84 × 147 in.
Dallas Museum of Art, The Art Museum League Fund, 1967

MORRIS LOUIS, *Broad Turning*, 1958
Acrylic on canvas, 90½ × 151¼ in.
Dallas Museum of Art, gift of Mr. and Mrs. Algur H. Meadows
and the Meadows Foundation, Incorporated, 1971

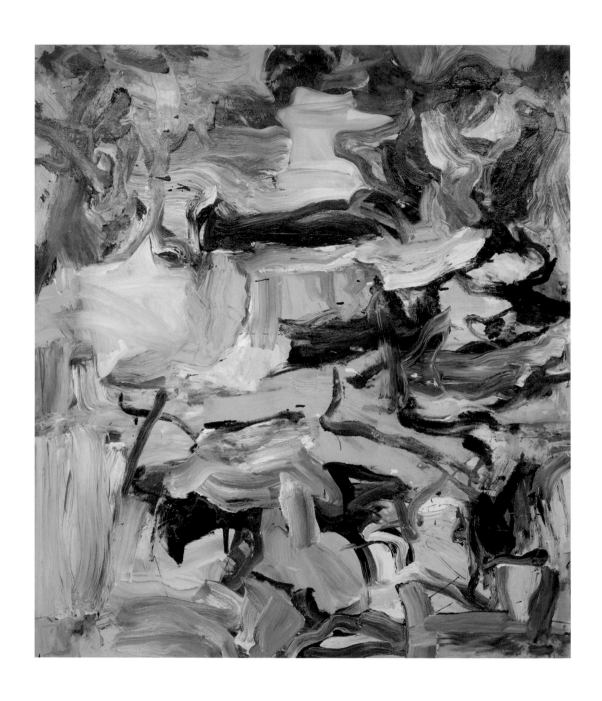

WILLEM DE KOONING, *Untitled III*, c. 1977
Oil on canvas, 88 × 77 in.
Collection of Marguerite and Robert Hoffman

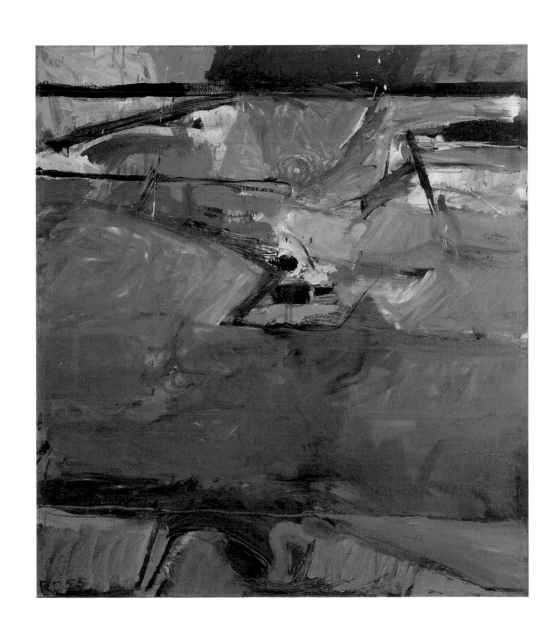

RICHARD DIEBENKORN, *Berkeley No. 31,* 1956
Oil on canvas, $58\frac{3}{4} \times 52\frac{3}{4}$ in.
Collection of Marguerite and Robert Hoffman

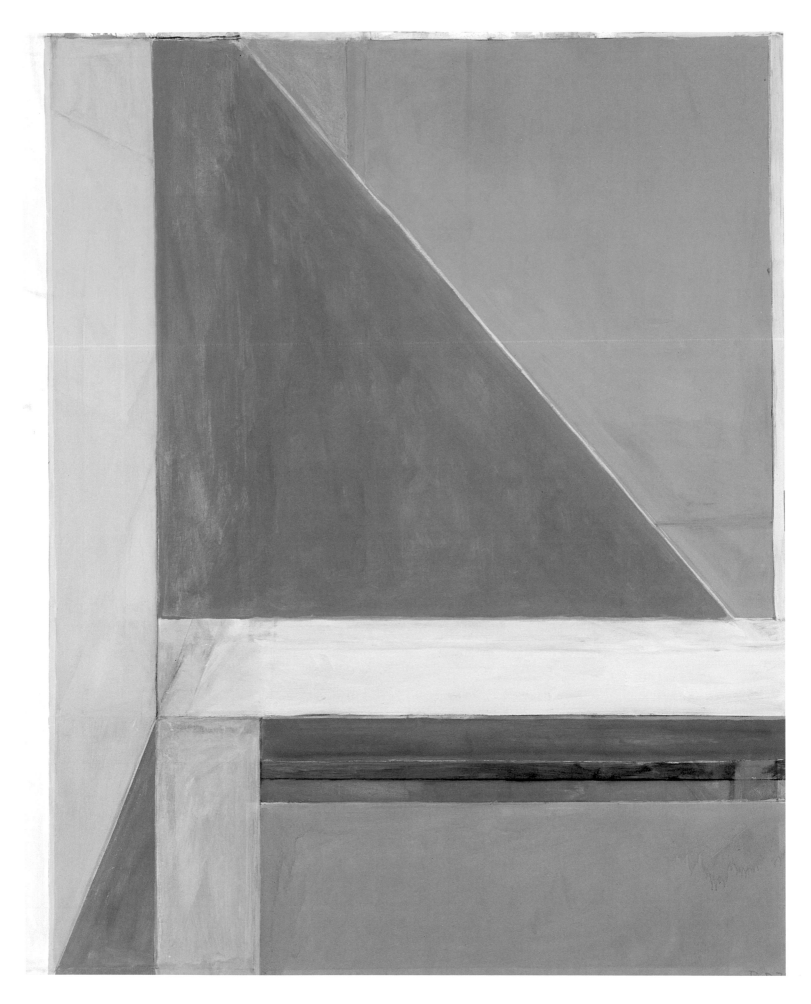

RICHARD DIEBENKORN, *Ocean Park No. 29*, 1970
Oil on canvas, 100⅛ × 81⅛ in.
Dallas Museum of Art, gift of the Meadows Foundation,
Incorporated, 1981

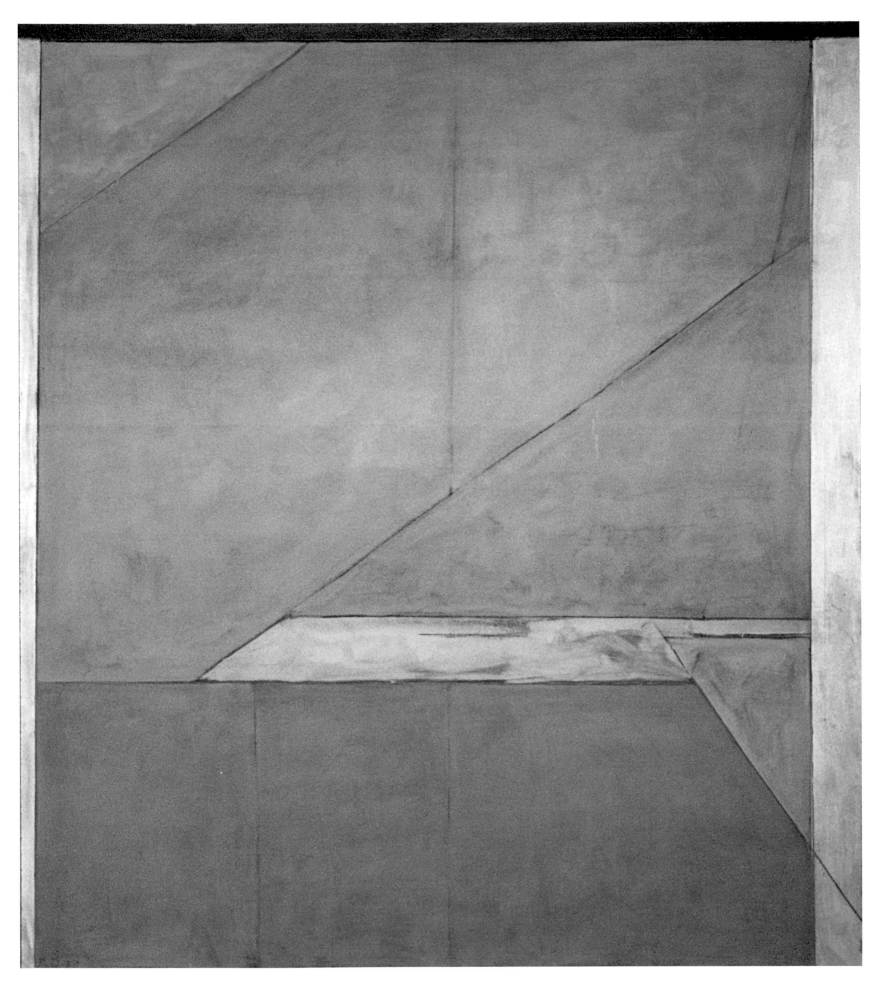

RICHARD DIEBENKORN, *Ocean Park No. 113*, 1979
Oil on canvas, 100 × 93 in.
Collection of Marguerite and Robert Hoffman

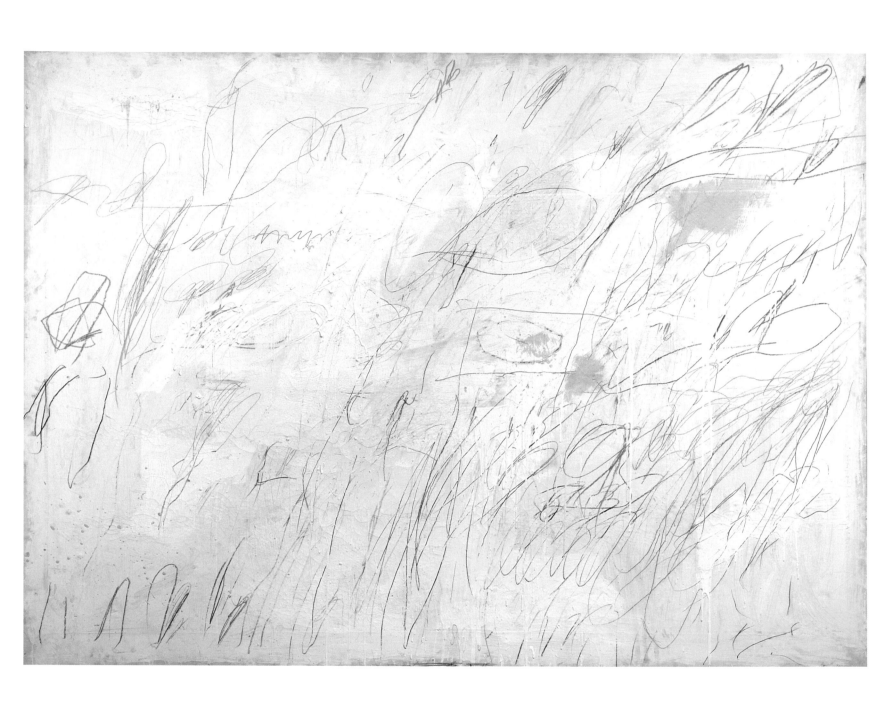

CY TWOMBLY, *Sunset*, 1957
Oil-based house paint, wax crayon, colored pencil, and lead pencil
on canvas, 56⅛ × 76⅜ in.
Collection of Marguerite and Robert Hoffman

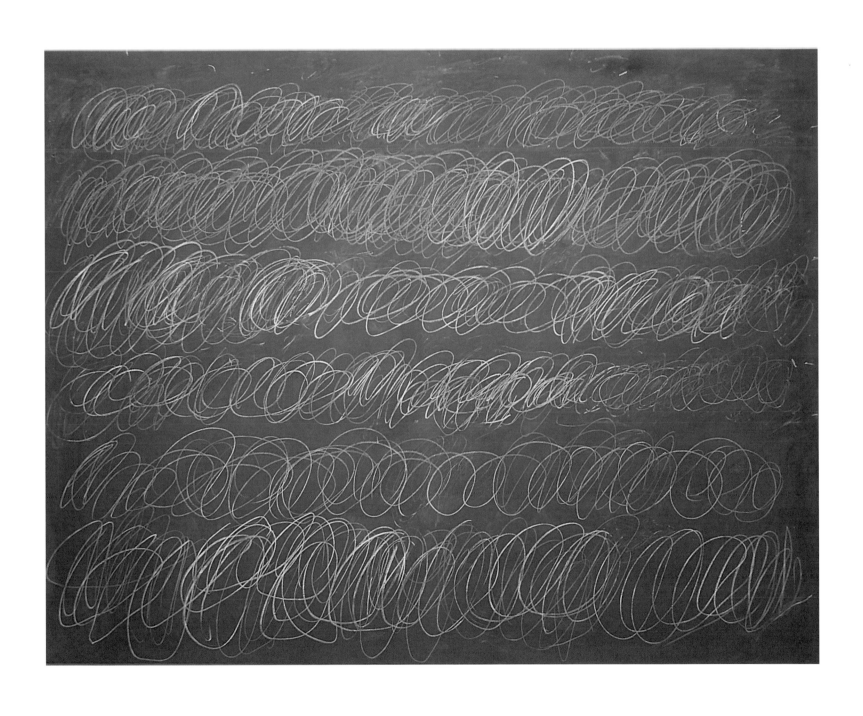

CY TWOMBLY, *Cold Stream*, 1966
Oil-based house paint and wax crayon on canvas,
78¾ × 99¼ in.
Collection of Marguerite and Robert Hoffman

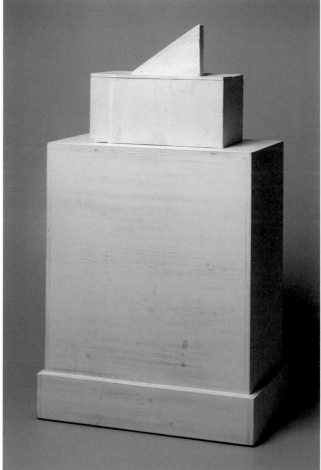

CY TWOMBLY, *Untitled*, 1959
Painted resin, 21⅝ × 14¼ × 14¼ in., base: 38 × 17¼ × 17¼ in.
Collection of Marguerite and Robert Hoffman

CY TWOMBLY, *Untitled*, 1981
Painted synthetic resin, 15½ × 18⅛ × 9½ in.
Deedie and Rusty Rose

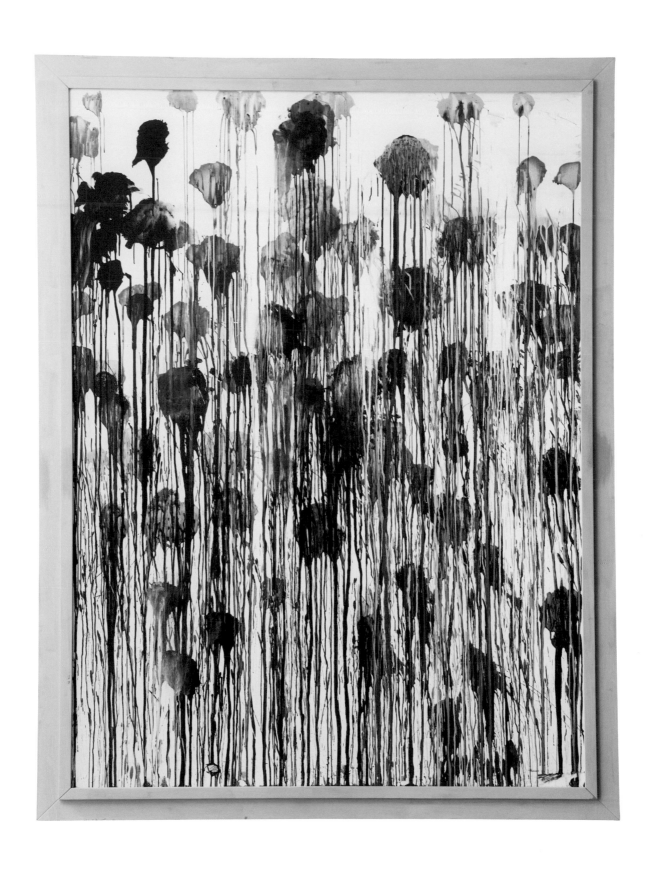

CY TWOMBLY, *Untitled*, 2004
House paint on wooden panel in artist's frame, 108½ × 82½ in.
Collection of Marguerite and Robert Hoffman

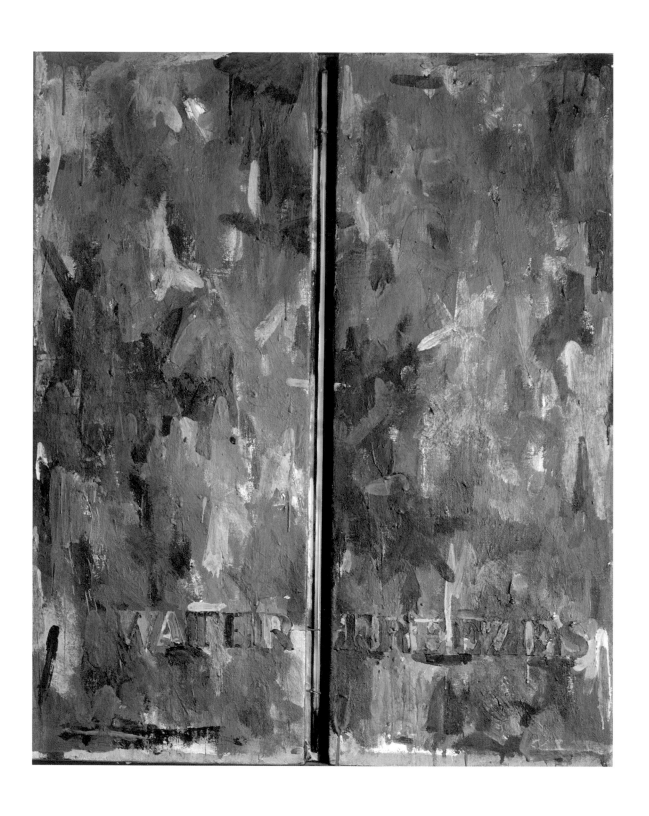

JASPER JOHNS, *Water Freezes*, 1961
Encaustic and paper collage on canvas, with thermometer
and nails, 31 × 25¼ in.
Collection of Marguerite and Robert Hoffman

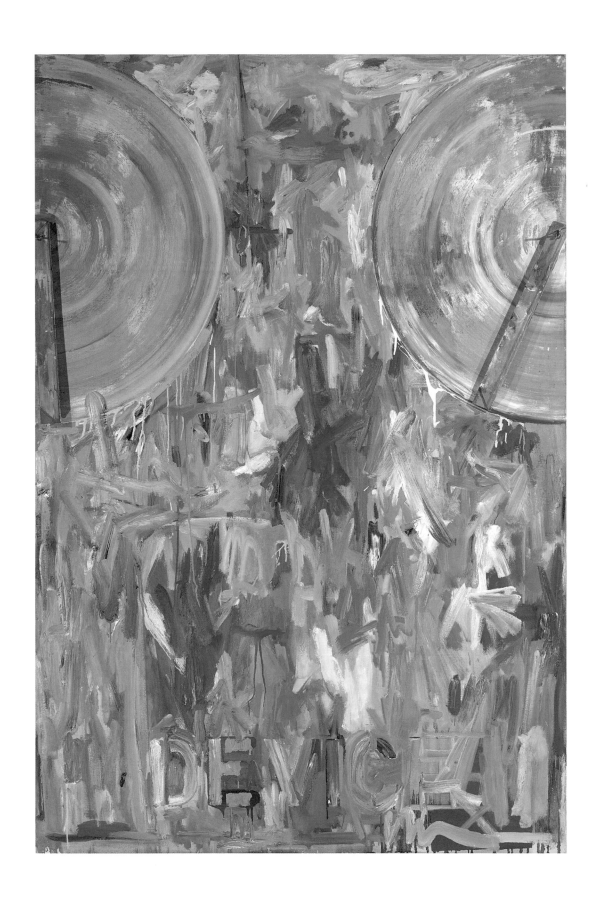

JASPER JOHNS, *Device*, 1961–1962
Oil on canvas with wood and metal attachments, 72⅛ × 48¾ × 4½ in.
Dallas Museum of Art, gift of The Art Museum League,
Margaret J. and George V. Charlton, Mr. and Mrs. James B. Francis,
Dr. and Mrs. Ralph Greenlee Jr., Mr. and Mrs. James H. W. Jacks,
Mr. and Mrs. Irvin L. Levy, Mrs. John W. O'Boyle, and Dr. Joanne Stroud
in honor of Mrs. Eugene McDermott, 1976

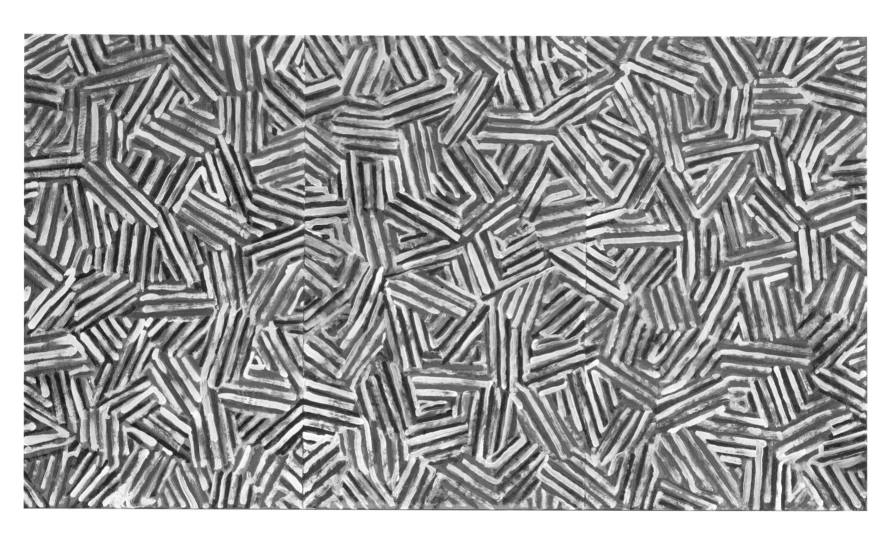

JASPER JOHNS, *Untitled*, 1980
Acrylic on plastic on canvas, $30\frac{3}{8} \times 54\frac{3}{8}$ in.
Collection of Marguerite and Robert Hoffman

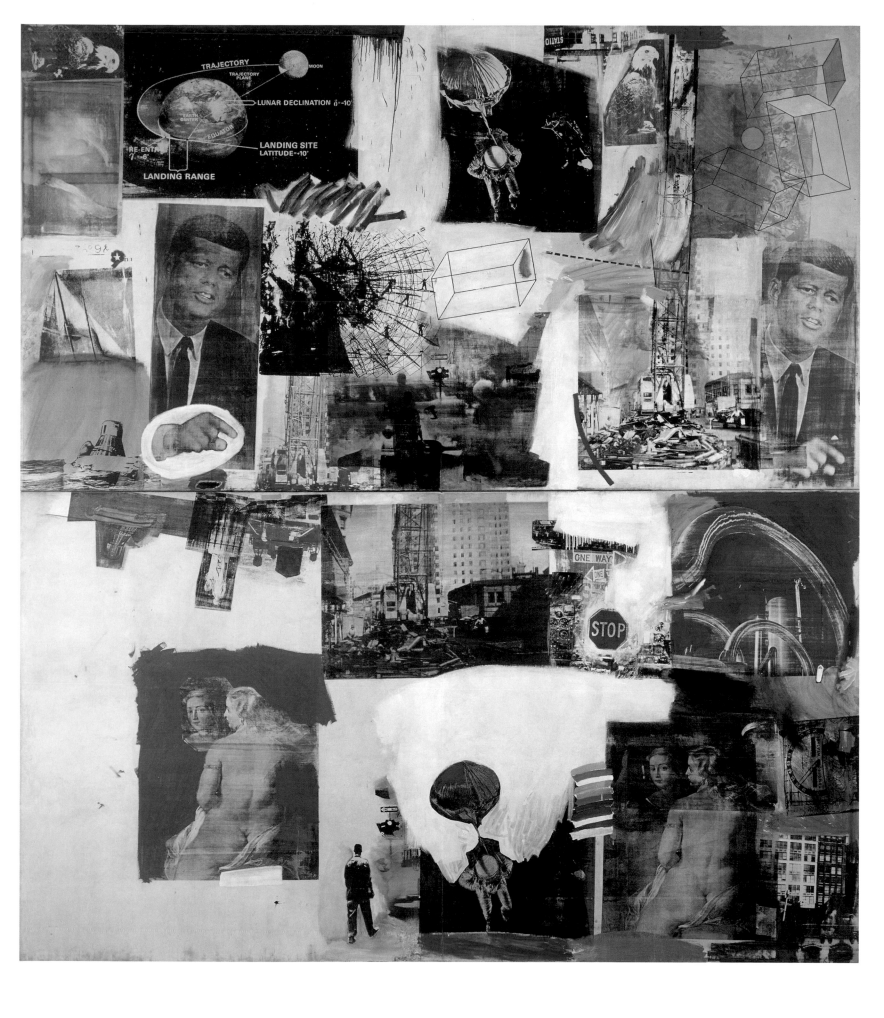

ROBERT RAUSCHENBERG, *Skyway*, 1964
Oil and silkscreen on canvas, 216 × 192 in.
Dallas Museum of Art, The Roberta Coke Camp Fund, The 500, Inc.,
Mr. and Mrs. Mark Shepherd Jr., and the General Acquisitions Fund,
1986

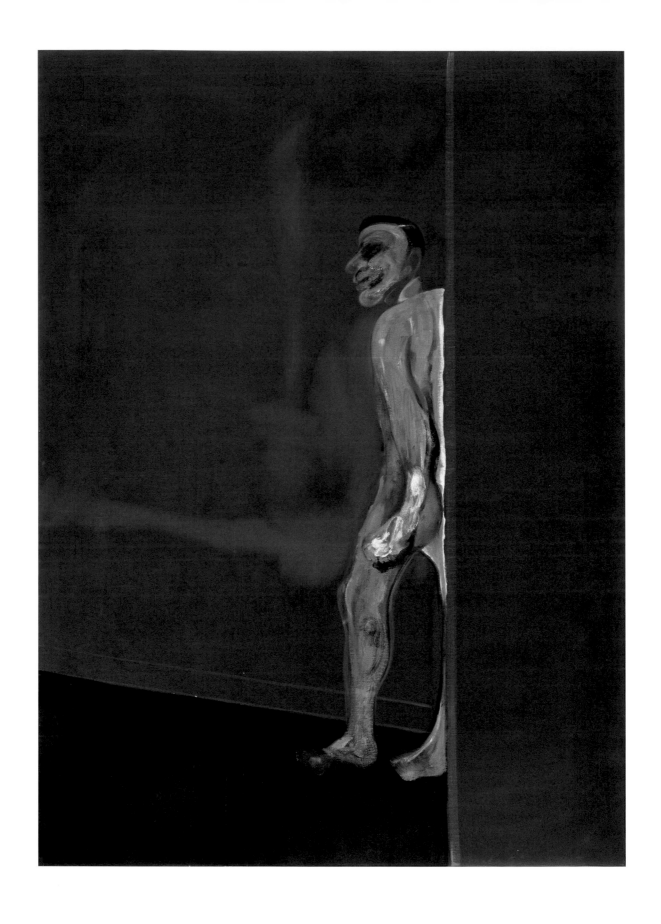

FRANCIS BACON, *Walking Figure*, 1959–1960
Oil on canvas, 78 × 56 in.
Dallas Museum of Art, Foundation for the Arts Collection, gift
of Mr. and Mrs. J. O. Lambert Jr. and Mr. and Mrs. David Garrison, 1963

LUCIAN FREUD, *Large Interior, Notting Hill*, 1998
Oil on canvas, 84 3/4 × 66 1/2 in.
Collection of Marguerite and Robert Hoffman

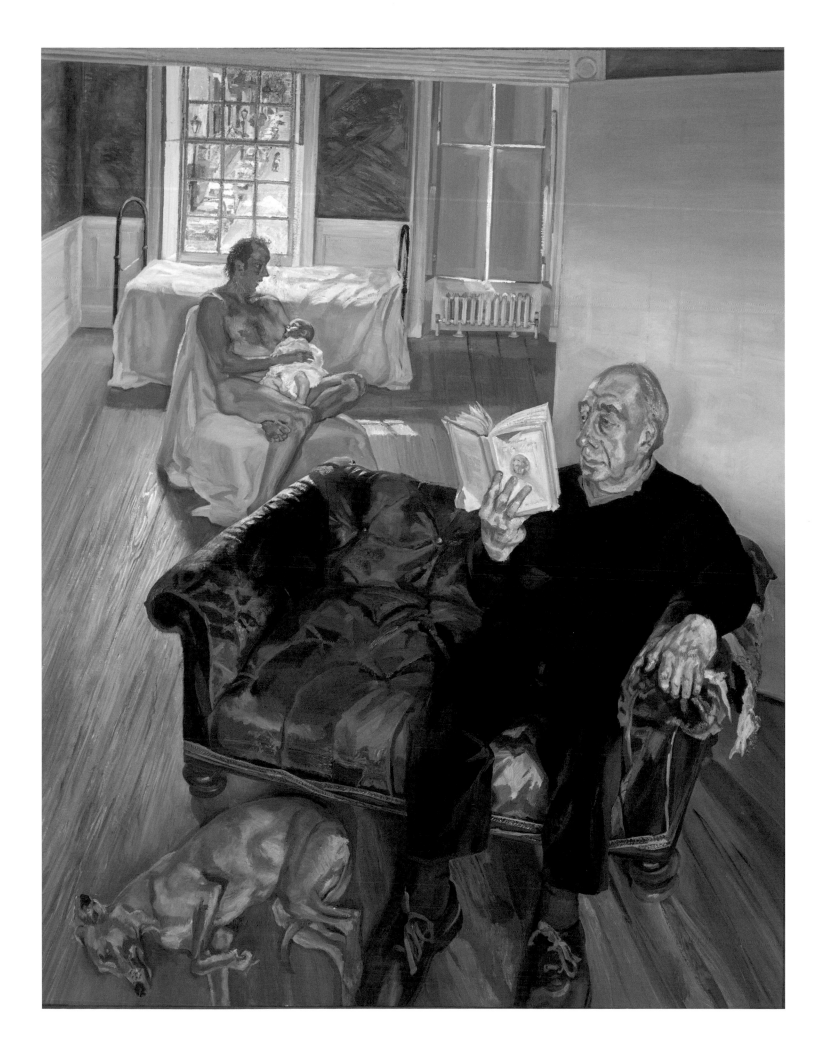

Frances Colpitt

The Apogee of Abstraction

IN A FAMOUS DIAGRAM, originally appearing on the cover of the catalogue for his groundbreaking exhibition, *Cubism and Abstract Art,* Alfred Barr outlined a dialectic responsible for the progress of modern art. His Rube Goldberg–like maze of lines and arrows identifies Vincent van Gogh and Paul Gauguin as the source of what he called "Non-Geometrical Abstract Art" and Paul Cézanne and Georges Seurat as the fathers of "Geometrical Abstract Art." Many twentieth-century artists, he observed, "were driven to abandon the imitation of natural appearance. 'Abstract' is the term most frequently used to describe the more extreme effects of this impulse away from nature."[1] As early as 1936, Barr detected a particularly fertile tradition, one that will be especially well represented in the enhanced collections of the Dallas Museum of Art. The addition of major early works by artists such as Agnes Martin, Frank Stella, Robert Ryman, Bruce Nauman, and Richard Serra reinforces the historical significance of the bequests.

In minimal art of the 1960s, the tradition of geometric abstraction reached its apogee. More than a style, minimal art represents a philosophical position that is committed to the self-sufficient materiality of artworks, rather than to narrative or metaphysical possibilities. Compositions are typically serial or repetitive, described by Donald Judd as "one thing after another," sometimes mathematical, but rarely characterized by traditional forms of balance. Minimal art's simple, regular forms, industrial or other plainspoken materials, and human scale appeal to the body of the viewer as much as to the eye. Often enhanced by a richness of color or conceptual complexity, these abstract works of art are exhilaratingly real.

Because of their hard-edge styles and use of the grid as a system of order, four major precursors, Ellsworth Kelly, Agnes Martin, Tony Smith, and Anne Truitt, were often included in exhibitions of minimal art. Kelly is a member of the last generation of American artists who considered study in Paris an essential education. Living in France from 1948 to 1954, he developed a form of abstraction based on direct observation and was drawn in particular to architectural elements such as windows and bridges. According to his friend Anne

1. Alfred H. Barr Jr., *Cubism and Abstract Art,* exh. cat. (New York: Museum of Modern Art, 1936), 11.

Weber, *Sanary* (1952) was inspired by "the bright light and color of Sanary," a resort town on the Côte d'Azur, where the artist spent the winter and spring of 1951–1952.[2] With the exception of the placement of the darker ones in three vertical rows, the colored squares in *Sanary* were arbitrarily arranged. In other works he used the color spectrum to avoid idiosyncratic or potentially self-expressive forms of composition.

Many of Kelly's works in the DMA and Hoffman collections use a gentle, attenuated curve, which entered his vocabulary in 1968. It is related to his interest in the arches of bridges, especially those over the Seine, but also, as E. C. Goossen pointed out, to the then-new Gemini photographs of the "earth's circumferential horizon."[3] The Museum's curved and folded sculpture from 1983 evolved from Kelly's earliest sculptural effort, *Pony* (1959). While visiting with his neighbor, Agnes Martin, Kelly bent the lid of a tin can and let it rock on the table. Martin "suggested that he 'make that.'"[4]

The gift of Martin's paintings fills a major void in the DMA's collection of postwar American art. All of her works are based on the grid, which not only suppresses the expressive ego—drawing attention to the artwork rather than to the artist—but also reinforces the abstractness of the painting. Although Martin conscientiously refused to represent nature, she was inspired by it: "When I first made the grid I happened to be thinking of the innocence of trees and then a grid came into my mind and I thought it represented innocence, and I still do, and so I painted it and then I was satisfied."[5] Two of the Museum's bequests date from 1960, the year she discovered the grid. Martin's work is distinguished by pale colors and a delicate pencil line that moves resolutely across the bumpy, woven texture of the canvas. "Thus the grid, though tight," Lawrence Alloway observed, "does not close the surface, but establishes an open plane … to suggest, for all its regularity, a veil, a shadow, a bloom."[6]

An exact contemporary of Martin and his friend Jackson Pollock (all three were born in 1912), Tony Smith was originally an architect with an interest in modular structures. From the 1930s through the 1950s, he painted quietly and without exhibiting his work. An important early example is *Untitled* (1934–1935), an architectonic painting composed of square and rectangular forms resembling building blocks. Influenced by Jay Hambidge's book, *The Elements of Dynamic Symmetry* (1919), which identified the source of dynamic symmetry in combinations of the five regular geometric solids, Smith began to make sculpture in 1960. According to Sam Hunter, Smith "settled on the components of the tetrahedra and octahedra in the mid-sixties when he made *Willy*," named after a character in a play by Samuel Beckett.[7] Before enlarging his sculptures in metal, Smith would arrange and rearrange four-sided and eight-sided cardboard modules until he arrived at a configuration that could convey the strong emotional presence he sought.

2. E. C. Goossen, *Ellsworth Kelly* (New York: Museum of Modern Art, 1973), 46.

3. Ibid., 92.

4. Ibid., 67.

5. Lilly Wei, "The Eternal Joy of an Attentive Mind," *Art in America* 93 (March 2005): 104.

6. Lawrence Alloway, *Agnes Martin*, exh. cat. (Philadelphia: Institute of Contemporary Art, University of Pennsylvania, 1973), 9.

7. Sam Hunter, *Tony Smith*, exh. cat. (New York: Pace Gallery, 1979), 5–7.

8. Jane Livingston, *Anne Truitt: Sculpture, 1961–1991*, exh. cat. (New York: André Emmerich Gallery, 1991), n. p.

9. William Rubin, *Frank Stella*, exh. cat. (New York: Museum of Modern Art, 1970), 16.

10. Bruce Glaser, "Questions to Stella and Judd," in *Minimal Art: A Critical Anthology*, ed. Gregory Battcock (New York: Dutton, 1968), 149.

Anne Truitt was after a similar quality of serenely commanding presence, although she was primarily interested in color. "What I want is color in three dimensions, color set free, to a point where, theoretically, the support should dissolve into pure color." With blocks of dark red seemingly suspended in a lighter red frame, "*Valley Forge*, of 1963, was made out of an interest," Truitt told Jane Livingston, "in 'cantilevering' color."[8] Despite the fact that her sculptures were actually painted in deep earth tones, Truitt was included in *Black, White, and Gray*, an exhibition organized by Samuel Wagstaff Jr. at the Wadsworth Atheneum in 1964. Signaling the ascendancy of minimal art, the exhibition brought together the works of several generations of artists, including Smith, Kelly, and Martin, and Stella, Robert Morris, and Dan Flavin. It was reviewed at length in *Arts Magazine* by Judd, whose work was not included. By this time, the effect of Stella's Black and Aluminum paintings, from 1959 and 1960 respectively, had spread throughout the New York art world. Inspired by Johns's flag paintings, which he had seen at the Leo Castelli Gallery in 1958, Stella began a series of box-and-stripe paintings using inexpensive housepainter's tints and black enamel. "When he 'got into trouble' with the color," reported William Rubin, "he simply overpainted the problematic areas in black."[9] Eschewing the kind of relational balance typical of modern European painting, Stella explained that younger American artists "strive to get the thing in the middle, and symmetrical.… The balance factor isn't important. We're not trying to jockey everything around."[10] To coincide with their patterns of diagonal stripes, the metallic Valparaiso paintings of 1963 are shaped in the form of trapezoids and parallelograms and the monumental canvases of the Protractor series are limned with wide curved stripes in fluorescent and other bright hues. Since the Protractors, Stella has pursued progressively more baroque compositions, substituting dynamic three-dimensionality for the modernist emphasis on flatness in painting. With the bequests, Stella's influential oeuvre will be comprehensively represented in the collection.

The Museum will also become a major repository of works by Judd, one of the twentieth century's great artists and, for many years, a resident of west Texas. Originally a painter, Judd began producing three-dimensional works, which he referred to as "specific objects," in 1963. Unlike traditional sculpture, his objects are not representational or referential. Originating in sheet form, his industrial materials, such as galvanized iron or the fluorescent Plexiglas of *Untitled* (1965), are specific and undisguised. Like Stella, Judd was adamantly opposed to relational composition and turned to symmetry, repetition, and mathematical progressions to determine the structure of his objects. The widths of the purple boxes supporting the square tube of *Untitled* (1970), for instance, are based on a Fibonacci progression (each unit in the progression is the sum of the two preceding units). Since Judd's death in 1994, critical emphasis has been redirected to his passion for color, frequently applied through the process of anodization, an electrolytic procedure that fuses color to aluminum.

The DMA's strong collection of minimal art includes major examples by Flavin and Morris. An important early sculpture by Carl Andre, *Pyramid (Square Plan)* (1959, remade 1970), reveals his interest in the repeated modules of Constantin Brancusi and the symmetrical stripe patterns of Stella, with whom he shared a studio. Describing his floor pieces, some of which can be walked on, Andre explained, "All I'm doing … is putting Brancusi's *Endless Column* on the ground."[11] This comment is literalized in *41 Endful Column* of 2000.

11. David Bourdon, "The Razed Sites of Carl Andre," in Battcock, *Minimal Art*, 104.

As the concrete objecthood of sculpture began to dematerialize in the late 1960s, many artists sought alternative forms of expression. Fred Sandback's stretched yarn sculptures, represented by a 1989 drawing as well as by a sculpture in the Rose collection, outline large geometric volumes in space. Alex Hay's drawings from 1968 relate to his career as a performance artist in the 1960s. Sol LeWitt supplemented his modular cube structures, which were begun in 1965, with wall drawings in the 1970s. The addition of LeWitt's *Wall Drawing #310* (1978) to the Museum's collection will provide visitors with a historical precedent for the more playful and decorative wall drawing that presently graces the Barrel Vault. Recalling the modular structures of LeWitt and Tony Smith, Robert Smithson's *Ziggurat* (1966) is derived from his interest in crystalline structures and complements the Museum's beautiful *Mirrors and Shelly Sand* (1969–1970), an indoor earthwork involving the displacement of crystalline grains of sand from a beach to the Museum.

Michael Heizer's large geometric abstractions on shaped canvases have a reciprocal relationship to his earthworks. Referring to his paintings from the 1960s, he said: "The physicality of the paintings had grown to the point where they had become sculptural. They had become diagrams of dimension. Two of these paintings gave me the basis for my first underground sculpture,"[12] *North*, dug into the Sierra Nevada in 1967. The geometric shapes of *North, East, South,* and *West*—cone, truncated cone, prism, and cube—provide the model for the negative cuts into the circumference of his painting, *Untitled #2* (1975).

12. Julia Brown, "Interview," in *Michael Heizer: Sculpture in Reverse*, exh. cat. (Los Angeles: Museum of Contemporary Art, 1984), 8.

The key figures of minimal painting are Brice Marden, Robert Ryman, Robert Mangold, and David Novros, who represent the last great period of abstraction in the twentieth century. Following a series of encaustic monochromes in the 1960s, Marden worked with multiple panels, separating his colors by actual divisions of the surface rather than by drawn lines. For many years, Marden lived part-time in Greece, which led to a group of paintings inspired by silvery green olive groves, such as *To Corfu* (1976). In 1987, Marden shocked the art world with what seemed to be a complete rejection of his previously minimal style. After traveling in Asia and studying Chinese poetry and calligraphy, he developed a new gestural form of brushwork that led to fluid, confident, yet still abstract, paintings such as *Red Rocks (2)* (2000–2002).

With ten major paintings, Ryman's work will be extensively represented in the collection. For more than forty years, he has reveled in the textural, coloristic, and viscous versatility of white paint. In *Untitled* (1962), a small grid of pencil lines in the lower right corner of a large raw linen canvas serves as an armature for a patch of green nearly hidden by squiggles of white paint. Ryman can be seen pursuing the same idea, now with a more holistic, nonrelational approach to composition and a mature, graceful style, in *Document* and *Lift* (both 2002), with masses of white paint floating over green or burnt sienna grounds. The variety of Ryman's brushwork and supports contributes to the sense of weight, temperature, atmosphere, and presence in his painting.

With his reputation as a painter's painter, Harvey Quaytman's abstractions were admired for their independence from prevailing trends. A conceptual approach to abstraction is seen in Jo Baer's elegant white paintings with crisp black framing edges and in the French artist Roman Opalka's white number paintings, produced daily to record the passage of time. Eleven years into the project, which will be concluded at the artist's death, he painted *1965/1-Infinity: Detail 3039180–3047372*.

13. Sol LeWitt, "Paragraphs on Conceptual Art," in *Conceptual Art: A Critical Anthology*, ed. Alexander Alberro and Blake Stimson (Cambridge, Mass.: MIT Press, 1999), 12.

For the conceptual artist, "the idea becomes a machine that makes the art."[13] A classic example of conceptual art, Joseph Kosuth's *One and Three Chairs* (1965) includes an actual chair, a photograph of the chair, and a dictionary definition of the word *chair*. Posing a question about chairness (a standard example used by philosophers in the investigation of essences), the work provides three forms of knowledge: material, imagistic, and linguistic. Working solely in the form of language, Lawrence Weiner presents statements about materials, such as *(HEAT) WATER + CLAY* (1991), that may or may not have material existence. Mary Kelly's *Primapara (Bathing series)* and Dan Graham's *Homes for America* represent key moments in conceptual art: Kelly's in its fusion of feminism and conceptualism (the grid of photographs represents the first bath of the artist's son, whose childhood served as the focal point of her seminal *Post-Partum Document*, 1973–1979), and Graham's in its immateriality (*Homes* originally took the form of a slide presentation and a magazine article).

14. Jeanne Siegel, "John Baldessari: Recalling Ideas," *Art Talk: The Early 80s*, ed. Jeanne Siegel (New York: Da Capo Press, 1988), 39.

Rejecting painting as "an elitist language," John Baldessari recalled, "I thought most people do read newspapers and magazines, look at images in books and TV, and I said this is the way I'm going to speak, be more populist in my approach."[14] A similar interest in words and pictures drew Ed Ruscha to the format of the book. His deadpan photographs record the mesmerizing sameness of commercial and residential architecture in Los Angeles. Page after page, the structures of his books echo Judd's "one thing after another," and, as Peter Plagens observed, "the photographs in them are *specific*, homely and accurate."[15]

15. Peter Plagens, "Ed Ruscha, Seriously," in *The Works of Ed Ruscha*, exh. cat. (New York: Hudson Hills in association with San Francisco Museum of Modern Art, 1982), 35. Italics mine.

With twenty-two works in the permanent collection, Vija Celmins will be especially well represented. In 1968, Celmins began using her own photographs of the Pacific Ocean, taken

from the Venice Pier near her studio, as source materials for drawings such as *Untitled (Ocean)*. She stresses the fact that her water drawings are not realistic images but pictures of photographs. "Making art, for me, is much more abstract," she said, "which is what I always want to bring it back to."[16] Indeed, the space in these drawings is at once deep, as the size of the waves decreases toward the top of the drawing, and flat, creating an allover rippling pattern on the surface. Inspired by satellite photographs, her galaxy paintings and drawings have smooth shimmering surfaces, enhancing their dusky light. The drawings of tiny stars in dense black space are produced by leaving empty spaces where the white acrylic ground is visible. Providing Celmins with another form of spatial ambiguity and allover design, the linear patterns of spider webs are ideal subjects for photogravure and mezzotint prints.

16. "Vija Celmins Interviewed by Chuck Close," *Vija Celmins*, ed. William S. Bartman (New York: A.R.T. Press, 1992), 38.

With a grisaille palette that mimics his photographic sources, Richard Artschwager draws the imagery for his paintings on Celotex, a low-budget wall covering, of images from upscale interior decorating magazines. His sculptures are also inspired by furniture. *Swivel* (1964), for example, resembles a pared down, nonfunctional swivel chair. Its simple geometric forms and industrial materials recall those used by minimal artists.

Eccentric Abstraction, organized by the critic Lucy Lippard at the Fischbach Gallery in New York in 1966, signaled a reaction against the hard-edge rigor of minimalism and ushered in a much more variable and fluid postminimalism. Among the seven artists represented were Eva Hesse, Louise Bourgeois, and the much younger Bruce Nauman, fresh from the University of California in Davis, where his graduate work consisted of quirky fiberglass sculptures such as *Untitled* (1965). Nauman's career has never been driven by medium; he uses whatever form or material is best suited to convey his ideas. His works in neon, for example, draw on the association with textual signage. Video allows for sounds and pictures to unfold temporally. *Setting a Good Corner (Allegory and Metaphor)* of 1999 shows Nauman digging a posthole on his ranch in New Mexico, a task that determined the length of the video tape. *Good Boy/Bad Boy* (1985) explores the issue of time and language through the use of two actors who read aloud the same texts at different speeds.

Typically small, fragile, and playfully crafted, Richard Tuttle's work is made by hand from unassuming scraps of material. Although his work is everything that minimal art is not, he recalls admiring Agnes Martin's paintings in *Black, White, and Gray* in 1964.[17] With Martin-like delicacy, *Sail* (1964) and *Equals* (1964–1965) were constructed that same year. Calling attention to the softness of the support, *Canvas Pale Purple* (1967) is unstretched and sliced. Among his most important works are the wire drawings, which trace nearly invisible shapes on the wall.

17. Michael Auping, *Agnes Martin/Richard Tuttle*, exh. cat. (Fort Worth, Tex.: Modern Art Museum of Fort Worth, 1998), 10.

18. Roberta Smith, *Joel Shapiro*, exh. cat. (New York: Whitney Museum of American Art, 1982), 20.

19. Ibid., 96.

When Joel Shapiro's sculpture was first shown in the early seventies, its most remarkable aspect was a refreshing sense of small scale. As Roberta Smith observed: "Shapiro took the new architectural space of minimalism and dramatized and emotionalized it, giving it some of his childish, lost feelings by shrinking his objects so that no matter how close you got to them, they remained at a distance."[18] Placing many of these tiny works on the floor, Shapiro forced his viewers to experience sculpture in a different way, more consciously engaging the body in the act of perception. Fusing representation with abstraction—"the imagery that attracted me was imagery that had abstract intention,"[19] he explained—Shapiro's house-shaped sculptures explore psychological concerns such as memory and nostalgia.

Also oriented to the human body, Richard Serra's work depends on weight, gravity, and balance. Made from lead antimony, a soft metal that is conducive to being rolled into tubes, his Prop pieces are not welded but rely instead on the equilibrium created by two elements pushing against each other. This delicate sense of balance also characterizes the pitch of the DMA's *Untitled* (1971) and the crushing force of *Zappa* (1995). As Serra's work grows in size and weight, the impact on the viewer's body and his awareness of scale, tension, and potential collapse are intensified.

It is both a big step and a small one from Ellsworth Kelly to Richard Serra, from the graceful curves of *Untitled* (1982–1983) to the hair-trigger tension of *Zappa*. As the collection at the Dallas Museum of Art will reflect, the trajectory of abstraction is one of modernism's strongest.

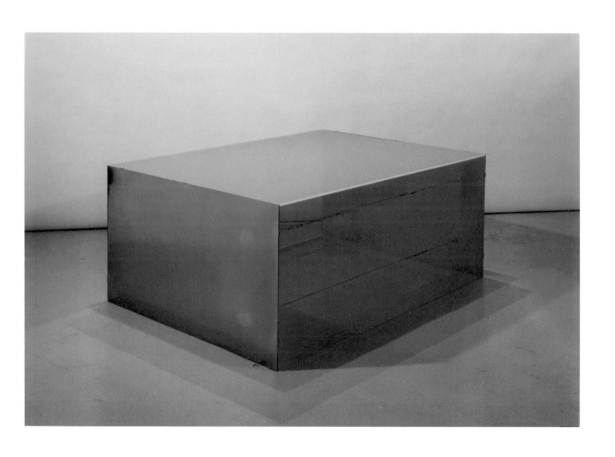

DONALD JUDD, *Untitled*, 1965
Stainless steel and fluorescent Plexiglas, 20 × 48 × 34 in.
The Rachofsky Collection

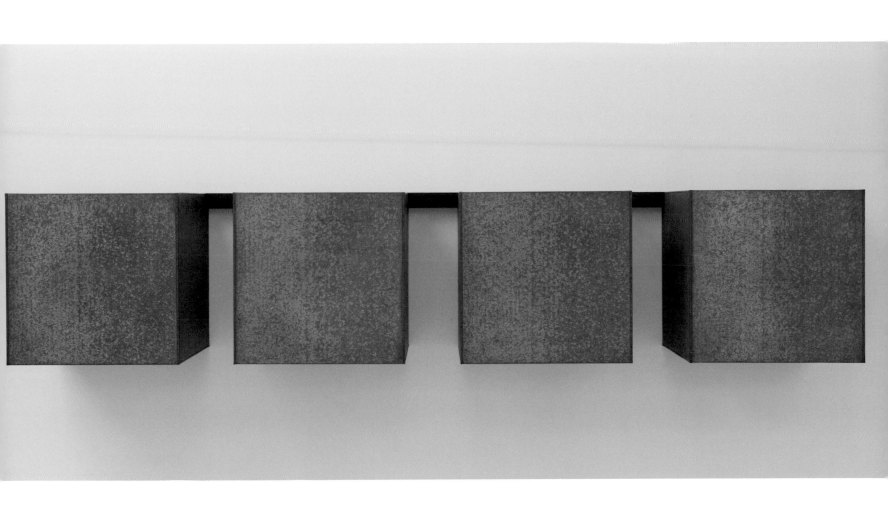

DONALD JUDD, *Untitled*, 1965
Galvanized iron, enamel on aluminum, 30 × 130 × 30 in.
Collection of Marguerite and Robert Hoffman

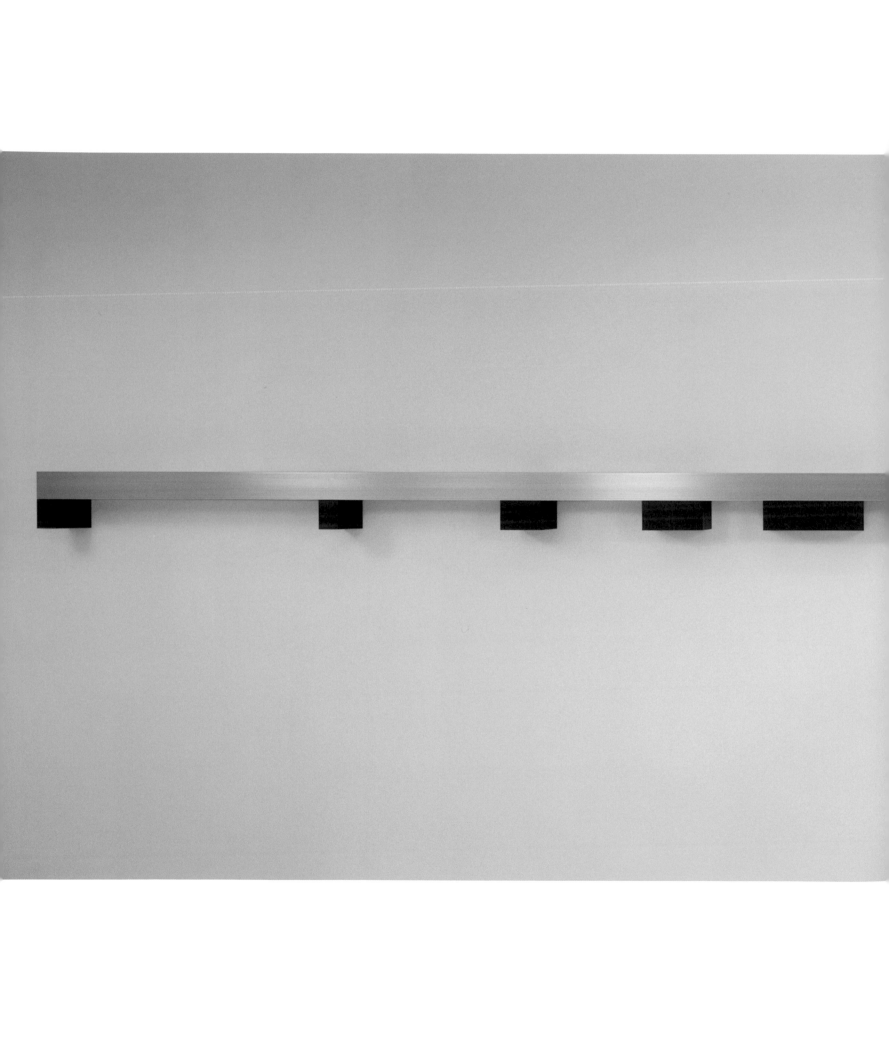

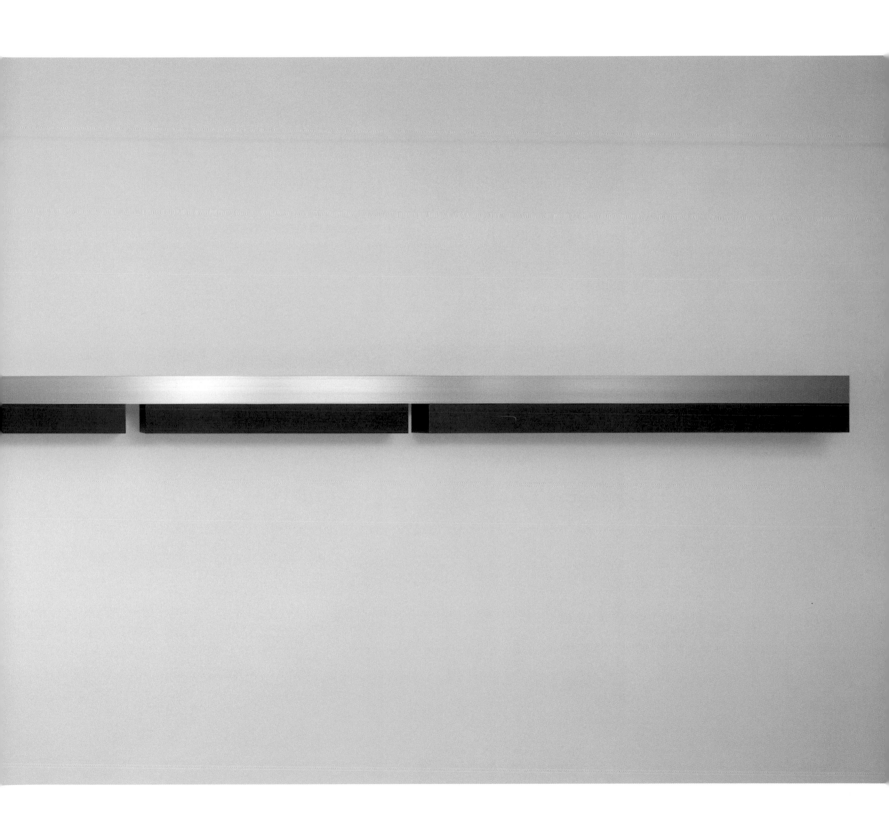

DONALD JUDD, *Untitled*, 1970
Clear and purple anodized aluminum, $8\frac{1}{4} \times 253\frac{3}{8} \times 8\frac{1}{4}$ in.
Dallas Museum of Art, fractional gift of The Rachofsky
Collection, 2001

DONALD JUDD, *Untitled #91–3*, 1991
Red anodized aluminum and gray Plexiglas, overall 118 × 27 × 24 in.
The Rachofsky Collection

DAN FLAVIN, *alternate diagonals of March 2, 1964
(to Don Judd)*, 1964
Fluorescent tubing, 144 × 12 in.
Dallas Museum of Art, gift of Janie C. Lee, 1976

ROBERT MORRIS, *Untitled*, 1965–1966
Fiberglass and fluorescent light, 24 × 14 in., 97 in. diameter
Dallas Museum of Art, General Acquisitions Fund and a matching grant
from the National Endowment for the Arts, 1974

CARL ANDRE, *Pyramid (Square Plan)*, 1959, remade 1970
Wood (fir), $68\frac{7}{8}$ × 31 × 31 in.
Dallas Museum of Art, General Acquisitions Fund and matching
funds from The 500, Inc., 1979

FRANK STELLA, *Valparaiso Green*, 1963
Metallic paint on canvas, 78 × 180 in.
Collection of Marguerite and Robert Hoffman

ANNE TRUITT, *Valley Forge*, 1963
Acrylic on wood, 60½ × 60¼ × 12 in.
The Rachofsky Collection

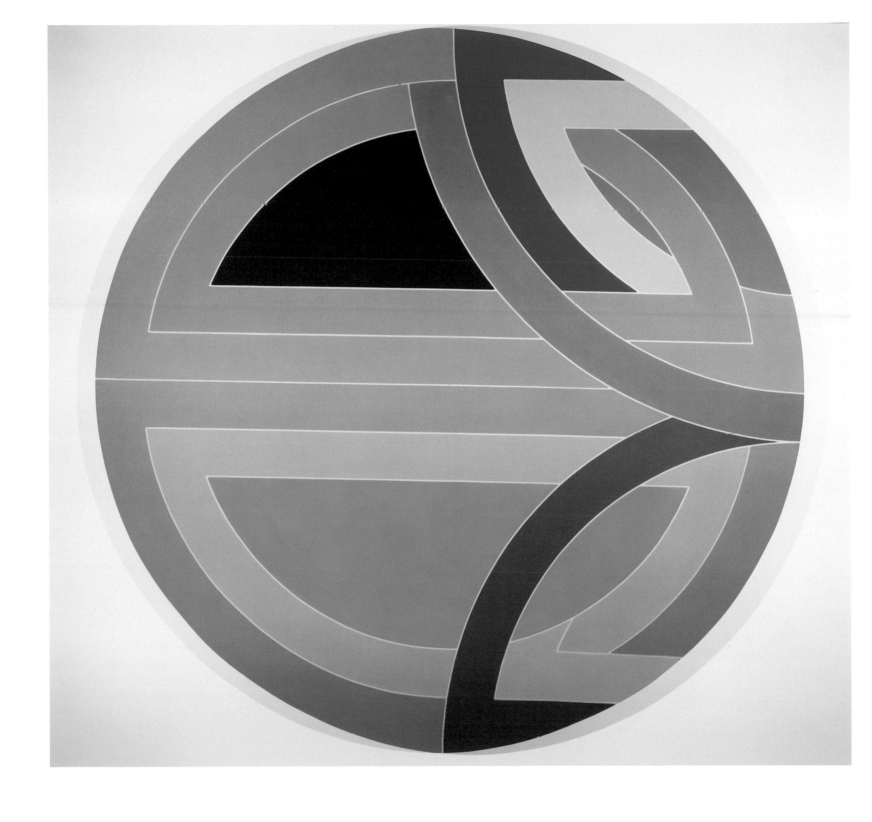

FRANK STELLA, *Sinjerli Variation I*, 1968
Acrylic on canvas, 120 in. diameter
The Rachofsky Collection

MICHAEL HEIZER, *Untitled #2*, 1975
Polyvinyl latex and aluminum powder on canvas, 96 in. diameter
Deedie and Rusty Rose

MICHAEL HEIZER, *Negative Sculpture—Nubia*, 1980
Granite and steel; overall 82 × 85¼ in.
Dallas Museum of Art, gift of Xavier Fourcade in honor
of Patsy and Ray Nasher, 1987

ELLSWORTH KELLY, *Black White*, 1967
Oil on canvas; two joined panels, overall 82 × 144 in.
Collection of Marguerite and Robert Hoffman

ELLSWORTH KELLY, *Wave Motif*, 1959
Oil on canvas, 60 × 94 in.
Collection of Marguerite and Robert Hoffman

ELLSWORTH KELLY, *Sanary*, 1952
Oil on wood, 51½ × 60 in.
Collection of Marguerite and Robert Hoffman, promised
bequest in honor of Dr. John R. Lane

ELLSWORTH KELLY, *Two Grays I*, 1975
Oil on canvas; two joined panels, overall 92 × 102 in.
Collection of Marguerite and Robert Hoffman

AGNES MARTIN, *Untitled VIII*, 1981
Acrylic and pencil on canvas, 72 × 72 in.
Collection of Marguerite and Robert Hoffman

ROBERT MANGOLD, *Four Triangles within a Square*, 1974
Acrylic and pencil on canvas, 72 × 72 in.
Dallas Museum of Art, Foundation for the Arts Collection,
anonymous gift, 1975

ROBERT RYMAN, *Untitled*, 1980–2003
Oil on steel panel with four fasteners, 19 × 19 in.
Collection of Marguerite and Robert Hoffman

ROBERT RYMAN, *Document*, 2002
Oil on canvas, 78 × 78 in.
Promised gift of Gayle and Paul Stoffel to the Dallas
Museum of Art

ROBERT RYMAN, *Series #9 (White)*, 2004
Oil on canvas, 53 × 53 in.
The Rachofsky Collection

SOL LEWITT, *Wall Drawing #398*, 1983–1985
Color ink wash; dimensions variable
Dallas Museum of Art, gift of The 500, Inc., Mr. and Mrs. Michael
J. Collins and Mr. and Mrs. James L. Stephenson Jr., 1985

BRICE MARDEN, *To Corfu*, 1976
Oil and wax on canvas, 84 × 72½ in.
Dallas Museum of Art, Foundation for the Arts Collection,
anonymous gift, 1976

BRICE MARDEN, *Red Rocks (2)*, 2000–2002
Oil on linen, 75 × 107 in.
Collection of Marguerite and Robert Hoffman

LYNDA BENGLIS, *Odalisque (Hey, Hey, Frankenthaler)*, 1969
Poured pigmented latex paint, 165 × 34½ in.
Dallas Museum of Art, DMA/amfAR Benefit Auction Fund, 2003

JACKIE WINSOR, *Burnt Paper Piece*, 1981–1982
Wood, reams of paper, and hydrostone, 32⅛ × 32⅛ × 32⅛ in.
Collection of Marguerite and Robert Hoffman

RICHARD TUTTLE, *Canvas Pale Purple*, 1967
Dyed and shaped unstretched canvas, 50 × 53 in.
Collection of Marguerite and Robert Hoffman

BARRY LE VA, *Cut, Placed Parallel*, 1967
Felt and metal, 330 × 226 in.
Dallas Museum of Art, DMA/amfAR Benefit Auction Fund, 2006

ROBERT SMITHSON, *Mirrors and Shelly Sand*, 1969–1970
Fifty 12-by-48-in. mirrors, back to back, and beach sand with shells
or pebbles, 360 × 96 × 15 in.
Dallas Museum of Art, gift of an anonymous donor; the Vin and Caren
Prothro Foundation; an anonymous donor in memory of Vin Prothro
and in honor of his cherished grandchildren, Lillian Lee Clark and
Annabel Caren Clark; The Eugene McDermott Foundation; Dr. and Mrs.
Mark L. Lemmon; American Consolidated Media; Bear/Hunter; and
donors to the C. Vincent Prothro Memorial Fund, 2002

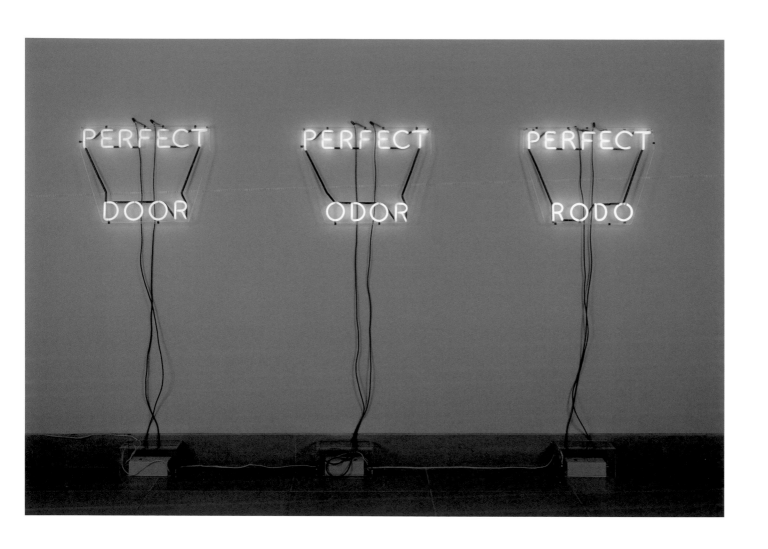

BRUCE NAUMAN, *Perfect Door/Perfect Odor/Perfect Rodo*, 1973
White glass tubing and clear glass tubing suspension frames; each 21½ × 28¾ × 1½ in., overall 21½ × 117 ×1½ in.
Dallas Museum of Art, General Acquisitions Fund, The 500, Inc., Dorace M. Fichtenbaum, Mrs. Edward W. Rose III, an anonymous donor, the Friends of Contemporary Art, and a matching grant from the National Endowment for the Arts in honor of Sue Graze, 1989

BRUCE NAUMAN, *Untitled*, 1965
Fiberglass and polyester resin, 67¼ × 6¼ × 3⅜ in.
Deedie and Rusty Rose

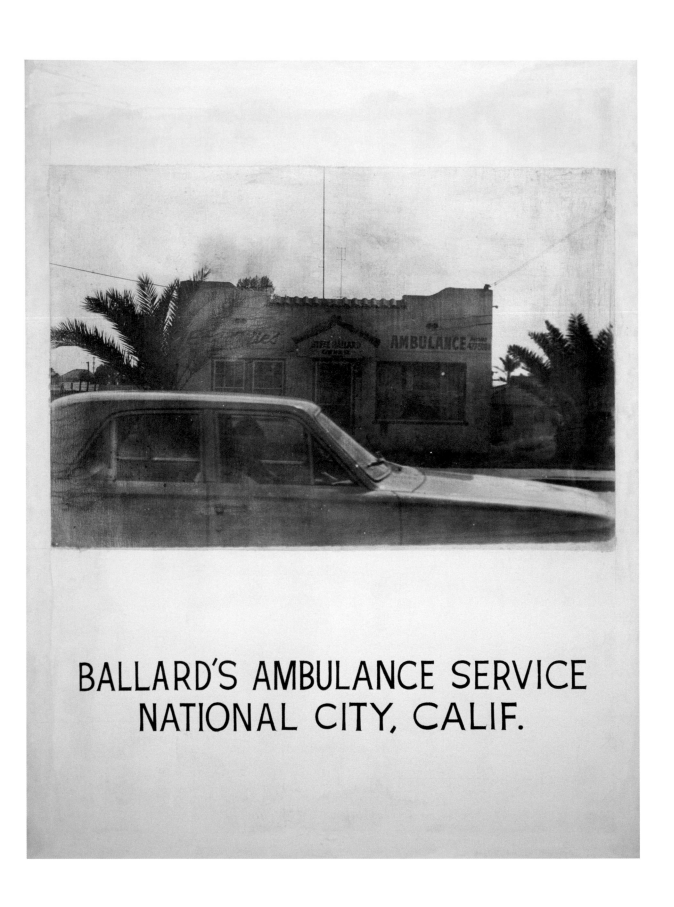

BALLARD'S AMBULANCE SERVICE
NATIONAL CITY, CALIF.

JOHN BALDESSARI, *Ballard's Ambulance Service, National City, California*, 1967–1968
Acrylic and photo emulsion on canvas, 59 × 45¼ in.
Promised gift of Gayle and Paul Stoffel to the Dallas Museum of Art

VARIOUS

SMALL

FIRES

SOME

LOS ANGELES

APARTMENTS

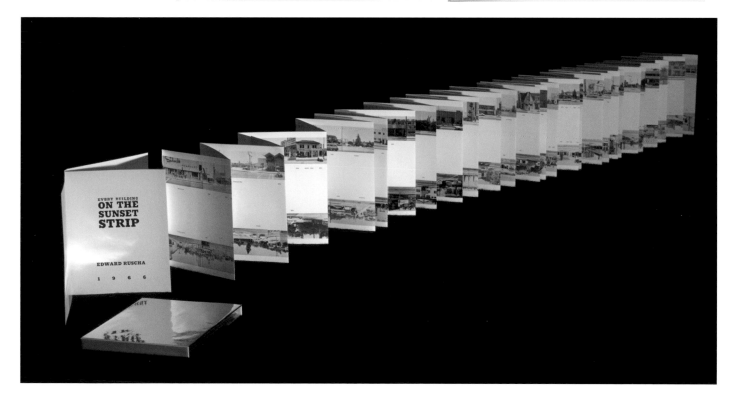

EDWARD RUSCHA, *Various Small Fires and Milk*, 1970 (1964)
Black offset printing, yellow varnish tint overprint, on 100-lb. white
Vicksburg Vellum text paper, 7¹⁄₁₆ × 5½ × ³⁄₁₆ in. closed
Anonymous promised gift in honor of David Breskin

EDWARD RUSCHA, *Some Los Angeles Apartments*, 1970
(1965)
Black offset printing on 100-lb. white Vicksburg Vellum text paper,
7¹⁄₁₆ × 5½ × ³⁄₁₆ in. closed
Anonymous promised gift in honor of David Breskin

EDWARD RUSCHA, *Every Building on the Sunset Strip*, 1966
Black offset printing on white paper, folded and glued, 7 × 5⁵⁄₈ × ³⁄₈ in.
Anonymous promised gift in honor of David Breskin

TRADEMARKS - SEPT 10, 1970

BITING MYSELF: BITING AS MUCH OF
MY BODY AS MY MOUTH CAN REACH.

MAKING BITE-PRINTS, LIKE FINGER-
PRINTS & STAMPING THE WORLD
AROUND ME.

VITO ACCONCI, *Trademarks*, 1970–2004
Mounted black-and-white photomontage, 52 × 102 in.
Promised gift of Sharon and Michael Young
to the Dallas Museum of Art

GILBERT AND GEORGE, *Prostitute Poof*, 1976
Sixteen black-and-white photographs; overall 95 × 79 in.
The Rachofsky Collection

MARCEL BROODTHAERS, *Oval of Eggs 1234567*
(*Ovale d'oeufs 1234567*), 1965
Eggshells and oil paint on wood panel, 39³⁄₈ × 31½ × 4¾ in.
Dallas Museum of Art, fractional gift of The Rachofsky Collection, 2001

YAYOI KUSAMA, *A Snake*, 1974
Mixed media, 256 × 10 × 12 in.
The Rachofsky Collection

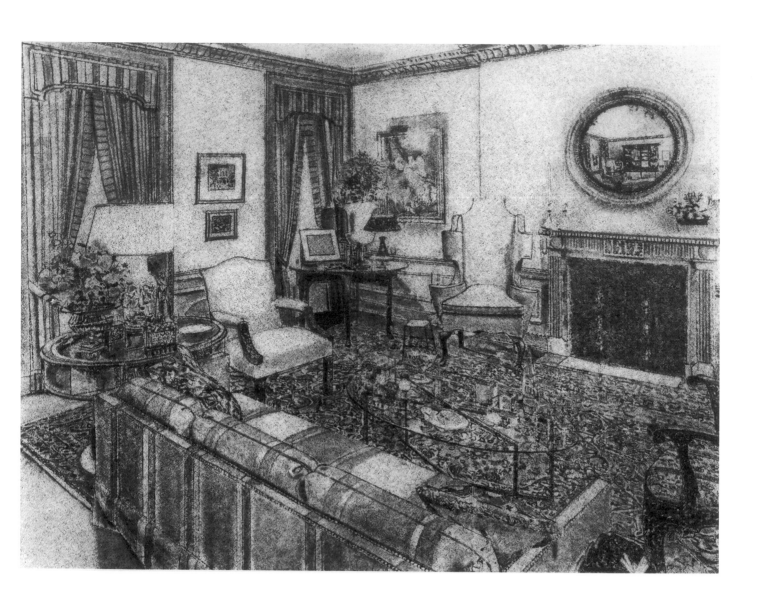

RICHARD ARTSCHWAGER, *Room*, 1970
Acrylic on Celotex, 48 × 62 in.
Collection of Marguerite and Robert Hoffman

NEIL JENNEY, *Outside*, 1984
Oil on wood, 40¾ × 36¾ in.
Collection of Marguerite and Robert Hoffman

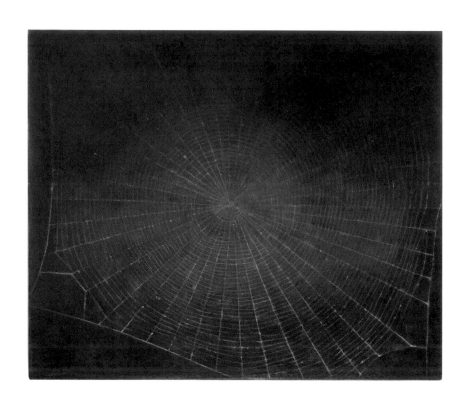

VIJA CELMINS, *Web*, 1992
Oil on canvas mounted on wood panel, 19 × 22¼ in.
Collection of Marguerite and Robert Hoffman

VIJA CELMINS, *Pink Pearl Eraser*, 1966–1967
Acrylic on balsa wood, 6⅝ × 18 × 3⅛ in.
Collection of Marguerite and Robert Hoffman

VIJA CELMINS, *Starfield II (Moving Out)*, 1983
Graphite on paper, 18¾ × 27 in.
Collection of Marguerite and Robert Hoffman

VIJA CELMINS, *Untitled (Ocean)*, 1968
Pencil on paper, 14½ × 19¾ in.
Collection of Marguerite and Robert Hoffman

Allan Schwartzman

From a
Prehistoric
Wind

THE VAST MAJORITY OF PUBLIC and private collections of modern art in this country have been built on the premise that before World War II all great art was made in Europe, whereas after the war all great art was made in the United States. As the story goes, this country came into its own artistically in the postwar period with the abstract expressionists, whose large paintings with their frenzied mark making were the ultimate expression of art for art's sake, of freedom. Europe was in tatters both physically and spiritually, and its artists were preoccupied with reconnecting with their own ruptured artistic lineages. They were consumed with a kind of provincial easel painting whose modest scale and studied control abstract expressionism had outgrown. This view was not entirely accurate but its clarity was convenient.

Throughout the years, despite occasional exhibitions, in both galleries and museums (Lucio Fontana at Martha Jackson Gallery in 1961, for example, and Joseph Beuys at the Guggenheim in 1979), the hegemonic perception of American postwar cultural domination held for decades (not only in the United States but also in Europe, where many museum and private collections reinforced this bias) until it was challenged by the ferocity of the newly exploding art market of the early 1980s and shattered by the international art exhibition Documenta VII in Kassel, Germany, in 1982. It took several more years for the American art public to realize that not all Germans were alike—that Richter, for example, was neither of the same generation nor the same sensibility as Kiefer, or that Polke had indeed been layering images before David Salle had reached puberty—and we are still just beginning to recognize the important contribution of Italian artists of the 1950s, 1960s, and 1970s. For the most part, even the museums that have been trying to play catch-up have yet to develop either connoisseurship or historical perspective in this regard.

The collection in formation for the Dallas Museum of Art is attempting to correct the record. Important art was being made throughout Europe in the 1950s—Yves Klein in France, Joseph Beuys in Germany—and beyond (Gutai in Japan remains one of the most potent and uncompromising postwar movements). But Italy occupies a unique position for depth of artistic invention pursued over several generations in the postwar period.

The story of postwar Italian art begins with Lucio Fontana. Although Fontana is best known for his elegant slash paintings of the 1960s, those are but one exquisitely lyrical, late manifestation of an aesthetic that began to coalesce in the late forties, when the sculptor, interested in creating an environmental art, began to cut small staccato holes into canvas. For Fontana, piercing the canvas was akin to opening a hole into the universe. If the detonation of the atomic bomb could be said to have given form to the explosive eddying rhythms of Jackson Pollock, then the exploration of outer space that was set in motion by new telescopic and aerospace technologies developed in the years immediately following the war gave rise to the mature work of Lucio Fontana.

By cutting holes or slashing through canvas or paper and thereby allowing light to pass through a two-dimensional surface, Fontana declared himself to be exploring infinite space. Indeed, he continued to make sculptures out of all sorts of materials, including bronze and neon. To examine more complex spatial relationships, he often added glitter, sand, and glass to canvas and paper surfaces. The best of his works are a fusion of the scientific and the poetic, and in their interest in reinventing pictorial space, give visual form to an evolving conception of the universe and our place in it. Although most of Fontana's work was in the small scale of earlier modern easel painting, his thinking was much more closely aligned with the vast, landscapish scale of the abstract expressionists than may be obvious. But he did not need a huge physical space in which to explore the infinite—he invoked it mentally. Most of his works of this time were entitled *Concetto spaziale* (spatial concept). By opening a painting's surface to light, Fontana was attempting to transcend the limits of painting and examine the real space of the shallow relief, while metaphorically giving form to the furthest reaches of scientific and artistic imagination. By making a two-dimensional work that attempted to destroy the confines of the canvas, Fontana set the stage for the shift in artistic dialogue from painting to sculpture, or from framed space to real space, that would be acted out more fully in the 1960s and 1970s with minimalism, earth art, process art, and performance.

Included in the Dallas collections is Fontana's marvelous glazed ceramic sculpture of an angel (1949), which in figurative form sets the stage for the *Concetto spaziale* work that will soon occupy him for the rest of his life. More than anything, this postfuturist work, made in the same year in which Fontana began piercing canvas, reveals the artist's interest in pure space by defining the figure both by its form and by the motion of space around it.

The year 1952 is especially important in Fontana's oeuvre, and one of the great Dallas works from this period is made of paper mounted on cardboard and, in archival photographs of the artist's studio, is often pictured propped up with light shining through it. This mostly black work, with its swirling clusters of pierced holes surrounding a golden center, depicts a kind of birth of the universe, and in it, as in Fontana's best works of this year, the artist's experimental curiosity and artistic pathos take off on a pictorial cosmic thrust.

It is common to romanticize the early alcoholic death of Jackson Pollock as existential proof that after his drip paintings the man had nowhere artistically to go. With Fontana we have no need to speculate about where he might go. He went there. In December of 1962, just eighteen months after the first manned space flight and at the age of sixty-three, Fontana began a series of large egg-shaped paintings that would preoccupy him for several years and be considered among the most extraordinary works of his career, a great example of which is *Concetto spaziale, la fine di Dio* (1964). These monochromatic works were made with bold, decidedly unarty colors such as pink or yellow; some were entirely covered in glitter. Some have been pierced with large, savagely cut holes; others are littered with smaller piercings that suggest both violence and wonder, displaying male aggression within the self-contained female form of the egg. The title, which may be translated as "end of God," suggests a new scientific conception of the beyond, of man, and of his place in the universe. Whereas an American artist such as Barnett Newman was dealing with a metaphysical notion of the transcendent, space travel, to an Italian raised on the Renaissance, provided a new framework for expressing awe at the cosmos, at what earlier Italian artists might have called "the heavens."

ATTILIO BACI, photograph of *Concetti spaziale* by Lucio Fontana, taken in raking light, 1952

If Fontana had his head in the cosmos, the Italian upstart Piero Manzoni, who emerged in the late fifties, was firmly consumed with earthly matter and human limit—even when his art was grand, such as when he made a pedestal and inverted it in the landscape, thereby appropriating our planet as his own creation (*Socle du monde,* 1961). With great flair that always kept his work from the dry, finite, and mundane, Manzoni made art out of his breath, his feces (which he had canned and numbered), and his thumbprint (he applied it to both eggs and humans). Much of his work was a commentary on authorship (and ownership), themes that would be more broadly explored decades later and that continue to preoccupy contemporary artists. The works for which Manzoni is best known are the paintings he called *Achromes,* which were made from 1957 until his death in 1963, principally of canvas, but also of cotton, velvet, gravel, fiberglass, Styrofoam, straw, plastic, and bread.

Manzoni's ambition was to make a work of art that had no illusion, no subjectivity, no human touch, no color, no narrative; as such, he is white to Ad Reinhardt's black and the consummate progenitor of minimalism. Among the Dallas *Achromes* is an uncommonly large work from a small group made in 1957–1958, at the beginning of the artist's mature phase, that looks like a fragment of a plaster wall. Its scumbly white surface might suggest the work of Robert Ryman (who was then just beginning to formulate his artistic vocabulary), but its faux found aesthetic that seems plucked from the real world places Manzoni closer to "the gap between art and life" that Robert Rauschenberg claimed as his artistic territory.

The type of *Achromes* for which Manzoni is best known was made by soaking canvas with kaolin (a soft clay used in the manufacture of porcelain) and leaving it to dry, causing the canvas to shrink, wrinkle, and sag. The result was a self-generating artwork, a thing made

PIERO MANZONI, *Socle du monde (Pedestal of the world),* 1961
Inscription: Socle magique no. 3 de / Piero Manzoni – 1961 – / hommage à Galileo
Iron and bronze, 32¼ × 39⅜ × 39⅜ in.
Herning Kunstmuseum, Denmark

by its own process. The artist may have eliminated the subjectivity of mastery that was central to the gestural painting of the abstract expressionists, but he did not eliminate aesthetics. What we prize in the *Achromes* is not just that they are self-generated, but that the best of them can be so poetic, haunting, and beautiful, qualities achieved through a process of their making—great examples of which are included in the Dallas collections. There is a certain impish conceit to Manzoni's claims for his work, a kind of genius in eliminating the usual signifiers of genius, akin to Reinhardt's making "the last painting" over and over again

Fontana's interest in making an environmentally spatial art that existed in both real and metaphoric space, and Manzoni's commitment to exploring the limits of the body, art, and culture identified essential values that would change the course of art history in general over the following decades. These values had an especially profound impact on successive generations of artists in Italy, who became grouped under the rubric of *arte povera*.

Like most art movements, *arte povera* was named by an art critic (in this case, Germano Celant) in response to a tendency he saw in Italy in the 1960s among artists who were working in diverse, often experimental ways to explore the intersections of art and life and of nature and culture. It was a reaction to the cool, precise antifigurative rigidities of minimalism and the cartoonish consumerism of pop. Like much of the art that came into being throughout the United States and Europe in the sixties, its spirit reflected the broader youth culture from which it emerged. Earth artists and political artists rebelled against the authoritarian nature of architecture and institutions; process artists challenged the need for art to have a fixed form; the *arte povera* artists sought to be materially free of formal orthodoxies. Like many of the important artists who emerged in the 1960s, most of the *arte povera* artists began as painters and, as their artistic positions coalesced, they rejected the formal rigidities and limits of painting and found freedom from artistic convention in three-dimensional, often multimedia work.

The Dallas community is fortunate in that its *arte povera* holdings concisely explore this historical shift. *Lunedi, Martedi, Mercoledi*, a painting by Jannis Kounellis from 1963, composed of three canvasses stitched together, suggests the exit of painting for painting's sake that is about to take place. An untitled work by Giulio Paolini made in the following year and consisting of a plywood sheet with several paint brushes, the tools of the trade, piled atop it like a statue on a pedestal, quite concisely, poignantly, even theatrically tells the story not only of the exit of painting but also of the painter (or author). Indeed, Paolini has turned the death of the author and the mourning of originality into a lifetime thematic playpen, which he examines again and again with conceptual tautness, dandyish style, acrobatic delicacy, and operatic ennui that are all characteristics of his work's unique Italianness.

Another work that could be seen as a treatise on the spirit of the times is *Vento preistorico dalle montagne* (Prehistoric wind from the mountains) of 1967, a breakthrough piece by Mario Merz which charts the moment when the painter of man and nature (who had been imprisoned during World War II for antifascist activities) leaves behind the rectilinear canvas and its physical and expressive limits. The work consists of a traditional, ostensibly abstract canvas and another canvas, the second bow-shaped, crashing through it, like the prow of a ship. Beneath the canvas sits a pile of brittle branches, piled up like some peasant collection of kindling. Resting on the twigs and rising up toward the canvas is a set of numbers made of neon that follow the Fibonacci sequence, a mathematical formulation in which each successive unit is the sum of the two preceding units. (The Fibonacci sequence is the underlying mathematical structure of many things found in nature, from the shell of a snail to the primitive cultural architectural structure of the igloo, and is an ongoing presence in the artist's work.) The whole grouping is pierced by a neon spear that ties together all the elements of this painted sculptural confluence like a lightning bolt of inspiration.

Although almost all the art prized, and shown, in the United States in the 1960s and 1970s was American, many American artists also exhibited in Europe—in fact, many were celebrated there before they were valued at home. (It is one of the great ironies of American postwar cultural domination that, while we could not imagine that great art could be made in Europe, we often needed Europeans to validate our own art before we could value it.) Indeed, there were many shared sensibilities in American and European art of the time, but what distinguished the Italian work was Italian culture, its connection to a place with historic continuity—both cultural and Cultural—and in that, a resistance to the generalizing universality of most other minimal and postminimal art. Each of the artists identified with *arte povera* developed a distinct sensibility and artistic identity, and several are represented in the Dallas collections—Michelangelo Pistoletto and his absorption with narcissism; Marisa Merz, who brought a female sensitivity to the self, the psychological, and the vulnerable to a world of potent men making big art; Giovanni Anselmo, who brought his own conceptual twist and poetic delicacy to an examination of sculpture; Luciano Fabro, one of the few artists who at that time was actually carving traditional sculptural materials but combined them in unorthodox and poetic and sensual ways (Fabro makes steel sexy); and Giuseppe Penone, who has spent a lifetime exploring the intersection of man and nature through a thorough examination of his body and its place in the world.

Another artist who is particularly well represented here is Alighiero Boetti. Boetti begins in the 1960s making works in strong dialogue with minimalism and its engagement with industrial materials and systemic thinking (*Zig Zag*, 1966) and goes on to produce a highly poetic art concerned with issues of identity and authorship. A series of so-called paintings in the form of maps of the world embroidered by Afghani women, which he began in 1971, anticipates the multicultural challenge to the tyranny of authorship and ownership that

became a central dialogue for a much younger generation of artists in the 1990s. Boetti is represented in Dallas by an extraordinary, unique white-on-white embroidered work, the imagery of which is based on a bell tower opposite the artist's studio in Rome.

He is also represented in Dallas by one of his last works, an uncommonly traditional looking sculpture—a statue, really—made of bronze, of the once arrestingly beautiful artist, now old, apparently fragile, standing like a statue in a park and holding a copper pipe, from which water arcs onto the figure's head, in which is embedded a hidden heating element that turns the water to steam. This work was made when the artist was dying of a brain tumor and, in the form of an enduring bronze monument, captures the sad vulnerability of life about to pass: as the artist tries to feed himself, as if he were a tree, he evaporates. To an art world that has been especially obsessed with youth and its invulnerable power, Boetti's *Self-Portrait* gives lasting form to the fleeting nature of life and, in its examination of mortality, one of the principal themes of contemporary art since the mid-1980s, remains one of the most profound works of our time.

In many ways the story of art after World War II is the story of the rise of sculpture. The large scale of abstract expressionism—the scale of landscape, of cinema—opened the door for artists to leave the studio for real space, real time, real life. The story of the emergence of sculpture in the postwar period, which is commonly told from an American perspective, could also be charted quite persuasively through the development of art in Italy in the 1950s and 1960s. Fontana, in piercing a two-dimensional surface, destroyed painting space and explored infinity. He gave Italian artists infinite license to explore the real world, setting in motion nothing less than the shift in sensibility from modern to postmodern.

LUCIO FONTANA, *Spatial Concept* (*Concetto spaziale*), 1952
Paint, powdered pigment, paper, linen, and cardboard attached
to a wooden stretcher, 31½ × 31½ in.
The Rachofsky Collection

LUCIO FONTANA, *Spatial Concept* (*Concetto spaziale*), 1962
Oil on canvas, $37\frac{3}{8} \times 51\frac{1}{8}$ in.
Dallas Museum of Art, fractional gift of The Rachofsky Collection,
2001

LUCIO FONTANA, *Spatial Concept, the End of God (Concetto spaziale, la fine di Dio)*, 1964
Oil on canvas, 70 × 48½ in.
The Rachofsky Collection

PIERO MANZONI, *Achrome*, 1958
Plaster on canvas, 47¼ × 23½ in.
The Rachofsky Collection

PIERO MANZONI, *Achrome*, 1962
Gravel and kaolin on canvas, 28¾ × 24¾ in.
Deedie and Rusty Rose

PIERO MANZONI, *Achrome*, 1958
Kaolin on canvas, $38\frac{3}{8} \times 51\frac{1}{8}$ in.
The Rachofsky Collection

ALBERTO BURRI, *Cretto B 2*, 1973
Acrylic vinyl on Celotex, 59 × 49¼ in.
The Rachofsky Collection

MARIO MERZ, *Fibonacci 1202*, 1970
Eleven black-and-white framed photographs, ten neon signs,
and one transformer, $19\frac{5}{8} \times 196\frac{7}{8}$ in. overall
Dallas Museum of Art, fractional gift of The Rachofsky Collection,
2001

MARIO MERZ, *Prehistoric Wind from the Mountains*
(*Vento preistorico dalle montagne*), 1967
Mixed media on canvas, neon tubes, and brushwood,
157½ × 94½ × 39⅜ in.
The Rachofsky Collection

MARIO MERZ, *Untitled*, 1969
Neon and hay, 127 × 44 × 40 in.
The Rachofsky Collection

JANNIS KOUNELLIS, *Monday, Tuesday, Wednesday* (*Lunedi,
Martedi, Mercoledi*), 1963
Oil on canvas, 70¾ × 88½ in.
The Rachofsky Collection

GIULIO PAOLINI, *Untitled* (*Senza titolo*), 1964
Plywood board and used paint brushes, 75⅝ × 63 × 1 in.
The Rose Collection and the Rachofsky Collection

GIULIO PAOLINI, *The Other Figure (L'altra figura)*, 1984
Plaster and artist's plinths; each bust 24¾ × 16½ × 12⅛ in.
The Rachofsky Collection

GIULIO PAOLINI, *Never Seen Before (Jamais vu)*, 2004–2005
Prepared canvases and chair, 96½ × 90½ × 61 in.
The Rose Collection and the Rachofsky Collection

MICHELANGELO PISTOLETTO, *Mercury's Gift to the Mirror*
(*Dono di Mercurio allo specchio*), 1971–1992
Bronze and mirror, 90⅛ × 47¼ × 39⅜ in.
The Rachofsky Collection

GIOVANNI ANSELMO, *Detail (Particolare)*, 1972
Slide projector, slide, and shelf; dimensions variable
The Rachofsky Collection

GIUSEPPE PENONE, *To Breathe the Shadow (Respirare l'ombra)*, 1998
Fifteen cages of laurel leaves, bronze; each 31 × 47 × 3½ in.,
overall 93 × 235 × 3½ in.
Promised gift of Sharon and Michael Young to the Dallas
Museum of Art

GIUSEPPE PENONE, *Skin of Leaves (Pelle di foglie)*,
1999–2000
Bronze, 138 × 70 × 60 in.
The Rachofsky Collection

ALIGHIERO BOETTI, *Tree of Hours (L' Albero delle ore)*, 1979
Tapestry, 128 × 76 in.
Dallas Museum of Art, fractional gift of The Rachofsky Collection,
2001

ALIGHIERO BOETTI, *Untitled*, 1990
Pencil and tempera on mounted paper, 106¼ × 118¼ in.
The Rachofsky Collection

ALIGHIERO BOETTI, *Self-Portrait*, 1993
Bronze, electrical and hydraulic attachments, 80 × 37 × 20 in.
The Rachofsky Collection

LUCIANO FABRO, *Efeso*, 1986
Marble, steel cable, 16 × 93 × 41 in., excluding cable
The Rachofsky Collection

Charles Wylie

A German Persistence

THE DALLAS MUSEUM OF ART'S COLLECTION of contemporary German art will become one of the most important in the United States and in most places outside Germany itself. Within the past ten years, the DMA has gone from having a handful of German works to possessing a fascinating, highly textured survey of superb quality of the art of a purposely selective and relatively small number of major artists. Tracing a broadly defined lineage from Joseph Beuys, Gerhard Richter, and Sigmar Polke, and their roles in Düsseldorf at the Düsseldorf Academy and in neighboring Cologne, to younger German artists working within this tradition and breaking away from it, the collective Dallas holdings of contemporary German art reveal the extraordinary ability of art itself to rebound from even the most devastating of catastrophes that is one of the most extraordinary chapters in recent art history.

Joseph Beuys's *Sled* and *Felt Suit* are among the most recognizable, one could confidently say iconic, works of German art of the past fifty years. Behind their everyday utilitarian guise, Beuys loaded ideas of protection, rescue, and salvation into these seemingly mundane objects by a subtle yet deeply considered use of materials and forms. These humanist concerns accorded with Beuys's notion that the culture at the moment needed a shamanistic force that would reintroduce ideas of the spiritual and the subjective into a materially obsessed society badly in need of potentially liberating introspection and self-reflection. By legitimizing the idea that art can indeed contain within it forces thought banished by a highly analytic and, to some minds, overly formal modernism, the influence of Beuys on German and contemporary art has been a foregone conclusion. When Beuys began his lecture and performance activities outside the world of the academy, he introduced to a fascinated, primarily European, audience the concept of social sculpture, the idea that the world one makes for one's self can be considered a work of art and that, therefore, everyone has the potential to be an artist.

Such idealist activism through the channels of the art establishment (Beuys conducted numerous performances around social and political themes wholly of their time in venues both within and outside the museum structure) was one response to the situation that German artists found themselves in after the annihilation of humanist culture in the wake of the cataclysmic disaster that was World War II. The profound brilliance of German and Germanic culture of centuries previous did nothing to stop the rise of the Nazis, and faith in the enterprise of the more recent efforts of modernism to change the world was fundamentally shaken. The challenge of making art in such a milieu was formidable, and it is one of the great achievements of German artists of the post–World War II era not only to have created an authentic and far-reaching body of work in the face of such odds, but also to have demonstrated art's continuing relevance to contemporary thought and life, something that was hardly a given in 1950s Germany.

Beuys's sculpture contains within it a world of archaic-looking objects that speak of antiquity and modernity at the same time, emphasizing the healing power of art to bring about social change through a secular, deeply committed ethos of social engagement. In contrast to Beuys's overt actions across the literal span of the globe, the art of Gerhard Richter represents a relentlessly focused response to the particular German art-making challenge. In his first mature works, Richter made gray paintings based on found media images that he chose for their random nature and seeming lack of meaning. In fact, as we see from decades of retrospection, these images are packed with meaning. Running parallel to American pop art but possibly more closely aligned with Jasper Johns's use of familiar images and objects such as maps and numbers, Richter's art signaled a distant remove. Perhaps such a remove was needed to consider how images formed what one knew and felt about events and people that occupied the often bewilderingly dense culture of Western industrialist growth and entrenchment.

Richter's investigation has extended into all areas of image making, not just media ads and family snapshots, by recreating at a distance the look of abstract expressionist brushstrokes and iconic spiritual symbols such as candles. This broad range of images and ideas both aesthetic and conceptual is easily seen, in the Dallas Museum of Art's collection, in the vast array of the artist's nearly 150 editioned works spanning virtually his entire career and including the media of painting, printmaking, photography, and sculpture. Richter imparted this far-reaching ambition to his Düsseldorf Academy student Thomas Struth, an artist whose work with photographs represents a similarly broad expanse of ideas within a single medium. Struth first studied painting with Richter but switched, at Richter's suggestion, to working under the photographers Bernd and Hilla Becher. Photography, it seemed to Richter, offered Struth the means by which he could explore his interest in a type of social analysis through imagery of the contemporary world.

Working under the Bechers, whose own serially taken and grouped photographs revealed the sculptural form of industrial structures of bygone days, Struth took to the streets of his hometown of Düsseldorf and registered the architecture thrown up in the 1950s to replace buildings that had been bombed. As the Bechers had done in revealing the way in which overlooked architecture can mark history, Struth expanded his view to a larger set of subjects, from portraits to landscape to cultural sites of public meaning (such as museums and houses of worship). In the process he took advantage of the astonishing range of techniques that had been developed in Düsseldorf and allowed artists as never before to make photographically based art that competed on the scale of painting and sculpture. In Struth's case, what we see is a rendering of the contemporary industrial, natural, and cultural world that is an incomparable mix of the formally beautiful with the rigorously analytic on a scale that has since become routine, but which at the time it appeared (in the late 1980s) posited and championed a completely new place for the photograph within contemporary art practice.

Struth's contemporary Thomas Ruff took a different tack in his landscape works by using the Internet as a source for his image of a cave in the Copper Canyon. Creating a series in which the artist used pixels to produce a latter-day version of a pointillist landscape à la Seurat, Ruff literally breaks down the parts of a picture and leaves the implications of the view to be seen by looking out from a cave in a desert to our reflective capacities. An even younger artist, Thomas Demand, takes the truth as well as the artificiality of photography for granted in his depictions of staged interiors and natural phenomena. In one of his most explicitly German works, Demand recreated the studio of Albert Speer, which contained models of buildings that would be built once the Nazis had conquered Paris (and Europe). Such a work resembles perhaps the Bechers' and Struth's use of sometimes-ominous architecture, but does so in a way that reminds us, grimly, of what could have been, not of what is.

Before Ruff's and Demand's investigations with image making, however, came Lothar Baumgarten's extensive, decades-long, multimedia project with camera, book, sound, and installation. In his *Carbon* works, Baumgarten (significantly, a student of Beuys) uses landscape to record the contemporary, often neglected, state of the American rail system that enabled the expansion of the country, but was made possible by (and even allowed) the near-total extinction of native America. An earlier project involving hundreds of slides and a mysterious soundtrack saw Baumgarten ingeniously using the wastelands around the Düsseldorf airport to recreate a supposedly pristine rain-forest setting that turned out to be none other than a fouled ecosystem of the industrialized West. In a related way, Rosemarie Trockel uses images, in this case moving images made possible by video, to present an ambiguous narrative suggesting the impossibility that childhood innocence can last or even exist within a charged range of particularly Eastern European historical (political?) and religious iconographies.

Anselm Kiefer, another of Beuys's students, represents a classic example of an artist seeking to invest art with meaning by reengaging with just those kinds of signs and symbols. Perhaps the clearest example of a German artist seeking to exorcize the malignancy of the Nazi era, Kiefer, in his early work, confronted that legacy head on and then sought to reflect on the very achievements of German culture up to and including the nineteenth century. Whether this citing of precedence was intended as rebuke or reminder, the fact remained that for Kiefer, as for other artists, the very realities of German history were now to be confronted after what was felt to be a post–World War II amnesia. In his works with books, Kiefer summons the ancient form of the large book containing the wisdom of the ages, while in his giant mid-1990s canvases, he takes the landscape again as bearer of meaning, conjoining the infinite with the artistic in a typically crossbred evocation of the power of art that no less a painter than the nineteenth-century German Romantic Caspar David Friedrich himself used in conjoining nature and mysticism.

Another Beuys student, Wolfgang Laib, represents a further and often literal way in which Beuys believed art could heal. Laib is a doctor who has never practiced medicine in the traditional sense, but believes his work is in its way as powerful a beneficent (if quiet and quietly rendered) force in the world. In his rice house and pollen works, Laib relies on universal basic forms found throughout world history and makes process as much a part of the artwork as material. Both archaic and modern, Laib's art addresses the power of the creative act to counter the purely mechanistic and commercial capacities of humans, something that was of paramount concern to the generation of German artists (many of whom are discussed here) who came of age in the 1960s during the undeniably far-reaching yet subjectively disengaged *Wirtschaftswunder* (economic miracle).

Possessed of a completely different sensibility from nearly all the artists mentioned above, Sigmar Polke represents a powerful expression of postwar German art but has consistently used the notion of irony, not earnestness, to buttress his jabs at the conventions and pretensions of both the art world and the broader culture in which it exists. Polke's earliest work relied like Richter's on a subtly more analytic use of popular imagery than that of the American pop artists Andy Warhol and Roy Lichtenstein (whose influence was even at the time acknowledged and who were the inspiration for Polke, Richter, and Konrad Lueg—who later became Konrad Fischer, the art dealer—to create the satirically named Capitalist Realism movement). Central to Polke's art is the use of the benday dot system that registers images in print through a half-tone process. A metaphor for the literal construction of images and thus their meaning, Polke's use of many printing techniques and mechanics actually rendered by hand is in effect often ironic to the point of a serious absurdity.

Behind his almost-too-easily grasped satire—on Texas gun culture, sex between men and women, the pomposity of conceptual artists, and the grandiosity of space travel, for

instance—is a deeply intelligent and profound questioning of the fundamental tenets of the culture itself. Polke's art exhibits a skepticism bordering on the nihilist that is brilliantly masked by often wryly humorous juxtapositions of images and titles. What brings Polke back from the brink is his insistence on making art that is formally assured and sometimes out-and-out soaringly beautiful, a sign that for all his subversive intent there is at work here an equally accomplished aesthetic sensibility that takes beauty as one more convention to be used and transformed in an art of an almost forbiddingly smart and aware engagement.

The irreverence sported by Polke's art found an apt successor in the sculpture of Martin Kippenberger, who took forms of cultural import and adapted them for his own purposes, investigating the way in which symbols functioned in both the larger sphere and in relation to his own experience as an artist inheriting what was already seen as a powerful tradition of German art making in the environs of Cologne and Düsseldorf of the 1970s and 1900s. Kippenberger died in the mid-1990s at a young age, yet his influence on the international practice of the making of art by a younger generation has been great and represents the continuing importance of the laboratory that has been centered in Germany since Joseph Beuys first conceived his idea that everyone can be and is an artist.

JOSEPH BEUYS, *Fluxus Object (Fluxusobjekt)*, 1962
Cardboard box, fat, oil color, broom, rubber ring, and toy,
21¼ × 26 × 33½ in.
Collection of Marguerite and Robert Hoffman

JOSEPH BEUYS, *Sled (Schlitten)*, 1969
Wooden sled, felt blanket, belt, flashlight, and fat,
35⅜ × 13⅞ × 13⅜ in.
Collection of Marguerite and Robert Hoffman

JOSEPH BEUYS, *Jason*, 1961
Zinc tub, small iron head, wooden rod, paint, and wire,
65¼ × 33½ × 26 in.
Collection of Marguerite and Robert Hoffman

JOSEPH BEUYS, *Double Objects (Doppelobjekte)*, 1974–1979
Vitrine with fourteen objects, 81 × 86⅝ × 19¾ in.
Collection of Marguerite and Robert Hoffman

JOSEPH BEUYS, *Felt Suit (Filzanzug)*, 1970
Felt and wood hanger, 80 × 28 × 8 in.
Collection of Marguerite and Robert Hoffman

GERHARD RICHTER, *Ema (Nude on a Staircase)*
(*Ema [Akt auf einer Treppe]*), 1992
Cibachrome print, 89 × 60½ × 1⅞ in. including frame
Dallas Museum of Art, Dallas Museum of Art League Fund, Roberta
Coke Camp Fund, General Acquisitions Fund, DMA/amfAR Benefit

Auction Fund, and the Contemporary Art Fund: Gift of Mr. and Mrs.
Vernon E. Faulconer, Mr. and Mrs. Bryant M. Hanley Jr., Marguerite and
Robert K. Hoffman, Howard E. Rachofsky, Evelyn P. and Edward W.
Rose, Gayle and Paul Stoffel, and two anonymous donors, 1999

GERHARD RICHTER, *Family (Familie)*, 1964
Oil on canvas, 59 × 70⅞ in.
Collection of Marguerite and Robert Hoffman

GERHARD RICHTER, *City Picture, Mü (Stadtbild Mü)*, 1968
Amphibolin on canvas, 70 7/8 × 63 in.
Collection of Marguerite and Robert Hoffman, The Rachofsky
Collection, and the Dallas Museum of Art: Lay Family Acquisition Fund,
General Acquisitions Fund, and gifts from an anonymous donor,
Howard Rachofsky, Evelyn P. and Edward W. Rose, Mr. and Mrs. Paul
Stoffel, and Mr. and Mrs. William T. Solomon, by exchange, 2002

GERHARD RICHTER, *Abstract Painting* (*Abstraktes Bild*),
1977
Oil on canvas, 88½ × 78¾ in.
Collection of Marguerite and Robert Hoffman

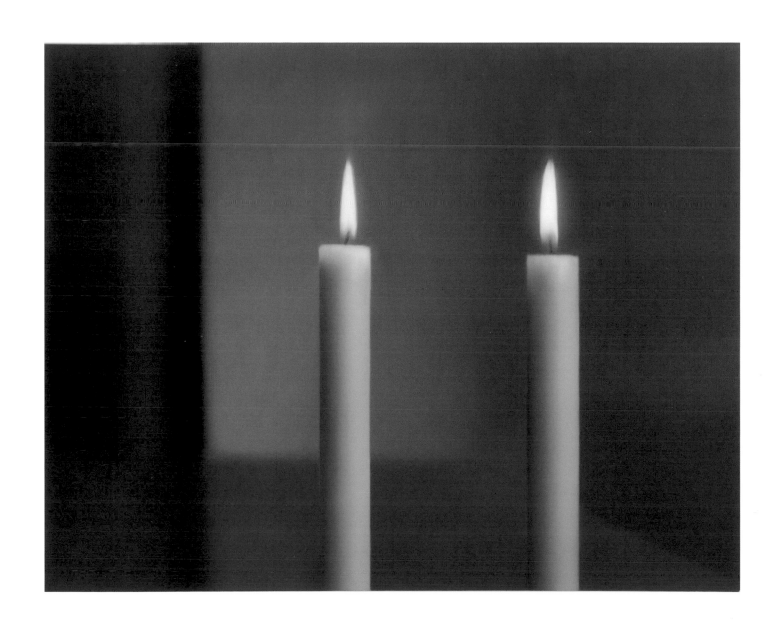

GERHARD RICHTER, *Two Candles (Zwei Kerzen)*, 1982
Oil on canvas, 43¼ × 55¼ in.
Collection of Marguerite and Robert Hoffman

GERHARD RICHTER, *Structure (Struktur)*, 1990
Oil on canvas, 88½ × 79 in.
The Rachofsky Collection

GERHARD RICHTER, *Demo*, 1997
Oil on canvas, 24⅜ × 24⅜ in.
The Rachofsky Collection

SIGMAR POLKE, *Potato Machine (Kartoffelmaschine)*,
or *Apparatus Whereby One Potato Can Orbit Another*
(*Apparat, mit dem eine Kartoffel eine andere umkreisen
kann*), 1969
Wooden frame, battery-driven electric motor, rubber band, wire,
and two replaceable potatoes, 31¾ × 15¾ × 15¾ in.
Dallas Museum of Art, DMA/amfAR Benefit Auction Fund, 2001

SIGMAR POLKE, *Constructions around Leonardo
da Vinci and Sigmar Polke*, 1969
Ink on graph paper, 27½ × 35½ in.
Dallas Museum of Art, anonymous gift and the Contemporary Art
Fund: Gift of Arlene and John Dayton, Mr. and Mrs. Vernon E. Faulconer,
Mr. and Mrs. Bryant M. Hanley Jr., Marguerite and Robert K. Hoffman,
Cindy and Howard Rachofsky, Evelyn P. and Edward W. Rose, Gayle and
Paul Stoffel, and two anonymous donors, 2002

SIGMAR POLKE, *Clouds (Wolken)*, 1989
Mixed media on canvas, 118¾ × 157½ in.
Dallas Museum of Art, DMA/amfAR Benefit Auction Fund and the
Contemporary Art Fund: Gift of Mr. and Mrs. Vernon E. Faulconer,
Mr. and Mrs. Bryant M. Hanley Jr., Marguerite and Robert K. Hoffman,
Cindy and Howard Rachofsky, Evelyn P. and Edward W. Rose, Gayle
and Paul Stoffel, and two anonymous donors, 2000

SIGMAR POLKE, *Cook Up Art with a Culinary Flair*, 2002
Mixed media on fabric, 118¼ × 157½ in.
The Rachofsky Collection and the Dallas Museum of Art through the
Contemporary Art Fund: Gift of Arlene and John Dayton, Mr. and
Mrs. Vernon E. Faulconer, Mr. and Mrs. Bryant M. Hanley Jr., Marguerite
and Robert K. Hoffman, Cindy and Howard Rachofsky, Evelyn P. and
Edward W. Rose, Gayle and Paul Stoffel, and three anonymous donors,
2003

SIGMAR POLKE, *Splatter Analysis*, 2002
Mixed media on fabric, 116⅛ × 116⅛ in.
Collection of an anonymous Dallas collector and the Dallas Museum
of Art through the Contemporary Art Fund: Gift of Arlene and John
Dayton, Mr. and Mrs. Vernon E. Faulconer, Mr. and Mrs. Bryant M.
Hanley Jr., Marguerite and Robert K. Hoffman, Cindy and Howard
Rachofsky, Evelyn P. and Edward W. Rose, Gayle and Paul Stoffel, and
three anonymous donors, 2003

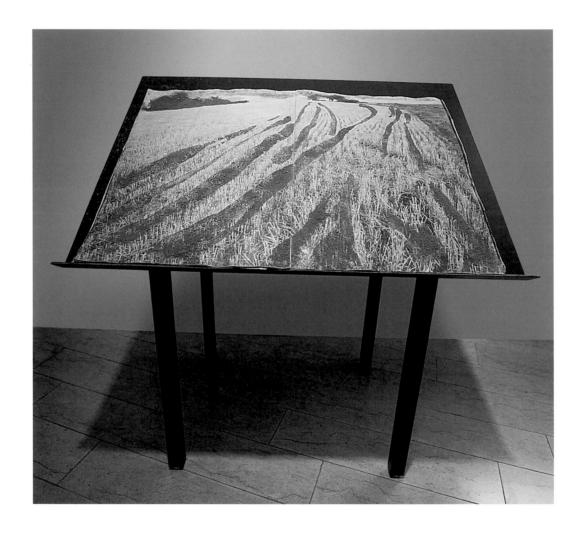

ANSELM KIEFER, *March Sand IV (Märkischer Sand IV)*, 1976
Mixed media, 23⅝ × 17 × 3 in. closed
Collection of Marguerite and Robert Hoffman

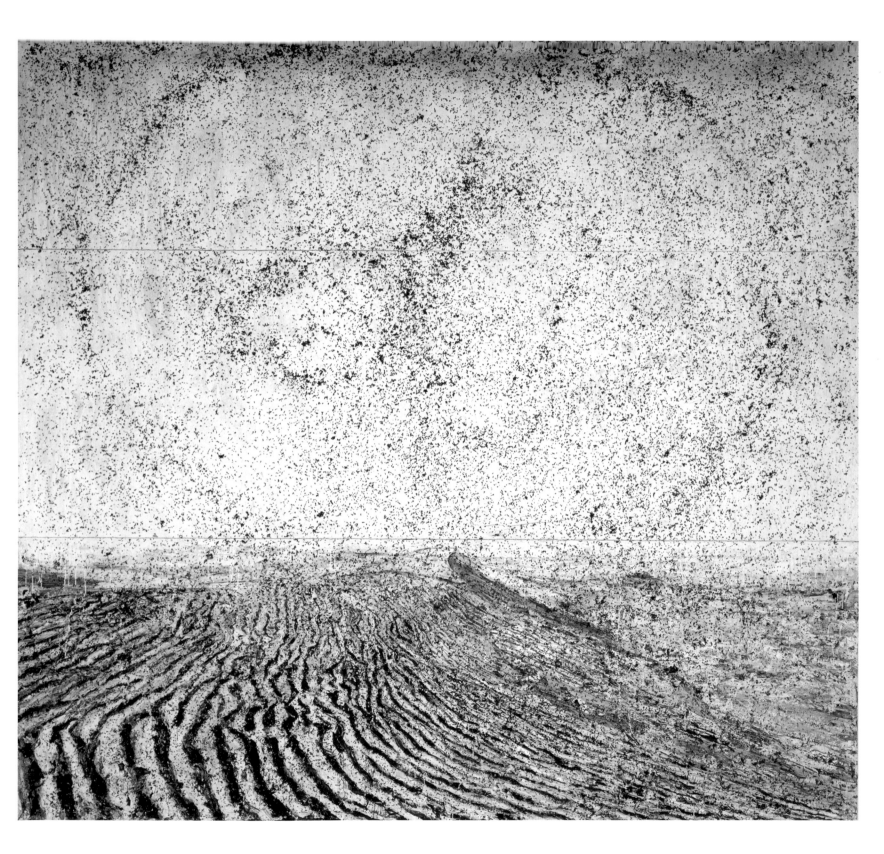

ANSELM KIEFER, *This Dark Brightness which Falls from
the Stars (Cette obscure clarté qui tombe des étoiles)*, 1996
Emulsion, acrylic, shellac, and sunflower seeds on canvas,
204¾ × 220½ in.
Dallas Museum of Art, Frances Moss Ryburn Memorial Fund, 2001

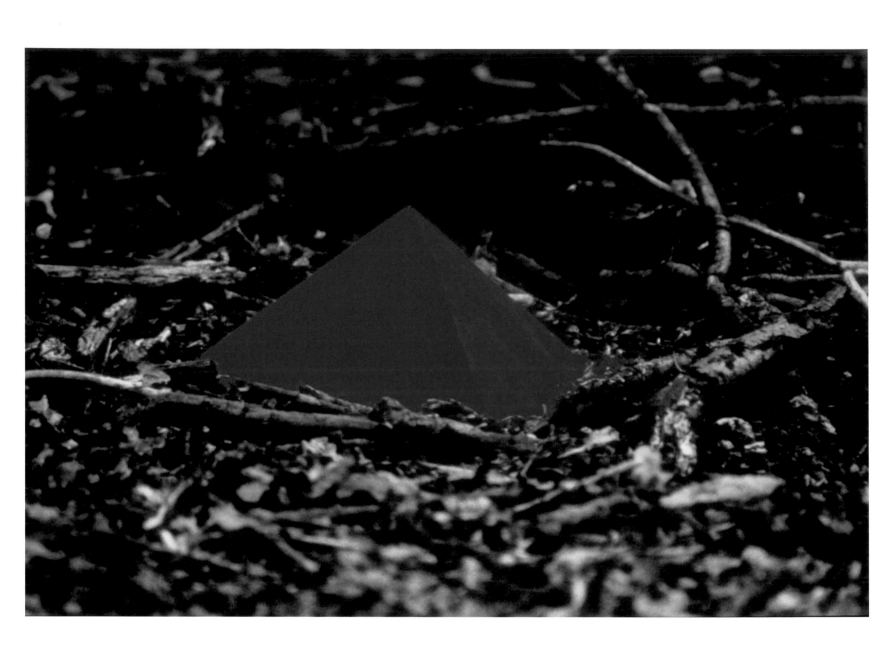

LOTHAR BAUMGARTEN, *"I like it better here than Westphalia,"* El Dorado 1968–1976 (*"Da gefällt's mir besser als in Westfalen,"* El Dorado 1968–1976), 1968–1976
Projection with sound: one hundred and eighty-seven 35-mm color slide transparencies, audio CD; running time: 36 min. 52 sec.
Dallas Museum of Art, DMA/amfAR Benefit Auction Fund, 2004

LOTHAR BAUMGARTEN, *Missouri-Kansas-Texas Railroad, Katy Yard, Continental Viaduct, Dallas, Dallas County, Texas*, 1989
Gelatin-silver print, 27⅜ × 33 × 1¾ in., framed
Dallas Museum of Art, gift of the artist and Marian Goodman Gallery, 2004

LOTHAR BAUMGARTEN, *Southern Pacific Transportation Co. and Amtrak's Sunset Limited, Continuous cantilever deck structure II, Pecos River, Val Verde County, Texas*, 1989
Gelatin-silver print, 27⅜ × 33 × 1¾ in., framed
Promised gift of Catherine and Will Rose to the Dallas Museum of Art, 2006

LOTHAR BAUMGARTEN, *Southern Pacific Transportation Company and Amtrak's Sunset Limited, Val Verde County, Texas*, 1989
Gelatin-silver print, 27⅜ × 33 × 1¾ in., framed
Dallas Museum of Art, gift of the artist and Marian Goodman Gallery, 2004

LOTHAR BAUMGARTEN, *Southern Pacific Transportation Company and Amtrak's Sunset Limited, Jefferson Davis County, Texas*, 1989
Gelatin-silver print, 27⅜ × 33 × 1¾ in., framed
Dallas Museum of Art, gift of the artist and Marian Goodman Gallery, 2004

BLINKY PALERMO, *Untitled*, 1967–1968
Casein paint on canvas, $23\frac{1}{2} \times 70\frac{3}{4}$ in.
Dallas Museum of Art, centennial fractional and promised gift of
Deedie and Edward W. Rose in honor of Inge-Lise Eckmann Lane, 2002

WOLFGANG LAIB, *Rice House*, 1988
Marble, rice, and hazelnut pollen, 7⅞ × 50 × 8⅝ in.
Deedie and Rusty Rose

MARTIN KIPPENBERGER, *Artaud's Cross (To Put an End to the Judgment of God)* (*Artauds Kreuz [pour en finir avec le jugement de dieu]*), 1987
Wood, plastic, and cassette tape, 78⅝ × 71 × 30⅜ in.
Dallas Museum of Art, fractional gift of Edward W. III and Evelyn P. Rose, 1999

214

ISA GENZKEN, *Door (Tür)*, 1988
Concrete and steel, 93 × 47 × 28 in.
The Rachofsky Collection and Dallas Museum of Art, DMA/amfAR Benefit Auction Fund, 2006

BERND AND HILLA BECHER, *Coal Bunkers*, 1978
Sixteen gelatin-silver prints; 20 × 16 in. framed; 40½ × 131½ in. installed
Dallas Museum of Art, gift of Carl, Elizabeth, Stahl, and Laura Urban,
1981

THOMAS STRUTH, *Dallas Parking Lot, Dallas,* 2001
Chromogenic print mounted on Plexiglas, 69½ × 97¼ in.
Dallas Museum of Art, gift of the artist and Marian Goodman Gallery,
2002

THOMAS STRUTH, *Milan Cathedral (Interior), Milan*, 1998
Chromogenic print, 73¼ × 91 in.
Collection of Marguerite and Robert Hoffman

THOMAS STRUTH, *Pergamon Museum I, Berlin*, 2001
Chromogenic print, 80¾ × 100¾ in.
Dallas Museum of Art, Contemporary Art Fund: Gift of Arlene and John
Dayton, Mr. and Mrs. Vernon E. Faulconer, Mr. and Mrs. Bryant M.
Hanley Jr., Marguerite and Robert K. Hoffman, Cindy and Howard
Rachofsky, Evelyn P. and Edward W. Rose, Gayle and Paul Stoffel, and
three anonymous donors, 2002

THOMAS STRUTH, *Boats at Wushan, Yangtse Gorge/China*, 1997
Chromogenic print, 63 × 78¾ in.
Dallas Museum of Art, fractional gift of Cindy and Armond Schwartz, 2000

THOMAS STRUTH, *Da Ning River, Wuxi/China*, 1997
Chromogenic print, 67 × 79¼ in.
Dallas Museum of Art, gift of the Junior Associates, 1999

THOMAS RUFF, *jpeg cc01*, 2004
Chromogenic print, 74 × 97¼ in.
Dallas Museum of Art, DMA/amfAR Benefit Auction Fund, 2005

THOMAS DEMAND, *Model (Modell)*, 2000
Chromogenic print, 64¾ × 82¾ in.
Dallas Museum of Art, Lay Family Acquisition Fund, 2001

Charles Wylie

From *Object* to *Image:*

Sculpture, Installation, Media

IN THINKING ABOUT SCULPTURE IN DALLAS, the Nasher Sculpture Center inevitably springs to mind, not only as a great act of philanthropy to the city of Dallas (of which the promised gifts of art in this catalogue are an inspired continuation) but also as a nearly ideal basis on which, in comparing and contrasting the Nasher's holdings with those of the Dallas Museum of Art and its patrons, to consider the ways in which sculptors have used forms and materials in the past. Focusing its recent acquisitions on the past three decades or so, the DMA has joined with its patrons in a loosely systematic attempt to continue and extend the great tradition of sculpture found at the Nasher. Part of this attention to the new has necessitated a reconsideration of what sculpture today is and can be, as artists have used a bewildering array of approaches to creating three-dimensional work, from film, video, and sound to LED numbers to store-bought candy.

David Smith's *Cubi XVII* is a useful object to consider when thinking of the various paths sculpture has taken. A historically major work of art from a place and period of major international influence, post–World War II New York, this piece from Smith's famous Cubi series represents a crucial bridge between past and future. Smith's work in general has been compared to that of the abstract expressionist painters because of his use of large-scaled gesturelike forms that occupy space in the same way that Franz Kline's forms, say, occupy a wall. Smith's achievement was not, however, to mimic painting but to create works of resolutely abstract form that commanded the space around them, space that included the viewer. In his Cubi series, for instance, Smith often burnished the welded metal sections, creating multiple impressions of a piece as one walked around it. This sense of full three-dimensionality and one's relationship to it will reappear again and again as sculpture progresses up to our own day.

The artists who acknowledged the importance of viewer in relation to object were the minimalists, such as Judd and Andre, artists discussed by Frances Colpitt in her essay in this volume. For certain artists, in their use of certain materials placed in a particular manner,

the encounter became even more active than Judd and others envisioned. Thus Richard Long creates a giant circle that nearly demands the viewer walk around it to experience its structure and mass; Charles Ray provides a decidedly unsettling encounter with abstract form by placing industrial objects in precarious positions that could at any moment come undone, leading to potential harm (something both explicit and latent in Richard Serra's sculpture as well). Both Long and Ray arrange their forms in relation to one another in a contingent balance, and both employ multiple parts to create a whole, rather as if a Smith sculpture has been taken apart and rearranged on the ground at a viewer's feet.

As may be seen in the sculptures mentioned above, basic forms have fascinated artists ever since the minimalist era (and before, if one thinks of Brancusi, to name but one artist), and this holds true for the artists Anish Kapoor, Martin Puryear, and Liz Larner. Kapoor created a giant, concave cone that hangs on the wall as a painting would but occupies space far exceeding the two dimensions of a stretched canvas. Kapoor's use of deep blue powdered pigment renders the form visually mysterious, suggesting a kind of mysticism but illustrating nothing beyond its own being. Martin Puryear's sculpture likewise exhibits the artist's interest in a geometry of simple shapes, but here the artist's handworking is apparent, as in the unevenly applied silver paint that imparts to the work a suggestion of a tin can or other such device. Liz Larner, too, plays with basic forms—in this case that of the cube, the subject of countless paintings and sculptures of the modern and contemporary eras—by warping the standard lines of two boxes, joining them in an eccentric composition, and painting them in subtle primary colors, all of which suggests a sense of organic growth or transmutation in a form that is normally decidedly staid and rigid.

In their fusion of function and form, Scott Burton and Zaha Hadid created seating that is both sculpture and furniture. In Burton's work, we see the minimalist aesthetic of blocks of material adapted to the needs of a bench, and viewers are encouraged to use Burton's works as seating. Hadid's bench is an echo of streamlined modernity from the Art Deco era, yet in its fully formed, seamless curved character and gleaming media-screenlike sheen, it bears the unmistakable imprint of our own time. In complete contrast in intent to these objects is Sherrie Levine's billiards table, which is taken from a representation of a billiards table in a painting by Man Ray. Here Levine subverts the idea of function by having had manufactured a three-dimensional object from a two-dimensional painting that looks amazingly lifelike and usable but is classically surrealistic in not being so.

If abstract form has been a dominant aesthetic, recognizable objects, either found or handmade, have played an important part in sculpture's trajectory as well. Joseph Cornell's mysterious conglomerations of images and objects contained within the framework of a shallow box present any number of associations that almost seem to be illustrations of a dream. Bruce Conner's assemblages play a similarly mysterious game

in their accumulation of cast-offs brought together in a more deliberately icon-making way. Similarly, Louise Bourgeois deals with detritus and worn-to-the-brink objects that she has placed within cell-like structures. In making their sculptures, all three of these artists relied on the fact that everyone brings to objects certain associations that are inescapable, and when these objects themselves seem to have a history and a certain relation to those around them, the impact can be startling and even unnerving in its uncanny, déjà-vu directness.

Franz West creates sculpture that bears a similar degree of wear and tear and thus a suggested history, but in his work the splattered and textured forms tell us little about their actual function, becoming tools of unknown provenance and utility. David Hammons invests a found stone with human traits by attaching human hair to a roughly human-sized stone, creating a powerfully simple portrait of anonymity that operates within the loaded terrain of African-American stereotype. Tony Cragg, too, uses found materials and has arranged them on a wall to resemble humans and trees, relying on materials to suggest manufactured emotion (the plastic humans) and transformation from one state to the next (the wooden planks upon which are painted trees).

Other artists have devised sculpture that provides an environment for viewers to experience. Rather than producing a single object, Chris Burden has assembled an installation of hundreds of small cardboard submarines. The accompanying text listing each submarine's name is resolutely neutral in its presentation of the bare physical reality of the actual number of submarines the United States produced from the late nineteenth through the late twentieth century. The numerous rectangles that Allan McCollum places side by side soon become, on closer inspection, a pattern; the aesthetic experience is perhaps more manufactured and replicable than we suppose. Dan Graham's pavilions seem almost like petri dishes for human interaction with both other humans and the world around them. Placing viewers in seemingly purposeless structures, Graham addresses, to direct and odd effect, questions about site and place and where we feel we are in the world.

Moving forward with the idea of sculpture as environment are artists who have relied on the inured experience we have in watching television or going to the movies by introducing the moving image into their work. In the past twenty years, and particularly in the past ten, electronic imagery has entrenched itself as a viable artistic tool that reflects and extends the role of media on the world stage and within our more immediate environments. Jenny Holzer uses LED sign technology and public seating to provide an unsettling set of declarations and half-formed narratives spoken by a voice of unknown reason. Tatsuo Miyajima relies on LED technology to create a glowing field of numbers that resembles a nocturnal city seen from the air or the control board of a huge mysterious, perhaps mystical, machine.

Single-channel films have entered the mainstream as well. Bruce Conner's evocative sound and image works were pioneering in their use of found footage of, in one famous work, an oceanic nuclear bomb test site that becomes as cringingly fascinating and ultimately terrifying as the future itself must have looked to those who first witnessed these scenes. Ant Farm creates its own brand of documentary in a Spinal Tap–like "mockumentary" that records a real event—the ramming of a pyramid of television sets with a souped-up sedan— with the satirical panache of 1970s performance artists. Christian Marclay takes found footage from the history of popular movies and creates an oddly touching sequence of people answering the telephone in an array of situations both comic and poignant.

The video installations of Bruce Nauman can also be comic and poignant, but often include situations that are blatantly unsettling. Nauman's use of video and sculpture set the stage for an immersive aesthetic that demanded the full physical participation of the viewer as spectator and subject of a work of art. Bill Viola's work similarly pioneered the role of the image as an overwhelming presence that had to be literally confronted, while Eija-Liisa Ahtila and Shirin Neshat employ a deft placement of screen and image to examine psycho- logical states. Almost uniquely in contemporary media practice, William Kentridge creates animated films of astonishing technical prowess that express poignant human dramas, while Pipilotti Rist uses staged sequences of beguiling color and movement in a deliriously disjunctive way to mimic the wanderings of the mind. All these artists employ the powerful mode of film and our experience with it to create masterful examinations of the interior life of the human psyche.

Rineke Dijkstra, Anri Sala, and Christian Jankowski use film to portray human experience as a kind of documentary. In a half-amused, half-mortified way typical of a teenager, Dijkstra's girl confronts the camera and mouths the words of a pop song that tell a tale of longing that would seem to be well beyond her experience. The artist's straightforward presentation echoes that of Anri Sala's subjects when they talk directly to the camera. Sala however provides a rich and detailed background of archival and contemporary foot- age of his native Albania and his mother's involvement as a young woman in the country's communist past, forcing both a personal and more broadly cultural reconsideration of past and present in the newly democratic country. Christian Jankowski's portrayal of a minister preaching the virtues of making art as an act of religious actualization is a record of a real event: Jankowski is seen lying prone in the position of a deposed figure in a Renaissance devotional painting while the minister conducts an act that is simultaneously performance art and exhortation. The fact that the minister had, himself, been an artist challenges the perhaps too-easy irony with which the work can be met, forcing an examination of what is conveyed through art and belief and whether the two are necessarily mutually exclusive.

Doug Aitken, Jane and Louise Wilson, and Paul Sietsema rely on film to create a sense of geography and place. Aitken's auctioneers perform a Midwestern American opera of registering bids that has as its libretto a staggeringly complex recitation of numbers and phrases. Jane and Louise Wilson register the mysteries of Las Vegas on its off hours as well as the institutionally pristine architecture of the nearby Hoover Dam in a multiple-screen portrait of a mythic site of American popular culture. Paul Sietsema films his own intricately crafted sculpture and architectural models in a hazy evocation of subjective symbols and cultural memory. In one of his most striking sequences, Sietsema, perhaps to examine the residual power of modernism's once-dominant position, recreates the American critic Clement Greenberg's apartment and examples of modernist painting that once hung there.

Finally there are artists who have literally combined the sculptural tradition with the moving image. Nam June Paik's television within a television is the record of an egg hatching while a stuffed chicken and rooster look on in a bed of straw, and a combination of symbols of the natural with the frank artificiality of the television image in a wry yet oddly moving tableau. Janet Cardiff and George Bures Miller use a highly realistic model of a movie theater in which a thriller is being played, and viewers are invited to don headphones to hear the action. From there the experience of the work melds conventions of film and sound with a parallel soundtrack of events that may or may not be happening next to us. The work challenges in an entertaining though serious way our capacity to differentiate the real and the unreal in life and on screen.

The path sculpture has taken from the lone object to the room-scaled installation, from a relatively uniform conception of object confronting viewer to the conception of immersion within an environment, is one that charts the rise of electronic media as a vehicle for addressing art's traditional concerns in new and profoundly intriguing ways. Combined with the collection of the Nasher Sculpture Center, the holdings of the Dallas Museum of Art and its patrons will provide audiences with a virtually unparalleled history of form, material, and experience in the art of the recent past and the present moment.

JOSEPH CORNELL, *Untitled (Trade Winds)*, c. 1956–1958
Box construction, 11 7/8 × 17 × 4 in.
Collection of Marguerite and Robert Hoffman

JOSEPH CORNELL, *Untitled (Pinturicchio Boy)*, c. 1950
Box construction, 15 3/4 × 10 7/8 × 3 7/8 in.
Collection of Marguerite and Robert Hoffman

JOSEPH CORNELL, *Object*, 1941
Box construction, 14½ × 10½ × 3½ in.
Collection of Marguerite and Robert Hoffman

JOSEPH CORNELL, *Pantry Ballet for Jacques Offenbach*,
1942
Box construction, 10⅝ × 14 × 5¼ in.
Collection of Marguerite and Robert Hoffman

LOUISE BOURGEOIS, *Untitled*, 2002
Fabric and stainless steel, 76 × 12 × 10 in.
Deedie and Rusty Rose

LOUISE BOURGEOIS, *Torso*, 1996
Fabric, 12 × 25 × 15 in.
Collection of Marguerite and Robert Hoffman

LOUISE BOURGEOIS, *Cell (You Better Grow Up)*, 1993
Steel, glass, marble, ceramic, and wood, 83 × 82 × 83½ in.
The Rachofsky Collection

BRUCE CONNER, *Knox*, 1963
Mixed media, 39½ × 36½ × 9½ in. including frame
Dallas Museum of Art, DMA/amfAR Benefit Auction Fund, 2005

DAVID HAMMONS, *Head*, 1998
Hair, stone, and metal stand, 14 × 12 × 5½ in.
The Rachofsky Collection

FRANZ WEST, *Sisyphos IX*, 2002
Papier-mâché, Styrofoam, cardboard, lacquer, and acrylic,
68½ × 59¾ × 44 in.
The Rachofsky Collection

FRANZ WEST, *Adaptive* (*Passstueck*), 1978–1980
Papier-mâché, plaster, gauze, and dispersion, 41¾ × 14 × 6 in.
Deedie and Rusty Rose

FRANZ WEST, *Adaptive* (*Passstueck*), 1976
Plaster, plastic tube, and wire, 15¾ × 15¾ × 13¾ in.
Deedie and Rusty Rose

MARTIN PURYEAR, *Noblesse O.*, 1987
Red cedar and aluminum paint, 98⅜ × 58 × 46 in.
Dallas Museum of Art, General Acquisitions Fund and a gift
of The 500, Inc., 1987

SHERRIE LEVINE, *After Man Ray (La Fortune): 6*, 1990
Mahogany, felt, and resin, 33 × 110 × 60 in.
Dallas Museum of Art, anonymous gift, 1999

CHARLES RAY, *Untitled*, 1973 (1993)
Gelatin-silver print, 24 × 32 in.
Promised gift of Sharon and Michael Young
to the Dallas Museum of Art

CHARLES RAY, *One Stop Gallery, Iowa City, Iowa*, 1971/1988
Concrete blocks and painted steel, 360 × 360 in. overall
Dallas Museum of Art, DMA/amfAR Benefit Auction Fund and the
Contemporary Art Fund: Gift of Mr. and Mrs. Vernon E. Faulconer,
Mr. and Mrs. Bryant M. Hanley Jr., Marguerite and Robert K. Hoffman,
Cindy and Howard Rachofsky, Evelyn P. and Edward W. Rose, Gayle
and Paul Stoffel, and two anonymous donors, 2001

TONY CRAGG, *Tree*, 1982
Painted wood construction, 115 × 85 in.
Deedie and Rusty Rose

ANISH KAPOOR, *Void #2*, 1988–1991
Fiberglass and pigment, 81 × 81 × 45½ in.
Dallas Museum of Art, gift of the Friends of Contemporary Art, 1993

Electronic Media Works

PAUL SIETSEMA, *Empire*, 2002
16-mm film in black-and-white and color without sound, shown on Eiki projector; running time: 24 min.
Dallas Museum of Art, Lay Family Acquisition Fund, 2002

SHIRIN NESHAT, *Soliloquy*, 1999
Two-channel video and sound installation; running time: 17 min. 33 sec.
Dallas Museum of Art, the Contemporary Art Fund: Gift of Mr. and Mrs. Vernon E. Faulconer, Mr. and Mrs. Bryant M. Hanley Jr., Marguerite and Robert K. Hoffman, Howard E. Rachofsky, Evelyn P. and Edward W. Rose, Gayle and Paul Stoffel, and two anonymous donors; the Lay Family Acquisition Fund; and the DMA/amfAR Benefit Auction Fund, 2000

ROSEMARIE TROCKEL, *For Example, Balthasar, Age 6 (z.B. Balthasar, 6 Jahre)*, 1996
Single-channel video and sound installation; running time: 10 min.
Dallas Museum of Art, anonymous gift, 1998

PIPILOTTI RIST, *I Couldn't Agree with You More*, 1999
Video and sound installation with two projectors and two players; running time: part 1 of 2 (face) 9 min. 36 sec. loop; part 2 of 2 (forest) 8 min. 35 sec. loop
The Rachofsky Collection

RINEKE DIJKSTRA, *Annemiek (I Wanna Be with You)*, *11-02-97*, 1997
Video projection; 4-min. loop
The Rachofsky Collection

CHRISTIAN JANKOWSKI, *The Holy Artwork*, 2001
One Beta sub-master, one DVD; running time: 15 min. 52 sec.
The Rachofsky Collection

CHRISTIAN MARCLAY, *Telephones*, 1995
Single-channel video and sound installation; running time:
7 min. 30 sec.
Dallas Museum of Art, Campbell Contemporary Fund, 1999

JANE AND LOUISE WILSON,
Las Vegas, Graveyard Time, 1999
Video and sound installation; running time: 7 min. 34 sec. loop
Dallas Museum of Art, Lay Family Acquisition Fund, 2001

ANRI SALA, *Intervista*, 1998
Single-channel video and sound installation; running time: 26 min.
Dallas Museum of Art, Lay Family Acquisition Fund, 2002

VALESKA SOARES, *Tonight*, 2002
DVD projection; running time: 8 min. loop
Deedie and Rusty Rose

ANT FARM, *Media Burn*, 1975, remastered 1983
Single channel projection; running time: 23 min. 50 sec.
Dallas Museum of Art, Laura and Walter Elcock Contemporary
Art Fund, 2005

BRUCE CONNER, *Crossroads*, 1976
16-mm film transferred to DVD, black and white, with sound;
running time: 36 min.
Dallas Museum of Art, gift of Michael Kohn Gallery, 2005

WILLIAM KENTRIDGE, *History of the Main
Complaint* and *Felix in Exile*, 1994
Laser disc; running times: 6 min. and 8 min.
The Rachofsky Collection

EIJA-LIISA AHTILA, *Talo/The House*, 2002
Three-channel video and sound installation; running time:
15 min. 50 sec. loop
The Rachofsky Collection and the Dallas Museum of Art: DMA/amfAR
Benefit Auction Fund, 2002

BRUCE NAUMAN, *Setting a Good Corner*
(Allegory and Metaphor), 1999
Video and monitor; running time: 60 min.
The Rachofsky Collection

JENNIFER STEINKAMP, *Eye Catching*, 2003
Laptop computers and projectors; dimensions variable
Deedie and Rusty Rose

DOUG AITKEN, *these restless minds*, 1998
Three laser discs in three-channel video installation;
running time: 8 min.
Dallas Museum of Art, Lay Family Acquisition Fund, 1999

BRUCE NAUMAN, *Shadow Puppet Spinning Head*, 1990
Wax head, white sheet, video projector, video monitor, videotape
player, and videotape; dimensions variable
The Rachofsky Collection and the Dallas Museum of Art through the
DMA/amfAR Benefit Auction Fund and Contemporary Art Fund:
Gift of Arlene and John Dayton, Mr. and Mrs. Vernon E. Faulconer,
Mr. and Mrs. Bryant M. Hanley Jr., Marguerite and Robert K. Hoffman,
Cindy and Howard Rachofsky, Evelyn P. and Edward W. Rose, Gayle
and Paul Stoffel, and two anonymous donors, 2004

CARDIFF AND MILLER, *Muriel Lake Incident*, 1999
Wood, audio, video projection, and steel, 72½ × 90¼ × 62 in.
Collection of Marguerite and Robert Hoffman

NAM JUNE PAIK, *TV Farm*, 1986
Mixed media: color TV set, videotape of chickens hatching,
and auto-rewind videocassette recorder, 37¾ × 26½ × 25¼ in.
Deedie and Rusty Rose

JENNY HOLZER, *Laments: Death came
and he looked like...*, 1989
LED sign and verde antique marble; sign: 128 × 9½ × 5¼ in.
sarcophagus: 18 × 24 × 54 in.
The Rachofsky Collection

TATSUO MIYAJIMA, *Counter Ground*, 1998–2000
LED, ion-exchange chromatography, electric wiring, and wooden panel,
4½ × 236¼ × 236¼ in.
Dallas Museum of Art, gift of the Friends of Contemporary Art, 1999

BILL VIOLA, *The Crossing*, 1996
Video and sound installation; 105 × 330 × 670 in.;
running time: 12 min.
Dallas Museum of Art, Lay Family Acquisition Fund,
General Acquisitions Fund, and gifts from an anonymous
donor, Howard E. Rachofsky, Gayle Stoffel, Mr. and Mrs.
William T. Solomon, Catherine and Will Rose, and Emily
and Steve Summers, in honor of Deedie Rose, 1998

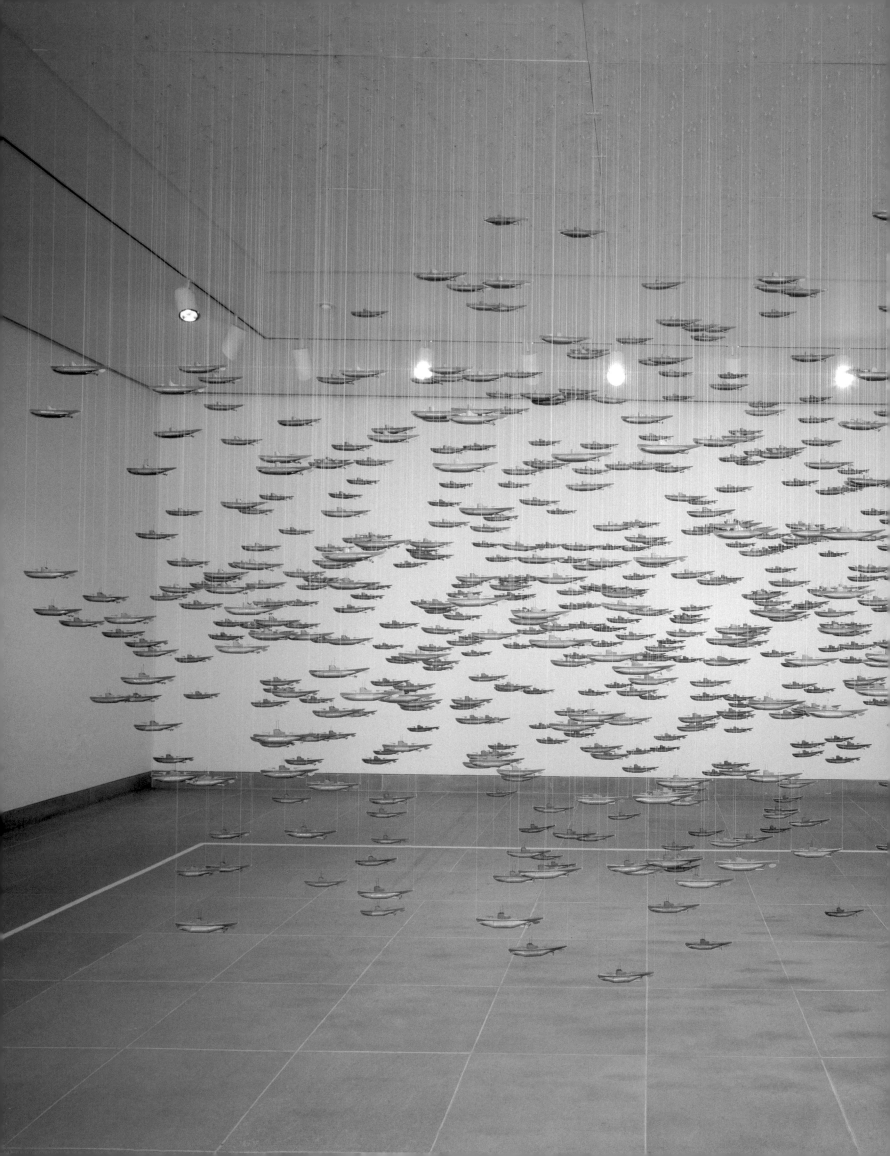

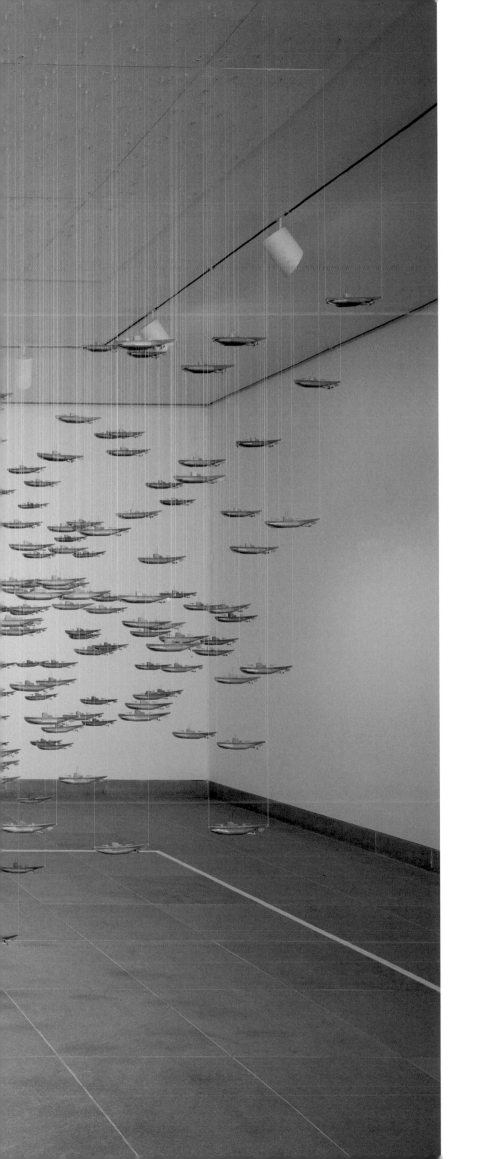

CHRIS BURDEN, *All the Submarines of the United States of America* (detail), 1987
Six hundred and twenty-five cardboard submarines suspended from filament, plastic type on wall, binder, 158 × 216 × 144 in.
Dallas Museum of Art purchase with funds donated by the Jolesch Acquisition Fund, The 500, Inc., the National Endowment for the Arts, Bradbury Dyer III, Mr. and Mrs. Bryant M. Hanley Jr., Mr. and Mrs. Michael C. Mewhinney, Mr. and Mrs. Edward W. Rose, and Mr. and Mrs. William T. Solomon, 1988

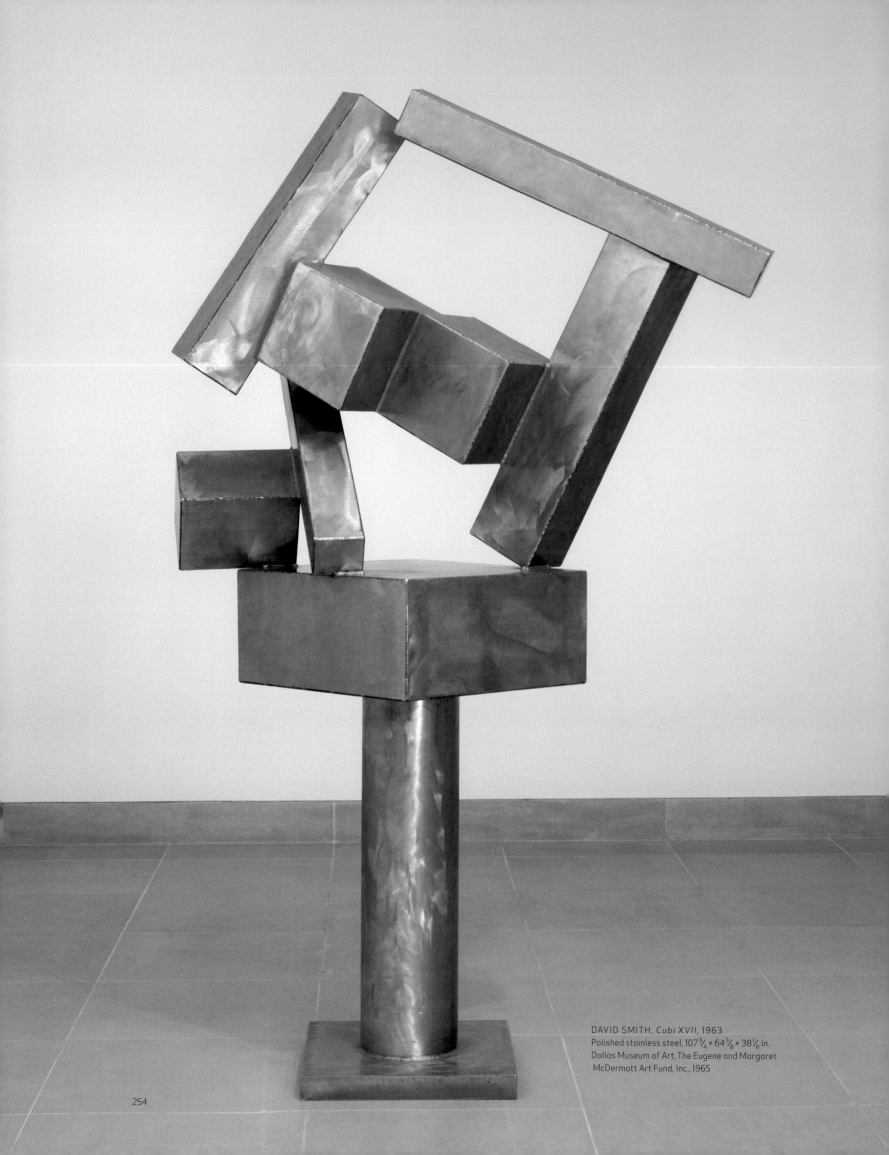

DAVID SMITH, *Cubi XVII*, 1963
Polished stainless steel, 107¾ × 64⅜ × 38⅛ in.
Dallas Museum of Art, The Eugene and Margaret
McDermott Art Fund, Inc., 1965

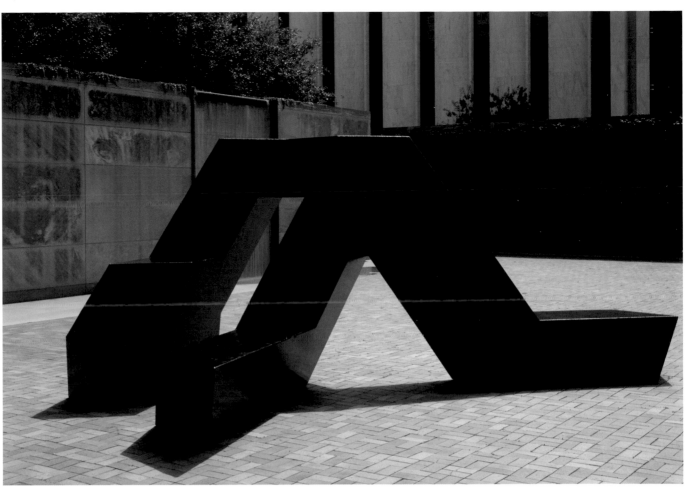

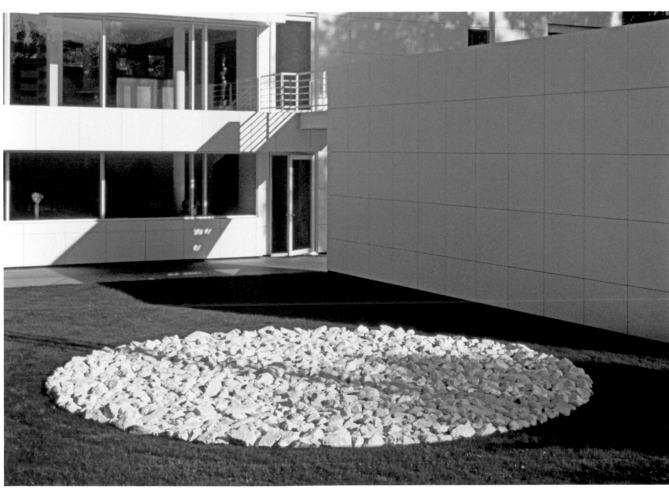

TONY SMITH, *Willy*, designed 1962, fabricated 1978
Steel, 91¼ × 224 × 135 in.
Dallas Museum of Art, Irvin L. and Meryl P. Levy Endowment
Fund and General Acquisitions Fund, 1977

RICHARD LONG, *Rochechouart Circle*, 1990
Kaolin stone, 120 in. diameter
The Rachofsky Collection

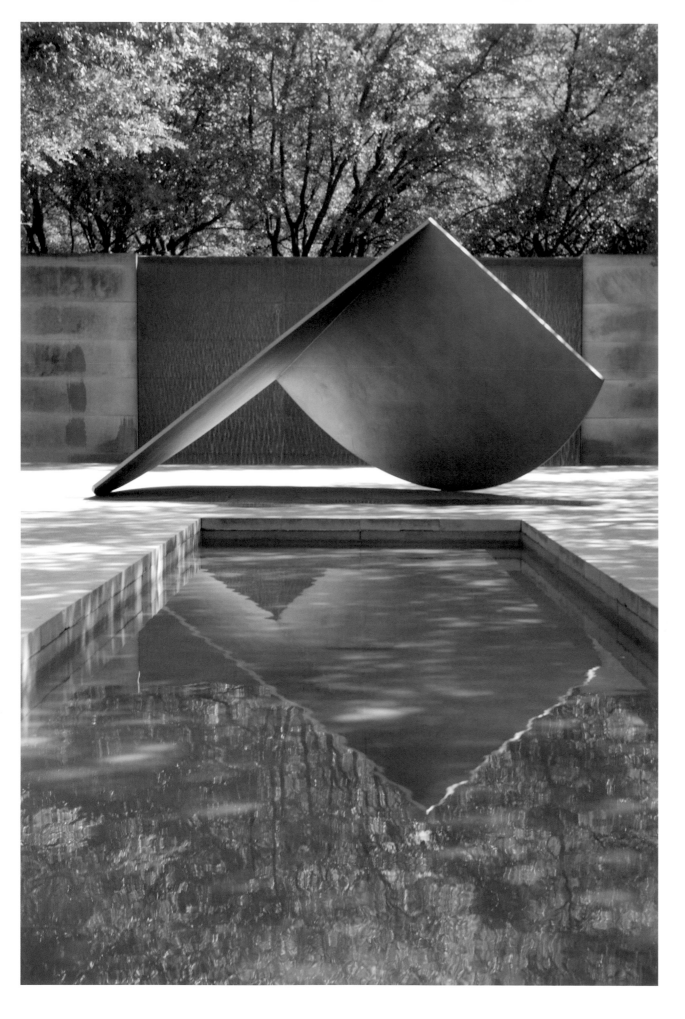

ELLSWORTH KELLY, *Untitled*, 1982–1983
Stainless steel, 120 × 228 × 204 in.
Dallas Museum of Art, commission made possible through funds
donated by Michael J. Collins and matching grants from The 500, Inc.,
and the 1982 Tiffany & Company benefit opening, 1983

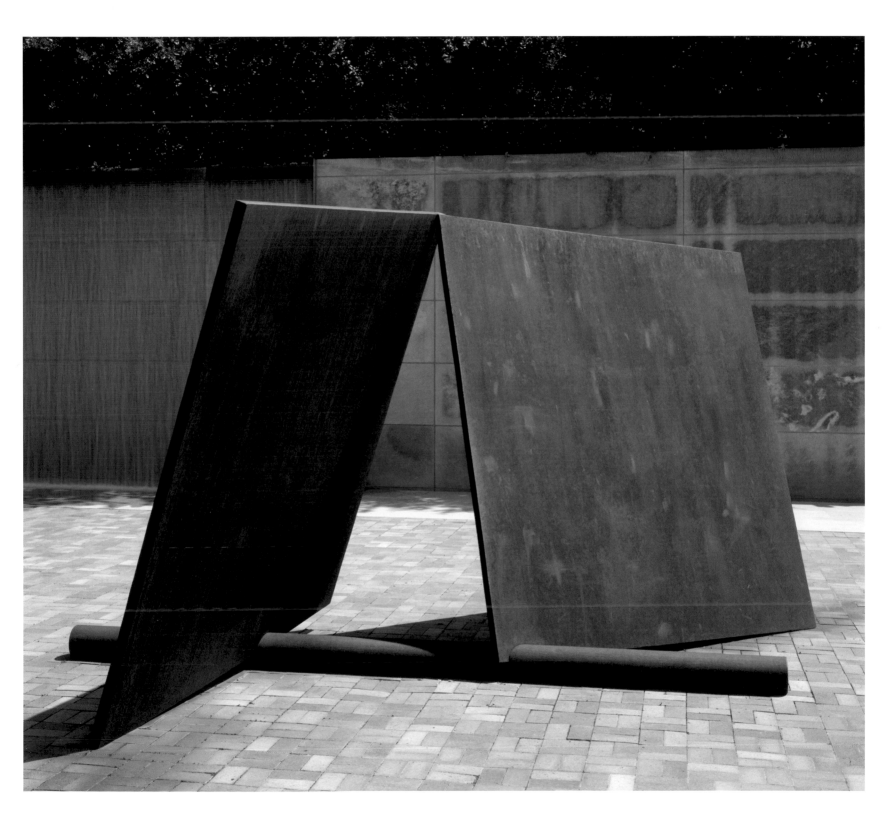

RICHARD SERRA, *Untitled*, 1971
Cor-Ten steel, 96 × 192 × 150 in.
Dallas Museum of Art, matching grants from the National Endowment
for the Arts and The 500, Inc., in honor of Mr. and Mrs. Leon Rabin, 1976

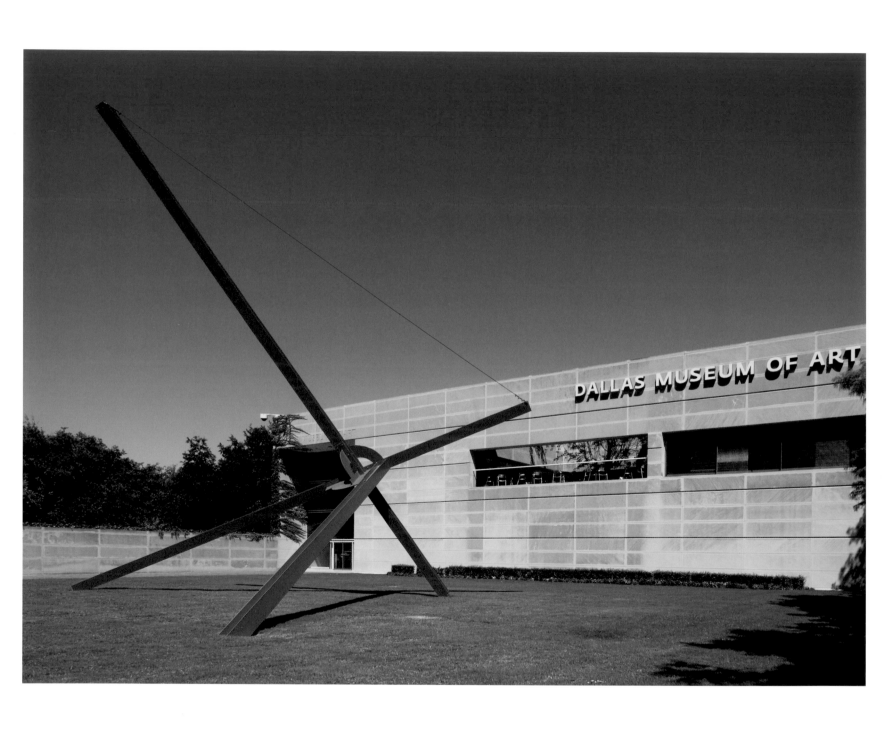

MARK DI SUVERO, *Ave*, 1973
Painted steel, 478 × 370 × 545 in.
Dallas Museum of Art, Irvin L. and Meryl P. Levy Endowment Fund, 1976

DAN GRAHAM, *Argonne Pavilion II*, 1998
Stainless-steel frame and floor, clear glass, and two-way mirror,
$101\frac{1}{2} \times 200\frac{1}{4} \times 200\frac{1}{4}$ in.
Dallas Museum of Art, fractional gift of The Rachofsky Collection,
2001

JOEL SHAPIRO, *Untitled*, 1991
Bronze, 84 × 125 × 54 in.
Dallas Museum of Art, fractional gift of The Rachofsky Collection,
2001

JUAN MUÑOZ, *Conversation Piece (1)*, 1991
Bronze, 54 × 30 × 30 in.
Deedie and Rusty Rose

SCOTT BURTON, *Granite Settee*, 1982–1983
Granite, 158 × 216 × 144 in.
Dallas Museum of Art, purchase through a grant from the National
Endowment for the Arts with matching funds from Robert K. Hoffman,
the Roblee Corporation, Laura L. Carpenter, Nancy M. O'Boyle, and
an anonymous donor, 1983

ZAHA HADID, *Bench*, 2006, designed 2003
Cast aluminum, 46½ × 166 × 55 in.
Dallas Museum of Art, gift of the Junior Associates, 2005

LIZ LARNER, *Two as Three and Some Too for Howard Rachofsky*, 1999–2000
Stainless steel, fiberglass, and paint, 120 × 120 × 112 in.
The Rachofsky Collection

JEFF KOONS, *Balloon Flower (Magenta)*, 1995–1999
Stainless steel and transparent color coating, 114 × 132 × 108 in.
The Rachofsky Collection

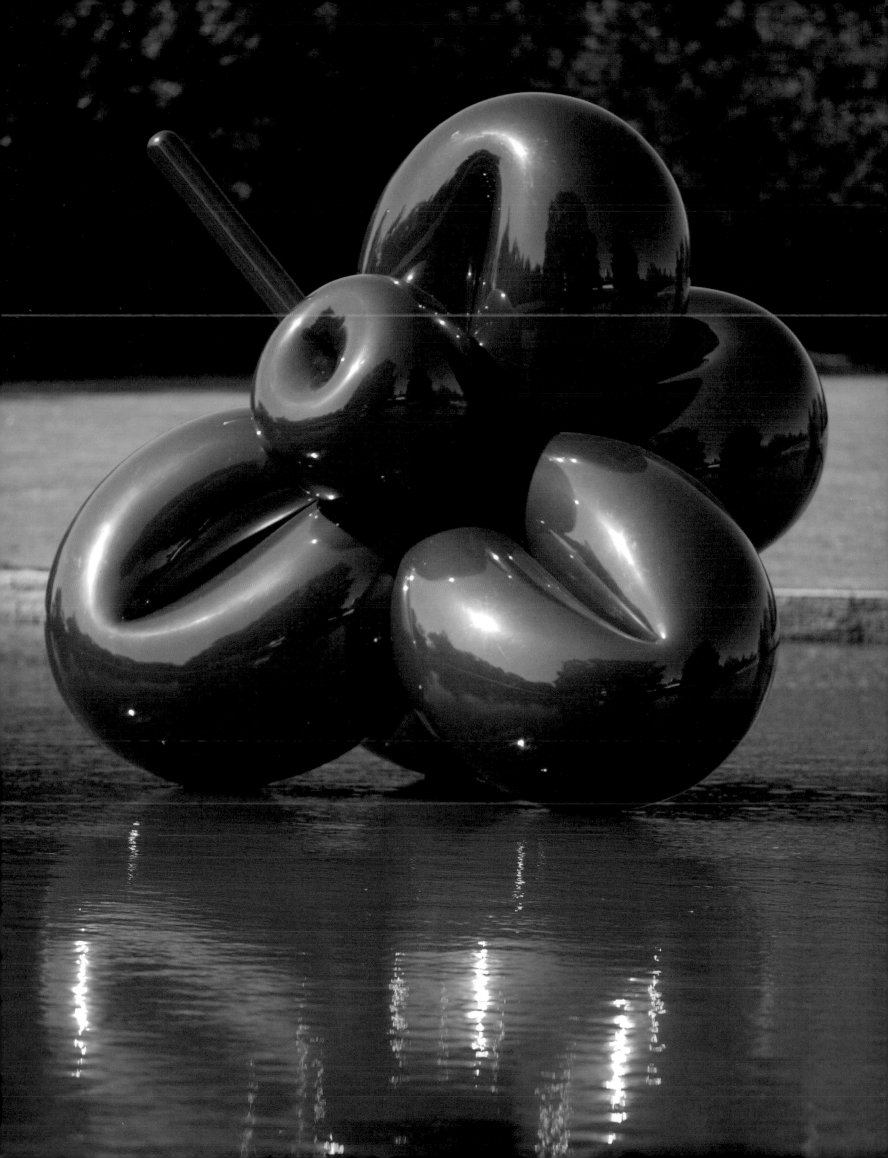

María de Corral

The *Territories* of *Art*

You have to love art once its beauty is revealed to you.

IN THE PAST TWO DECADES the beauty in art has not been immediately apparent to us; we have had to look for it and to find it for ourselves. Since the 1990s, art has been unquestionably linked to the Western world's political, social, and cultural circumstances and, in the challenge of creating art that is meaningful in this new context, artists have tried to find new explanations and answers.

The 1990s offer a marked contrast to the panorama of expressive individualities that was characteristic of the 1980s and reflect the breakdown of the certainties in which modernity developed. We find ourselves facing the end of the grand stories, the end of an unshakable faith in reason and the conviction that the development of knowledge and technological progress will make the world more equable and fair. It is the end of the belief that history is a progression and its achievements are invariably directed toward freeing society and the individual. In this now-disquieting place, artists find themselves needing to rethink subject, body, identity, and so on, to undertake a new reading of history, and to consider the discourse of diversity and the languages of other cultures.

Artists have become researchers in different disciplines and areas of knowledge. The artwork has acquired a process-oriented and fragmentary sense. Its conceptual reflection overshadows its visual appearance. Thus, we find ourselves facing artistic practices that are much more oriented toward concepts than toward visual gratification, an art more steeped in thought than in pleasure or comfort.

Never before has art been so demanding, not only in its reading and interpretation, but also in the very roots of its existence. Because today's artistic discourse is neither closed nor finished, different artistic practices have made huge changes in the relations between an artwork and how it is received by the viewer. In order for art to take on its full meaning, it must be understood as the practice—both aesthetic and ethical—of making and remaking reality, a process that must be carried out by both the artist and the viewer.

At this time of apparent globalizing uniformity, what current artists share is not a style but rather their efforts to build personal aesthetic universes and to defend their spaces and their worldviews, to put forth their own formal necessities and to build themselves a new reality. The particular territories of intimacy, interpersonal relations, the expression of desire, of fragility, of the purely emotional are subjects of exploration in which art made by women has made a decisive contribution. Yet, while the artists may share a new territory, their maps are their own; this exhibition and catalogue offer some notes on their journeys.

In order to build awareness, Robert Gober tries to mobilize the spectator with fragmented stories of love, death, and loss. In these, he expresses the need to redefine the body outside tradition, through its fragments, its dismemberment, or as an alteration of gender or identity.

Cindy Sherman shows us the degree to which we are exposed to a life that obliges us to play the most varied roles—which we struggle to do without even realizing it—and how our personalities change or begin to disintegrate as a result of media and social pressure.

In Julião Sarmento's work, images are always fragmented and limited, creating uncertainty and the conviction that everything appearing in his works lacks a definitive, unmistakable aspect.

The narrative of experiences lived by those who are beset by violence, and her own striving to understand and transmit what it means to suffer its effects, is the central subject of Doris Salcedo's work. Beyond mere testimony, her pieces seek to be the memory of a world that is consciously or unconsciously forgotten.

Tony Oursler always uses two systems of signs: text and the language of images. His work focuses on basic psychic and emotional aspects of today's man, such as his behavior, desires, vices, and dreams.

A fascinating aspect of Mona Hatoum's work is her imaginative and virtuosic use of unorthodox materials. Her works are imbued with ideas relating to the body, identity, gender, politics, and culture. Her work simultaneously attracts and repels us.

Janine Antoni conceives her work as a continuing process, just like the everyday activities that shape our existence.

In an unorthodox way, Kiki Smith draws on aspects of the classical ideals of beauty and, at the same time, rejects them, taking the body's existential expressive power as her central subject in order to let life speak for itself, with its own emotional language.

An interest in defining our surroundings on the basis of one's own experience, one's own skin and body, and the space one occupies, is the theme around which Ron Mueck's work revolves.

Jim Hodges tests the meaning of reality by imagining fictitious scenarios, which he then sets down in drawing, sculpture, photography, and installations.

Félix González-Torres, metaphorically expressing the poetic and transitory nature of the human experience, places his works in the ambiguous space of the individual.

Each piece by Matthew Barney is ambivalent in its original composition and its nature. The works always belong to more than one category at a time: object and image, object and performance, body and machine. He often makes a world that is, itself, a complex and labyrinthine field.

Drawing is the medium of expression chosen by Raymond Pettibon in works that contain the favorite themes of comics: violence, sex, the culture of gay bodybuilders, sports, and military life. His drawings are often accompanied by written sentences, and together they expose social, political, and sexual prejudice.

Maurizio Cattelan uses humor as a paradox to blur the line between illusion and reality, artifice and truth, the momentary and eternity.

IN CONTEMPORARY ART'S PROCESS of hybridizing languages, the notion of the image has played an essential role in the transformation of artistic expression. The proliferation of images in our culture has created an area of fiction, a floating universe of evanescent realities that have come to destabilize our beliefs about what is real. This situation has led to considerable questioning of the mechanisms of representation and their influence on the perceptions prevalent in our modern and advanced society. But, at the same time, it has permitted new relations with what is visible, making it possible to shape the appropriation of reality in other ways.

Photography, which was previously used as a vehicle for information and documentation, has become an important means of expression and experimentation. For some time, both video and photography have been forceful presences in museums, by now so much a part of the idea of what is contemporary that they have managed to blur the lines that once separated them from traditional forms of artistic representation such as painting and sculpture.

Since the 1980s, a select group of New York–based artists have concentrated their work, using photography, on the meaning of art in the era of media consumption and on the meaning of representation in this art. Artists such as Richard Prince, Cindy Sherman, Jenny Holzer, and Barbara Kruger include in their work symbols, images, slogans, and stereotypes that pose questions about the social context in which words and images function and manipulate us. They explore the instability, the ambiguity, the fragility, and the falseness of the cultural structures of *classic* representations of contemporary subjects. These are artists who are aware of themselves more as a vehicle than as the end of a discourse. Others, such as Gregory Crewdson and Nic Nicosia, renounce the illusion of being objective witnesses and instead use their art as an instrument that allows them to reconcile the fictitious with a means of capturing what is real. In order to reconstruct a narrative, they establish various levels of representation, involving the viewer, too, in an ambivalent play

of reality and fiction. The theatricality of their photographic images acquires a sense of credibility through their relation with a real scene created by photography itself. The spiritual and emotional values of light in architecture are represented in pictorial style in the photos of James Casebere. There, he creates a clear approach to the senses, perception, and relations of time and space.

European photographers provide us with an intimate and psychological medium for our communication. Starting from their individual vision and feeling, their work transforms reality and establishes a relationship between photography, psychology, and sociology. German photography has always had a coolness in the choice of motifs and in the manner of framing them and capturing them. Every detail in the images is clearly visible, but stripped of its daily function, of any sense of attachment. German artists are part of a long history and an intense relationship with the most existential, social, and even aesthetic aspects of photography. For Thomas Ruff, Thomas Struth, and Thomas Demand, photography is a current and universal medium in which form and content, mind and spirit, are inseparably mixed, constituting a new way of thinking about reality.

The British artist Saul Fletcher portrays mainly his habitat, his personal objects, and his intimacy in small, intense photographs that are like sealed boxes of urban anxiety.

Willie Doherty addresses the representation of violence in a subtle manner, creating a claustrophobic atmosphere in his works. More than simply landscapes, his photographs are a reflection of the political history of his native Ireland.

Olafur Eliasson suggests in his photographic work that perception must be studied and understood within the context of one's environment and as a construct of one's culture. The scenario chosen for his work is always Iceland, with its majestic landscapes that are a living manifestation of nature, almost uncontaminated by progress.

IT IS ONLY RECENTLY that painting has been readmitted as a language, accepted as a reasonable art form through which to express the complexity of our time. Painters of the new generation do not conceive art in a militant way, nor do they try to create an all-encompassing pictorial paradigm to replace or even be the equivalent of the natural order. They use modern art styles as meanings rather than as ends, ignoring norms and prejudices in order to relate forms and theories that would previously have been opposed to one another.

They all share one thing: they are not painting images of the world, they are painting only images *about* the world. Painting has become an instrument that allows them to create an entirely personal art using the wealth of data, facts, and impressions produced by the multifaceted worlds of our daily life. Here, at the beginning of the twenty-first century, we are again able to contemplate paintings that are being made now, with open eyes.

In Sue Williams's work, figurative elements have been taken to such an extreme that they exist on the borderline between abstraction and the imagery of the subconscious, but without ever losing the perversity and humor of her early work.

The work of Guillermo Kuitca is rooted in a philosophical reflection on loneliness, a universal theme that he has developed through biographical references; this philosophical character goes beyond the dialogue between figuration and abstraction, between painting and architecture. In his paintings he uses a process that runs from the treatment of the surface as an abstract play of lines and objects to the representation of a possible space. This space can be real, but it is also abstract, isolated in time, with no links to enable us to recognize its origin or its destination.

Peter Doig's paintings of fictitious landscapes and interiors are often imbued with a sense of mystery and magic; the scenes he depicts possess the hazy quality of distant memories. He uses motifs from the worlds of photography and the cinema to create the magical atmosphere of his paintings that entice the viewer into a strange world that lies somewhere in the unconscious.

In making her paintings, Laura Owens accepts any ideas that come into her imagination. In a language that mixes photos and copies, pieces of printed cloth, illustrations, and other paintings, she insists on the coexistence of abstraction and representation.

The work of Luc Tuymans encourages fundamental questions about our understanding of pictures in general and of painting in particular. He addresses issues such as the relationship between document and fiction, the perception of history in pictorial terms, and the political side of painting.

Franz Ackermann has made travel the method and the subject matter of all his artistic work, which is on two scales. On the one hand are the small-format works, or Mental Maps; on the other, the large-format pieces, where he produces a surprising deviation from reality.

Matthew Ritchie has built an imaginary world, a synthetic visual language, a working model that uses signs parallel to the languages of religion, science, alchemy, and aesthetics. This vocabulary is used first to build a model, an artificial universe, and then, within the artwork, to describe a story. His paintings are made with a simplicity that reflects the now almost impossible goal of constructing a coherent world.

It is clear that it is not possible today to offer an all-encompassing view of the achievements of contemporary art. Their work reveals the drastic changes in the role that artists play in society and culture and demonstrates how many different forms of art have become fields of exchange, rather than of expression. In this future we are constructing, artists will probably not be dedicated exclusively to redefining art; they may well be an important part of the redefinition of our lives.

CARROLL DUNHAM, *Shape with Points*, 1989–1990
Vinyl paint, acrylic, and pencil on cotton, 66⅜ × 87⅞ in.
The Rachofsky Collection

VERNON FISHER, *Horta*, 1991
Oil and blackboard slating on tempered hardboard
and wood, 111 × 119½ × 9 in.
Promised gift of Amy and Vernon Faulconer to the
Dallas Museum of Art

SARAH MORRIS, *The Endeavor (Los Angeles)*, 2005
Household gloss paint on canvas, 84¼ × 84¼ in.
Dallas Museum of Art, DMA/amfAR Benefit Auction Fund, 2006

CHRISTOPHER WOOL, *Untitled*, 1990
Enamel on aluminum, 108 × 72 × 1⅛ in.
Dallas Museum of Art, gift of the Friends of Contemporary Art, 1991

THESHOWISOV
ERTHEAUDIE
NCEGETUPTOL
EAVETHEIRSE
ATSTIMETOC
OLLECTTHEIR
COATSANDGOH
OMETHEYTUR
NAROUNDNOM
ORECOATSAN
DNOMOREHOME

JULIÃO SARMENTO, *Emma (32)*, 1991
Mixed media on canvas, 75 × 86¾ in.
The Rachofsky Collection

ONE NIGHT A JETLINER FLEW A LITTLE TO CLOSE TO MY HOUSE. I WAS WALKING FROM THE BEDROOM TO THE KITCHEN AND THE STEWARDESS TOLD ME TO SIT DOWN.

RICHARD PRINCE, *Too Close*, 2001–2002
Acrylic on canvas, 54 × 168 in.
The Rachofsky Collection

ROBERT GOBER, *Untitled Leg*, 1989–1990
Wax, cotton, wood, leather, and human hair, 12½ × 5½ × 20 in.
Collection of Marguerite and Robert Hoffman

ROBERT GOBER, *Untitled*, 2000–2001
Willow, wood, beeswax, human hair, silver-plated cast brass,
and pigment, 16 × 32½ × 26 in.
The Rachofsky Collection

ROBERT GOBER, *Untitled*, 2003–2005
Bronze and oil paint, 9 × 46½ × 61 in.
The Rose Collection and the Rachofsky Collection

CINDY SHERMAN, *Untitled #302*, 1994
Color photograph, 67 × 45 in.
The Rachofsky Collection

CINDY SHERMAN, *Untitled #306*, 1994
Cibachrome print, 76 × 51 in.
The Rachofsky Collection

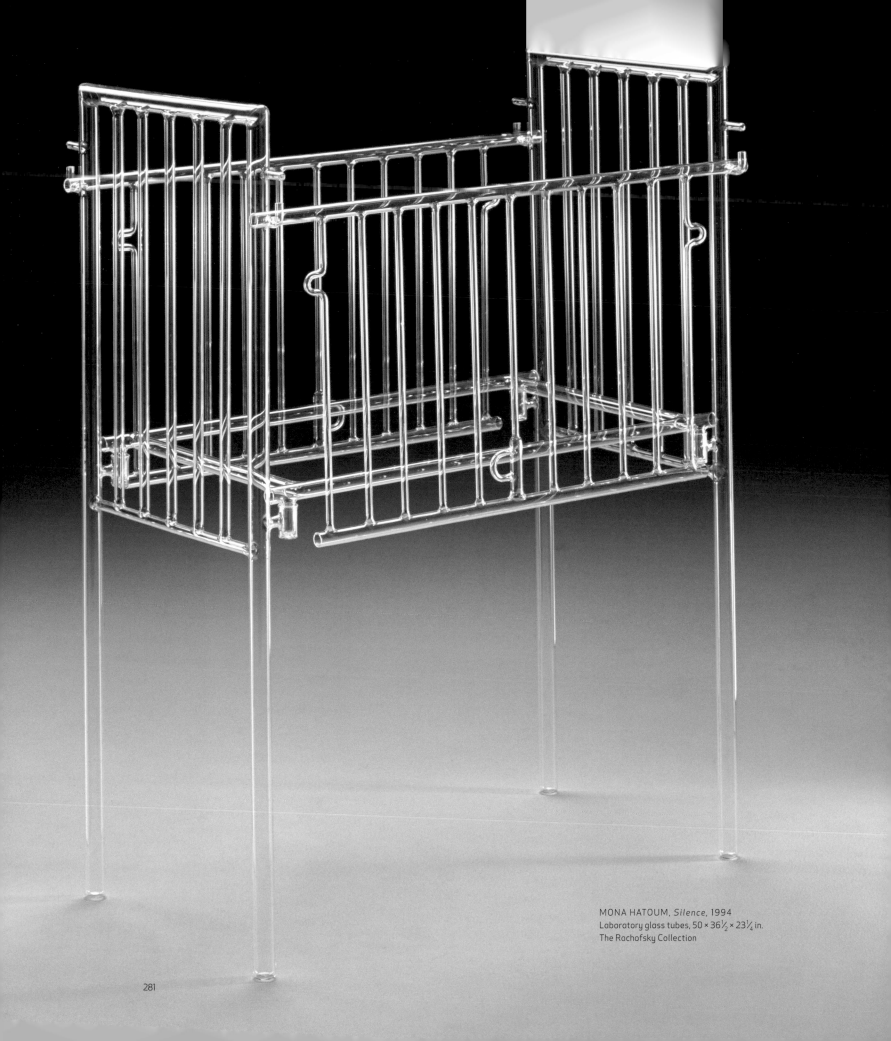

MONA HATOUM, *Silence*, 1994
Laboratory glass tubes, 50 × 36½ × 23¼ in.
The Rachofsky Collection

RACHEL WHITEREAD, *Untitled (Air Bed)*, 1992
Plaster, polystyrene, and steel, 9 x 76½ x 47½ in.
Collection of Marguerite and Robert Hoffman

DORIS SALCEDO, *Untitled*, 2001
Wood, concrete, glass, fabric, and steel, 80⅛ × 67 × 50 in.
The Rachofsky Collection

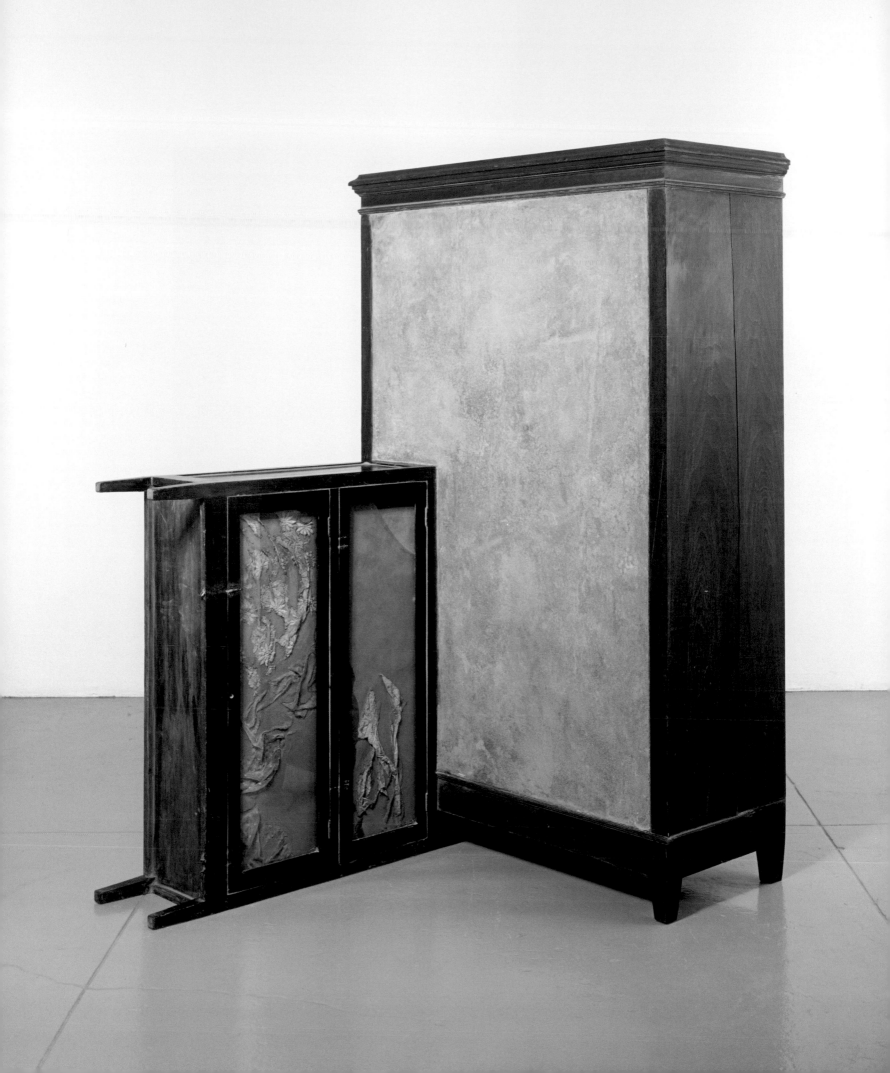

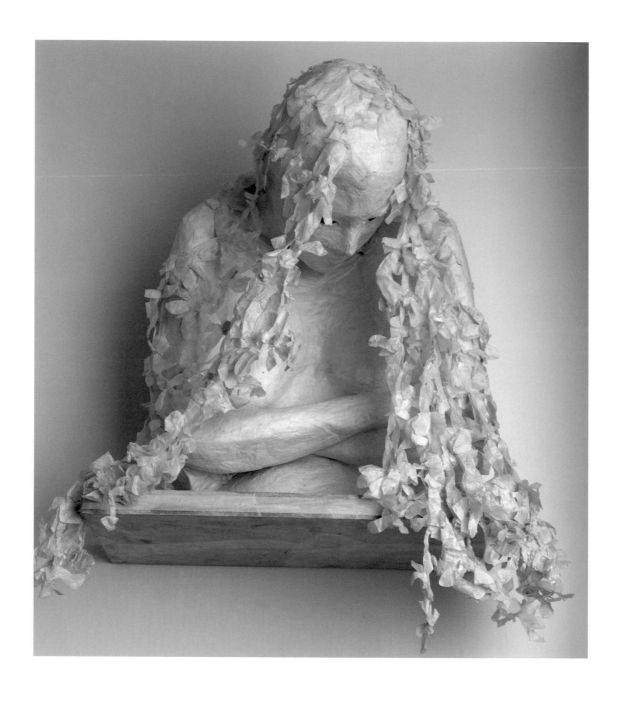

KIKI SMITH, *Daisy Hair*, 1994
Papier-mâché, nepal paper, glass eyes, and wood, 27 × 18 × 17 in.
The Rachofsky Collection

KIKI SMITH, *Virgin*, 1993
Papier-mâché, glass, and plastic, 60 × 18½ × 9 in.
The Rachofsky Collection

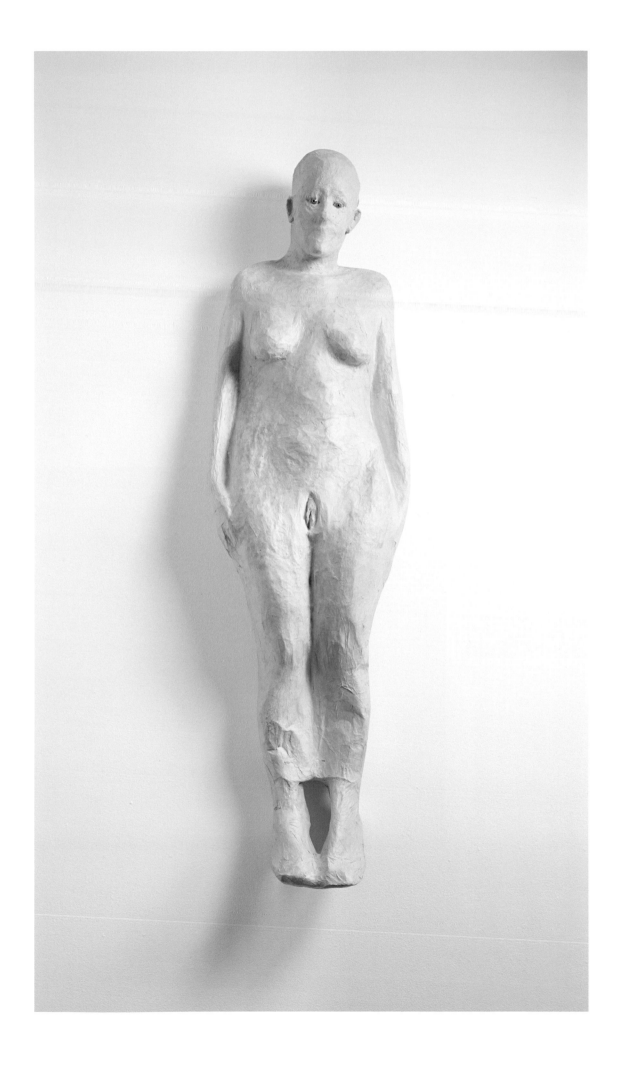

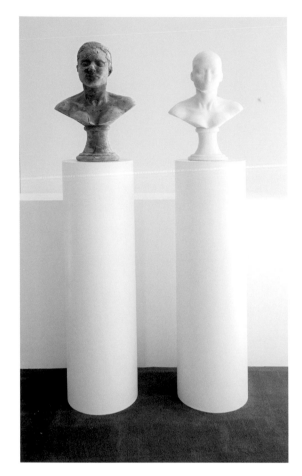

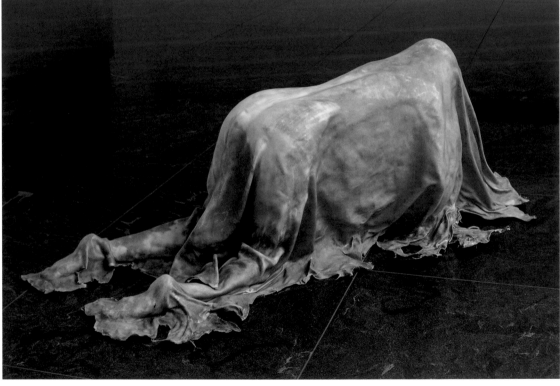

JANINE ANTONI, *Lick and Lather*, 1993
Chocolate and soap busts; each 24 × 15 × 13 in.,
overall dimensions variable
The Rachofsky Collection

JANINE ANTONI, *Saddle*, 2000
Full rawhide, 25½ × 78½ × 32½ in.
The Rachofsky Collection

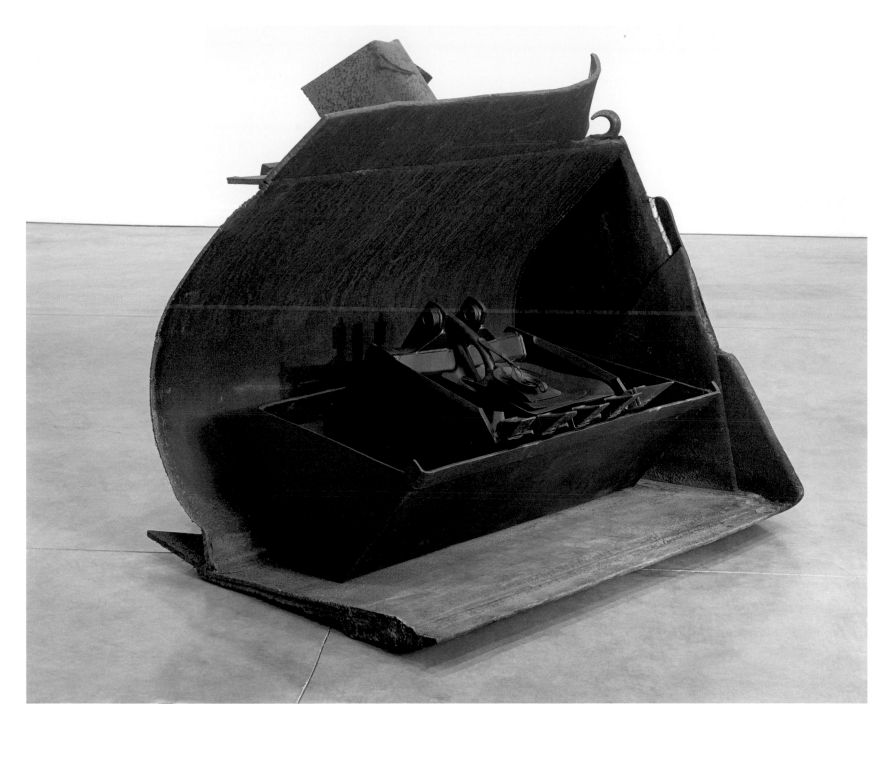

JANINE ANTONI, *Cradle*, 1999
Steel, 72 × 60 × 48 in.
The Rachofsky Collection

TONY OURSLER, *MMPI Test Dummy*, 1993
Cloth head, brown polyester suit, Quasar LCD color monitor
projector, Panasonic videocassette recorder, one hinged piece
of wood, and videotape; dimensions variable
The Rachofsky Collection

RON MUECK, *Angel*, 1997
Silicone rubber and mixed media, $43\frac{1}{2} \times 34\frac{1}{4} \times 31\frac{7}{8}$ in.
Collection of Marguerite and Robert Hoffman

FÉLIX GONZÁLEZ-TORRES, "Untitled" (Perfect Lovers),
1987–1990
Wall clocks; overall 13½ × 27 × 1¼ in.
Dallas Museum of Art, fractional gift of The Rachofsky Collection,
2001

FÉLIX GONZÁLEZ-TORRES, "Untitled" (L. A.), 1991
Green candies, individually wrapped in cellophane, endless supply;
dimensions vary with installation; ideal weight: 50 lb.
The Rachofsky Collection

JIM HODGES, *Far*, 1996
Silver-plated chain, dimensions variable
The Rachofsky Collection

JIM HODGES, *Changing Things*, 1997
Silk, plastic, and wire, 76 × 148 in.
Dallas Museum of Art, Mary Margaret Munson Wilcox Fund and
gift of Catherine and Will Rose, Howard Rachofsky, Christopher Drew
and Alexandra May, and Martin Posner and Robyn Menter-Posner,
1998

MATTHEW BARNEY, *CREMASTER 3: The Entered Novitiate*, 2002
Chromogenic print in acrylic frame, 54 × 44 in.
Dallas Museum of Art, Contemporary Art Fund: Gift of Arlene
and John Dayton, Mr. and Mrs. Vernon E. Faulconer, Mr. and Mrs. Bryant
M. Hanley Jr., Marguerite and Robert K. Hoffman, Cindy and Howard
Rachofsky, Evelyn P. and Edward W. Rose, Gayle and Paul Stoffel,
and three anonymous donors; DMA/amfAR Benefit Auction Fund; and
Roberta Coke Camp Fund, 2003

MATTHEW BARNEY, *CREMASTER 3: Hiram Abiff*, 2002
Chromogenic print in acrylic frame, 54 × 44 in.
Dallas Museum of Art, Contemporary Art Fund: Gift of Arlene
and John Dayton, Mr. and Mrs. Vernon E. Faulconer, Mr. and Mrs. Bryant
M. Hanley Jr., Marguerite and Robert K. Hoffman, Cindy and Howard
Rachofsky, Evelyn P. and Edward W. Rose, Gayle and Paul Stoffel,
and three anonymous donors; DMA/amfAR Benefit Auction Fund; and
Roberta Coke Camp Fund, 2003

MATTHEW BARNEY, *CREMASTER 3: The Cloud Club*, 2002
Mason and Hamlin Symetrigrand piano with stainless steel, silver,
white mother-of-pearl, gold lip mother-of-pearl, black lip mother-
of-pearl, green abalone, quartersawn Honduras mahogany, lacewood,
walnut, ash burl, redwood burl, madrone burl, and Chilean laurel
marquetry; internally lubricated plastic; potatoes, concrete, and
sterling silver, 57 × 108 × 84 in.
Dallas Museum of Art, Contemporary Art Fund: Gift of Arlene
and John Dayton, Mr. and Mrs. Vernon E. Faulconer, Mr. and Mrs. Bryant
M. Hanley Jr., Marguerite and Robert K. Hoffman, Cindy and Howard
Rachofsky, Evelyn P. and Edward W. Rose, Gayle and Paul Stoffel,
and three anonymous donors; DMA/amfAR Benefit Auction Fund; and
Roberta Coke Camp Fund, 2003

MATTHEW BARNEY, *Drawing Restraint 8: Drawing Restraint,*
2003
Graphite, watercolor, and petroleum jelly on paper, in rotomolded
polycarbonate frames with nylon fiber, acrylic, and vivac,
$36\frac{1}{2} \times 62 \times 41$ in.
The Rachofsky Collection

MAURIZIO CATTELAN, *Untitled*, 2003
Resin body, synthetic hair, clothes, electronic device, and
bronze drum, $31\frac{1}{2} \times 33\frac{1}{2} \times 22$ in.
The Rachofsky Collection

TOM FRIEDMAN, *Untitled*, 1999
Sugar cubes and sugar, 48 × 17 × 10 in.
The Rachofsky Collection

TOM FRIEDMAN, *Untitled*, 1998
Drinking straws, 9½ × 5 × 7 in.
The Rachofsky Collection

TOM FRIEDMAN, *Untitled (big/small figure)*, 2004
Styrofoam and paint, 144 × 75 × 85 in.
The Rachofsky Collection and the Dallas Museum of Art through
the DMA/amfAR Benefit Auction Fund, 2004

OLAFUR ELIASSON, *Jokla Series*, 2004
Forty-eight framed color photographs; each 14¼ × 21¼ in.
including frame, 99 × 181 in. overall
Dallas Museum of Art, DMA/amfAR Benefit Auction Fund, 2006

HIROSHI SUGIMOTO, *Tyrrhenian Sea, Scilla*, 1993
Black-and-white photograph, 20 × 24 in.
Edition 15/25
The Rachofsky Collection

HIROSHI SUGIMOTO, *N. Pacific Ocean, Mt. Tamalpais*, 1994
Black-and-white photograph, 20 × 24 in.
Edition 13/25
The Rachofsky Collection

HIROSHI SUGIMOTO, *N. Pacific Ocean, Mt. Tamalpais*, 1994
Black-and-white photograph, 20 x 24 in.
Edition 17/29
The Rachofsky Collection

HIROSHI SUGIMOTO, *Tyrrhenian Sea, Capri*, 1994
Black-and-white photograph, 20 × 24 in.
Edition 11/25
The Rachofsky Collection

WILLIE DOHERTY, *The Outskirts*, 1994
Cibachrome photograph on aluminum, 48 × 72 in.
Dallas Museum of Art, anonymous gift, 1997

NIC NICOSIA, *Real Pictures #11*, 1988
Black-and-white photograph, 78 × 48 in.
Dallas Museum of Art, DMA/amfAR Benefit Auction Fund, 2005

GREGORY CREWDSON, *Untitled*, 2001–2002
Digital chromogenic print, 48 × 60 in.
The Rachofsky Collection and the Dallas Museum of Art:
DMA/amfAR Benefit Auction Fund, 2002

SAUL FLETCHER, *Untitled #94 (red glass)*, 1998
Chromogenic print, 3½ × 3½ in.
The Rachofsky Collection

SAUL FLETCHER, *Untitled #92 (two wires)*, 1998
Chromogenic print, 3½ × 3½ in.
The Rachofsky Collection

SAUL FLETCHER, *Untitled #45 (corner/wire)*, 1997
Chromogenic print, 5 × 5 in.
The Rachofsky Collection

SAUL FLETCHER, *Untitled #44 (broken mirror)*, 1997
Chromogenic print, 5 × 5 in.
The Rachofsky Collection

SAUL FLETCHER, *Untitled #93 (white corner)*, 1998
Chromogenic print, 3½ × 3½ in.
The Rachofsky Collection

SAUL FLETCHER, *Untitled #53 (hand on door knob)*, 1997
Chromogenic print, 5 × 5 in.
The Rachofsky Collection

SAUL FLETCHER, *Untitled #68 (light/fly)*, 1997
Chromogenic print, 5½ × 5½ in.
The Rachofsky Collection

WILLIAM EGGLESTON, *Untitled (Greenwood, Mississippi),*
1973
Dye-transfer print, 12½ × 18¾ in.
Centennial promised gift of Catherine and Will Rose

JAMES CASEBERE, *Empty Room*, 1995
Cibachrome print, 51 × 63 in.
The Rachofsky Collection

JAMES CASEBERE, *Asylum*, 1995
Cibachrome print, 51 × 63 in.
The Rachofsky Collection

MARIKO MORI, *Burning Desire*, 1997–1998
Glass with photo interlayer, 120 × 240 × ⁷⁄₈ in.
The Rachofsky Collection

RAYMOND PETTIBON, *No Title (Culture and Good)*, 1987
Pen and ink on paper, 11 × 19¾ in.
Dallas Museum of Art, Lay Family Acquisition Fund, 2001

RAYMOND PETTIBON, *No Title (The professor added)*, 2000
Pen and ink on paper, 11 × 8½ in.
Dallas Museum of Art, Lay Family Acquisition Fund, 2001

RAYMOND PETTIBON, *No Title (The revolution will)*, 1987
Pen and ink on paper, 14½/₃₂ × 11 in.
Dallas Museum of Art, Lay Family Acquisition Fund, 2001

RAYMOND PETTIBON, *No Title (A drop every)*, 1991
Pen and ink on paper, 17 × 16 in.
Dallas Museum of Art, Lay Family Acquisition Fund, 2001

RAYMOND PETTIBON, *No Title (This is 1944)*, 1997
Pen and ink on paper, 15 × 19½ in.
Dallas Museum of Art, Lay Family Acquisition Fund, 2001

RAYMOND PETTIBON, *No Title (A big black)*, 1987
Pen and ink on paper, 14½/32 × 10³/32 in.
Dallas Museum of Art, Lay Family Acquisition Fund, 2001

RAYMOND PETTIBON, *No Title (No one can)*, 1987
Pen and ink on paper, 11 × 8½ in.
Dallas Museum of Art, Lay Family Acquisition Fund, 2001

RAYMOND PETTIBON, *No Title (Why didn't you)*, 2001
Pen and ink on paper, 30 × 22¼ in.
Dallas Museum of Art, Lay Family Acquisition Fund, 2001

RAYMOND PETTIBON, *No Title (That long? Long)*, 1989
Pen and ink on paper, 9½/32 × 6 in.
Dallas Museum of Art, Lay Family Acquisition Fund, 2001

RAYMOND PETTIBON, *No Title (Light a Candle)*, 1987
Pen and ink on paper, 23 × 14½ in.
Dallas Museum of Art, Lay Family Acquisition Fund, 2001

GUILLERMO KUITCA, *Untitled*, 1998
Oil on canvas, 72 × 108 in.
The Rachofsky Collection

PETER DOIG, *House of Pictures (Carrera)*, 2004
Oil on canvas, 78¾ × 118½ in.
Promised gift of Gayle and Paul Stoffel to the Dallas Museum of Art

MAMMA ANDERSSON, *Gone for Good*, 2006
Oil and lacquer on panel, 48 × 62⅞ in.
The Rachofsky Collection and the Dallas Museum of Art through the
DMA/amfAR Benefit Auction Fund, 2006

LUC TUYMANS, *Courtesy*, 2005
Oil on canvas, 55½ × 103½ in.
Promised gift of Gayle and Paul Stoffel to the Dallas Museum of Art

ELISABETH PEYTON, *Truffaut at the Cannes Film Festival, 1968*, 2005
Oil on linen, 40 × 30 in.
Promised gift of Gayle and Paul Stoffel to the Dallas Museum of Art

GLENN LIGON, *Untitled*, 2002
Coal dust, printing ink, oil stick, glue, acrylic paint, and gesso
on canvas, 74⁷⁄₈ × 118¹⁄₈ in.
Dallas Museum of Art, DMA/amfAR Benefit Auction Fund, 2004

SUE WILLIAMS, *Shower Cap in Red, Blue, and Green*, 1998
Oil and acrylic on canvas, 82 × 104 in.
The Rachofsky Collection

TRENTON DOYLE HANCOCK,
Good Vegan Progression #2, 2005
Mixed media on felt, 129 × 170 in.
Promised gift of Nancy and Tim Hanley to the Dallas Museum of Art

MATTHEW RITCHIE, *The Idea of Cities*, 1998
Oil and marker on canvas, 62 × 134 in.
The Rachofsky Collection

LAURA OWENS, *Untitled*, 2004
Oil and acrylic on linen, 132 × 111 × 3 in.
The Rachofsky Collection and the Dallas Museum of Art through
the DMA/amfAR Benefit Auction Fund, 2005

ARTISTS

ALLAN MCCOLLUM, *Surrogates*, 1983
Two hundred plaster and enamel elements; dimensions variable
The Rachofsky Collection

MARK ROTHKO
American, 1903–1970
Pages 76–77

THOMAS RUFF
German, b. 1958
Lives and works in Düsseldorf
Page 220

EDWARD RUSCHA
American, b. 1937
Lives and works in Los Angeles
Page 149

ROBERT RYMAN
American, b. 1930
Lives and works in New York
Pages 132–36

ANRI SALA
Albanian, b. 1974
Lives and works in Paris
Page 243

DORIS SALCEDO
Colombian, b. 1958
Lives and works in Bogotá, Colombia
Page 283

JULIÃO SARMENTO
Portuguese, b. 1948
Lives and works in Estoril, Portugal
Page 276

RICHARD SERRA
American, b. 1939
Lives and works in New York
and Nova Scotia
Page 257

JOEL SHAPIRO
American, b. 1941
Lives and works in New York
Page 260

CINDY SHERMAN
American, b. 1954
Lives and works in New York
Page 280

PAUL SIETSEMA
American, b. 1968
Lives and works in Los Angeles
Page 242

DAVID SMITH
American, 1906–1965
Page 254

KIKI SMITH
American, b. 1955
Lives and works in New York
Pages 284–85

TONY SMITH
American, 1912–1980
Page 255

ROBERT SMITHSON
American, 1938–1973
Pages 144–45

VALESKA SOARES
Brazilian, b. 1957
Lives and works in Brooklyn, New York
Page 243

JENNIFER STEINKAMP
American, b. 1948
Lives and works in Los Angeles
Page 245

FRANK STELLA
American, b. 1936
Lives and works in New York
Pages 120–21, 123

CLYFFORD STILL
American, 1904–1981
Page 84

MYRON STOUT
American, 1908–1987
Page 82

THOMAS STRUTH
German, b. 1954
Lives and works in Düsseldorf
Pages 217–19

HIROSHI SUGIMOTO
Japanese, b. 1948
Lives and works in New York
Page 302

RUFINO TAMAYO
Mexican, 1899–1991
Page 14

ROSEMARIE TROCKEL
German, b. 1952
Lives and works in Cologne
Page 242

ANNE TRUITT
American, 1921–2004
Page 122

RICHARD TUTTLE
American, b. 1941
Lives and works in New Mexico
and New York
Page 142

LUC TUYMANS
Belgian, b. 1958
Lives and works in Antwerp
Page 315

CY TWOMBLY
American, b. 1928
Lives and works in Lexington, Virginia,
and Italy
Pages 94–97

BILL VIOLA
American, b. 1951
Lives and works in Long Beach, California
Page 251

LAWRENCE WEINER
American, b. 1940
Lives and works in New York and
Amsterdam
Page 50

FRANZ WEST
Austrian, b. 1947
Lives and works in Vienna
Pages 234–35

RACHEL WHITEREAD
British, b. 1963
Lives and works in London
Page 282

SUE WILLIAMS
American, b. 1954
Lives and works in Brooklyn, New York
Page 318

JANE AND LOUISE WILSON
British, b. 1967
Live and work in London
Page 243

JACKIE WINSOR
Canadian, b. 1941
Lives and works in New York
Page 141

CHRISTOPHER WOOL
American, b. 1955
Lives and works in New York
Page 275

PHOTOGRAPH AND COPYRIGHT CREDITS

We greatly respect the protected status of all copyrighted material. We have endeavored, with due diligence, to identify and contact each copyright owner. In some cases we have been unable to trace current copyright holders. We welcome notification and will correct errors in subsequent editions.

© 2007 by the Dallas Museum of Art
"From a Prehistoric Wind" © 2007 by Allan Schwartzman
Except for what Section 107 of the Copyright Act of 1976 permits
as "fair use," no part of this publication may be reproduced, stored
in a retrieval system, or transmitted in any form or by any means,
electronic, mechanical, photocopying, recording, or otherwise,
without written permission of the copyright holders, aside from
brief quotations embodied in critical reviews.

Dallas Museum of Art
John R. Lane, The Eugene McDermott Director
Charles Wylie, The Lupe Murchison Curator of Contemporary Art
Tamara Wootton-Bonner, Director of Exhibitions and Publications
Eric Zeidler, Publications Coordinator
Victoria Estrada-Berg, Curatorial Administrative Assistant
Edited by Frances Bowles
Proofread by Sharon Rose Vonasch
Designed by Lorraine Wild and Stuart Smith with Victoria Lam
 and Leslie Sun, Green Dragon Office, Los Angeles
Typeset by Green Dragon Office in Apex New
Color separations by Dr. Cantz'sche Druckerei
Printed and bound by Dr. Cantz'sche Druckerei

Distributed for the Dallas Museum of Art by
Yale University Press, New Haven and London
www.yalebooks.com

Library of Congress Cataloging-in-Publication Data
Dallas Museum of Art.
 Fast forward : contemporary collections for the Dallas Museum of Art
/ edited by María de Corral and John R. Lane ; with contributions by
Frances Colpitt . . . [et al.].
 p. cm.
 Exhibition catalog.
 Includes bibliographical references.
 ISBN: 978-0-300-12291-6
 1. Art, Modern—20th century—Exhibitions. 2. Art, Modern—
21st century—Exhibitions. 3. Art—Texas—Dallas—Exhibitions.
4. Dallas Museum of Art—Exhibitions. I. Corral, María de. II. Lane, John
R., 1944– III. Colpitt, Frances. IV. Title.
 N6487.D35D35 2007
 709.04'00747642812—dc22
 2006028702